CONTENTS

INTRODUCTION

GEAR & SETUP

001 Get Familiar with Cameras

002 Go Out and Shoot

003 Read the Manual

004 Capture RAW Images

005 Start Out in Manual Mode

006 Get Organized

007 Learn Your Camera's Limits

008 Protect Your New Purchase

009 Experiment with Camera Functions

010 Learn About Illumination

011 Discover Diffusion

012 Understand Lighting Angles

013 Play with Illumination

014 Know Your Lighting Gear

015 Smooth Skin with a Clamshell

016 Use Clothes as Reflectors

017 Turn a Room into a Portrait Studio

018 Go with a Single Light Source

019 Let There Be Light

020 Carry a Lighting Setup in Your Backpack

021 Move On Up to Car Kits

022 Create a Closet Lighting Cache

023 Bring Everyday Essentials

024 Finesse Flash Exposure

025 Work Your Shoe Mount

026 Use a Flashmeter

027 Make the Best of Phone Flash

028 Turn on TTL Flash

029 Learn About Light Falloff

030 Punch It Up with Hard Light

031 Take a Leap in the Dark

032 Amp Up the Action

033 Soar with Strobe Power

034 Shoot an Easy Rider

035 Sync at High Speed

036 Catch Speed from the Passenger Seat

037 Fire Up a Flash Party

038 Free Yourself with Wireless Flash

039 Capture Dancing Paint

040 Experiment with an Audio Trigger

041 Acquaint Yourself with Light Accessories

042 Shoot Flowers in a Light Tent

043 Protect Your Knees During Fieldwork

044 Style a Food Shoot

045 Respect the Restaurant

046 Shoot Dinner from Above

047 Flatter Your Food

048 Craft a V-Card Reflector

049 Mimic a Dutch Masterpiece

050 Capture Cool Pinhole Shots

051 Build a Pinhole Camera

052 Get to Know Tripods

ose decto know inpod

053 Paint with Light

054 Draw with a Flashlight

055 Know Your Lightbrushes

056 Paint a Panorama

057 Find the No-Parallax Point

058	Photograph Star Trails
059	Shoot the Moon
060	Capture Stars Without Trails
061	Comprehend Crop Factor
062	Tether Your Camera to Your Computer
063	Try a Tethered Still Life
064	Build a Smartphone Tripod Mount
065	Mix Up a Drink Shot
066	Fake Ice Cubes
067	Use Treats to Photograph Puppies
068	Capture the Shine of Creatures' Coats
069	Wade for the Shot
070	Watch Your Garden Grow
071	Shoot Desert Flora
072	Sync Up with Monarchs
073	Scout Sites
074	Shoot a Gorgeous Jellyfish
075	Swim with Sharks
076	Prepare to Go Deep
077	Protect Your Gear in Extreme Climates
078	Track Light with a Compass
079	Explore a Cave
080	Seek Out a Sherpa
081	Shoot Sky-High Photos
082	Shoot Through a Window
083	Go Fly a Kite
084	Bag a Bird's-Eye View
085	Shoot Overseas
086	Locate Lost Sites
087	Explore Safely

088 Get the OK to Shoot Ruins

089 Light Up Hidden Spaces 090 Consider the Realm of Infrared 091 Shoot with IR Film 092 Set Up the Ideal IR Shot 093 Learn the Benefits of Film 094 Know Your Film 095 Have Film in the Bag 096 Preserve Pupils 097 Avoid Red-Eye 098 Make Your Own Ring Flash **099** Pose a Nude Portrait 100 Light the Body's Contours 101 Always Get a Model Release 102 Write a Basic Model Release COMPOSING & SHOOTING 103 Learn the ABCs of Composition 104 Explore an Urban Canyon 105 Mix Up Scale 106 Break the Rules **107** Picture Nature's Patterns 108 Make a Phone Microscope 109 Pick a Lens for Patterns 110 Follow the Rule of Thirds **111** Leverage the Landscape 112 Get Familiar with Lenses 113 Stay Straight with Tilt/Shift 114 Play with the Scheimpflug Effect 115 Reverse the Scheimpflug Effect 116 Do the Vampire Tilt/Shift

117 Improvise a Macro Lens

118	Invest in Macro Tools	149	Make the Most of Live View
119	Do the Macro Math	150	Fight Battery Drain
120	Learn Focus Stacking	151	Go to Extremes with Your Histogram
121	Use a Beanbag Support	152	Know Your Lighting Ratio
122	Get Close to Animals	153	Get the Lo-Fi Lowdown
123	Make Everyday Objects Appear Cosmic	154	Try Lo-Fi
124	Toy with Abstraction	155	Go for Bokeh
125	Prowl for Urban Patterns	156	Float Above It All
126	Consider All the Angles	157	Experiment with Flash Exposure
127	Go Abstract	158	Picture Neon
128	Highlight Detail with a Ring Light	159	Shoot Fairs at Night
	Frame with the Foreground	160	Evaluate the Scene
130	Switch the Perspective	161	Expand Dynamic Range
131	Clean a Lens with Vodka	162	Play Around with Autobracketing
	Adjust Exposure on Your Phone	163	Flatter with Flash
133	Consider Color	164	Get the White Right
	Wrangle White Balance	165	Jump-Start JPEGs
	Cope with Color in Mixed Light	166	Get Fired Up About Fireworks
	Look Deeply into a Subject		Snag Many Salvos in One Shot
	Be Shallow	168	Blur the Bursts
	Fake Depth	169	Amp Up the Magic
	Straighten Out a Skyscraper	170	Light the Way with Candles
	Get Hyper About Focal Depth	171	Sharpen Shadows
	Hold That Horizon	172	Explore the Dark Side
	Finesse Your F-Stops	173	Work with Available Light
	Shoot with a Mosaic in Mind	174	Factor in Color Temperatures
	Zap Specks with Dust Mapping	175	Shoot Outdoors with Ambient Light
	Fight Zoom Creep		See Things in Black and White
	Create a Portable Camera Manual		Master Monochrome Metering
	Take Notes Without a Notebook		Block Out the Blues
148	Perfect Your Optics with Lens Correction	179	Shoot in Color for the Best B&W

180	Pan Like a Pro
181	Show Motion with Flash
182	Freeze Motion with Flash
183	Make Poetry with Motion
184	Extend Exposure in Action Shots
185	Beat Mirror Shake
186	Make People Disappear
187	Capture the Blue Hour
188	Fake Motion
189	
190	
191	
192	5
193	Use Old Lenses on Your DSLR
194	Add Your Filters
195	8
196	Account for the secondary six cases were store
197	
198	8
199	
200	Find Fog
201	Keep Dry in the Damp
202	
203	Go Shooting in the Rain
204	Chase Raindrops
205	
206 207	
	5
208 209	Brush Up on Sea Shooting Basics
210	
210	Protect Gear from Saltwater

211	Play with Tiny Waves
212	Seize a Starburst
213	Shoot into the Sun
214	Grab a "God Ray"
215	Outrun Ghosts
216	Make Art out of Art
217	Capture the City's Bustle
218	Shoot a Stranger
219	Sneak a Smartphone Snap
220	Snap a Candid
221	Use Wet-Weather Reflectors
222	Shoot in Snow Light
223	Smooth Out Skin
224	Slim Down a Model
225	Sculpt a Face
226	Flatter with Color
227	Pack Away Eye Bags
228	J
229	Use Fast Lenses for Family
230	Stage Manage Your Crew
231	Light Your Kin Right
232	Try Posing Primers
233	Catch the Band Offstage
234	
235	
236	
	Picture Live Performance
238	1 0
239	0
240	3
241	Follow the Five-Second Rule

242	Limit Focus with a Lensbaby	271	Unlock the Background
243	Make Your Flowers Dance		Fake a Neutral-Density Filter
244	Go for Blooming Beauty	273	Stack Layers to Enhance a Macro Photo
245	Find a Fresh Take on Flowers	274	Try Touch for Mobile Editing
246	Get Artsy with Seaweed	275	Make a Tilt/Shift Effect
247	Master Flight Fundamentals	276	Rotate Shots
248	Fool the Birdie	277	Super Undo It
249	Try a Medium-Length Lens for Birdlife	278	Clean Up a Background
250	Create Catchlights	279	Crop to Improve Your Shots
	Background Your Bird		Uncrop a Photo
	Photograph Wildlife Safely	281	Put a Twist in Your Shot
	Play to Animal Instincts	282	Scratch Up Some Polaroid Art
	Plunge into the Pool with a Compact	283	Cook with RAW Files
	Snap Easy Snorkeling Shots	284	Learn When to Go RAW
	Light and Shoot Deepwater Photos	285	Choose a RAW-Specific Program
	Zero in on Zoo Creatures	286	Dodge and Burn Digitally
	See Eye to Eye	287	Convert an Image to B&W
	Lure Animals to Your Lens		Make Yours Monochrome with Efex
260	Delve into Detail		Fade (a Background) to Black
			Cruise with Curves
	ESSING & BEYOND		Get Perfect Contrast
	Know Your Image Tools		Up a Silhouette's Contrast
	Customize Photoshop for Optimal Workflow		Fix It with Levels
	Optimize a Computer for Editing Performance		Fix It with Curves
	Protect Your Pictures		Soften with Blur
	Sample a Scrubby Slider		Replace Odd Color with One Color
	Use Layers for Superior Editing		Tone with Masks
	Dive into Layers		Use Grayscale to Fix Color
	Master Selections		Restore Some Original Color
	Make Masks for More Editing Control		Add Color by Hand
270	Double Up Your Layers	301	Add Selective Grayscale with Hue/Saturation

302	Split Tones with Curves
303	Control Tone with Lightroom
304	Light-Proof Your Darkroom
305	Set Up a Home Darkroom
306	Buy the Right Enlarger Lens
307	Clean a Negative
308	Make Your First Darkroom Print
309	Store Film Securely
310	Dodge and Burn
311	Protect Your Photo Paper
312	Opt for Easier HDR
313	Go Pro for Top-Notch Prints
314	Fake an Antique Photo
315	Create Contact Sheets
316	Understand Resolution
317	Determine Maximum Size
318	Save Files as TIFFs
319	Fix Noise Without Losing Detail
320	Pick the Right Printer
321	Choose a Printer Ink
322	Display Your Best Shots
323	Comprehend Copyright
324	Protect with Metadata
325	Choose the Right Color Profile
326	Store Images in the Cloud
327	Be a Picky Editor
328	Bring an Old Photo Back to Life
329	Edit Eyes
330	Extend Eyelashes
331	Undo a Squint
333	Damaria Dad Tua

332 Remove Red-Eye

333	Retouch Subtly for Perfect Portraits
334	Fix Facial Flaws with Your Phone
335	Save Face with Software
336	Preview Your Retouching
337	
338	Decipher Distorted Images
339	Wield the Warp Tool
340	Warp a Wild Panorama
341	Give a Photo the Fisheye Look
342	Widen Your World with Panoramas
343	Go Global
344	Make a Vertorama
345	Ditch Distortion
346	Create an Optical Illusion
	Craft a Composite
348	
349	Switch Out Colors for Graphic Pop
350	Fake a Reflection
351	Quickly Sharpen a Landscape
352	Cut off Fringe
353	Level Your Horizon
354	Pump Up the Clouds
355	Add Spot Contrast

INDEX IMAGE CREDITS ACKNOWLEDGMENTS

INTRODUCTION

A small, dark-brown box, about the size of a thin brick, sits discreetly on a table in my living room. Pick it up by its leather handle, press a button on top, and a door on the front drops open to reveal a lens in a metal apparatus that's attached to a retractable bellows. This little marvel is my grandmother's first camera, a No. 2A Folding Pocket Brownie Automatic made by the Eastman Kodak Co. of Rochester, New York. My grandfather gave it to her for her 17th birthday in 1912, and it still works perfectly—when I manage to track down film that fits.

A century ago, my grandmother's Brownie—simple to use, small and light enough to carry anywhere—represented the apex of consumer technology. But even the most casual of snapshooters must understand the essentials of photography to take a picture with it. A dial governs the size of an opening (aperture) in the eight-bladed metal diaphragm behind the lens to let light in and expose the film. A lever offers three ways to control how long this diaphragm shutter remains open. And, to focus, the bellows extend to a length determined by a scale marking the distance to the photo's subject.

Today, taking pictures is a whole lot easier and more automatic than it was when Grandmom was a teenager. Yet, to get the photos you really want—whether you're enjoying the incredible convenience of a cellphone camera or exploring the endless capabilities of a digital single-lens reflex (DSLR)—you have to master the same basics: the amount of light coming into the camera at any one moment, how long the light streams in, and the optical properties of the lens that focuses that light. The better you control light and the way your camera captures it, the more satisfying your photos will be—and the more fun you can have with photography.

This book will help you get there. You'll find hundreds of tips for every aspect of photography, from choosing the right gear to setting up your shots to capturing and enhancing your images. You'll discover quick fixes for typical situations and longer projects that will challenge your skills and creativity. You'll learn not just how to best capture the light, but how to shape it for precise pictorial effects. And you'll learn how to translate the scene you see in your mind's eye into a finished photograph that you can share with the world.

Every camera, from my grandmother's Brownie to the latest device you just ordered online, is really nothing more than a dark box with a hole on one side and light-sensitive material (film or a sensor) on the other. The pictures that you make with it are entirely up to you—and this book will get you started on that adventure.

Miriam Leuchter Editor-in-Chief

Miriam Levelter

Popular Photography

GEAR & SETUP

001 GET FAMILIAR WITH CAMERAS

Digital cameras vary widely in how much control they offer photographers when it comes to settings. Point-and-shoots, which do everything but click the shutter for you, produce good standard shots. Digital single-lens reflex (DSLR) cameras are your best bets once you've moved past the novice stage, however. Although they require a longer learning curve, they create distinctive, high-quality photos.

FLECTRIC-VIEWFINDER ULTRAZOOM This choice is similar to the advanced

compact (below), but it has a built-in, large-range zoom lens.

Ultrazooms help get your viewers much closer to far-away subjects. such as the zebras here.

POINT-AND-SHOOT

The most basic model available, this camera automatically adjusts all settings and permits no manual control.

INTERCHANGEABLE-LENS COMPACT (ILC)

The ILC generally has a bigger sensor than other compacts and lets you use various lenses.

ADVANCED COMPACT

This option, which can be as pocketable as a point-and-shoot, offers many different modes for shooting, and some models allow full manual control.

DIANA LOMO

This plastic film camera produces dreamy, streaky low-res images.

A '60s cult classic, the Diana is back, updated with pinhole, panorama, and shutter-lock options.

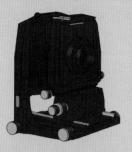

LARGE-FORMAT VIEW CAMERA

This top-of-the-line option has a sensor larger than a medium-format DSLR's to capture astonishing detail.

From still lifes to landscapes, large-format view cameras capture the greatest detail and offer the most precise focus.

DIGITAL SINGLE-LENS REFLEX (FULL-FRAME DSLR)

A DSLR uses a mirror system to allow you to see exactly what the camera will capture through the lens.

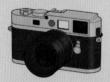

DIGITAL RANGE FINDER

This camera has a bright, oversize viewfinder, which you'll need for manual focusing.

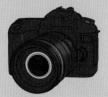

DSLR (SMALL SENSOR)

This alternative has the same functions as a full-frame but a smaller sensor size that is brand specific.

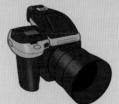

DSLR (MEDIUM-FORMAT)

It functions like a full-frame DSLR, but its larger sensor creates highly detailed images.

MEDIUM-FORMAT WITH DIGITAL BACK

This double-duty camera can be used with different backs for film or a digital sensor larger than a full-frame DSLR's.

MOBILE PHONE

For shots on the go, this option is increasingly sophisticated, with 2MP or higher sensors, autofocus lenses, and decent color accuracy.

002 GO OUT AND SHOOT

Were you just the lucky recipient of a shiny new DSLR? Or perhaps you used your bonus to buy a large-format beauty? Congratulations!

Since your new gear is likely calling you to use it, go right ahead. Charge up the battery and snap it in, along with the memory card. Then fire off some frames. Now that that's out of your system, it will be a bit easier to fight distraction. Settle in with this book, which is designed to teach you the ins and outs of your camera so you can make the most of it—and realize your photographic dreams.

003 READ THE MANUAL

Sure, we're trying to get you to do a lot of reading, but you'll thank us later. You don't necessarily have to plow through your camera's manual all in one go, though it should be your first resource when questions arise. Wondering how to set in-camera noise reduction to your liking? Wish the thing would stop beeping every time you get something in focus? The manual will straighten you out. And you might find fantastic new tips and tricks in its pages. (Some people suggest you keep it in the bathroom so you'll actually read it.)

004 CAPTURE RAW IMAGES

Your new DSLR likely has lots more imaging firepower than your old camera, especially if you're stepping up from a compact. But to get as much as you can out of your camera, you need to shoot RAW. Not only does RAW give you uncompressed files, but because it captures maximum image data, it gives you more flexibility when you're processing photographs.

Processing RAW files (see #283) is a bit more complicated than working with JPEGs, so if you're new to the mode, set your camera to capture in both RAW and JPEG. That way, you'll have JPEGs to quickly share online and RAW files to adjust in postproduction. Yes, this strategy demands lots of space on your memory card and hard drive, but the payoff is well worth it.

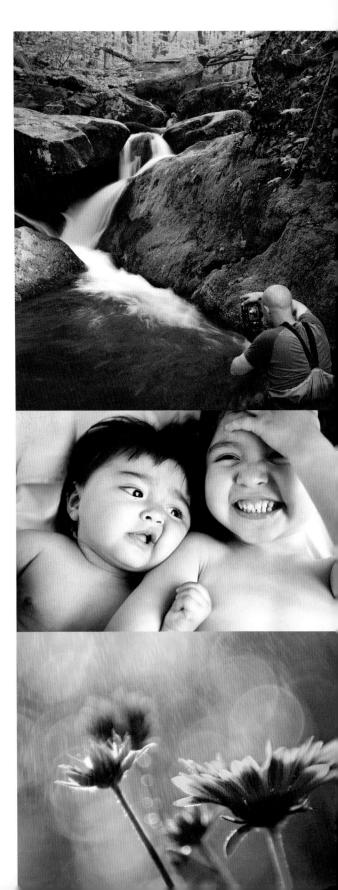

005 START OUT IN MANUAL MODE

DSLRs are so smart that you can get passive and let them do almost everything for you. But switching to manual exposure mode makes you think about the actual process of taking a photo. If your previous camera was a compact (or smartphone), you probably weren't setting your aperture and shutter speed. Now's the time to learn how to do that.

Manual also helps you get a feel for your new camera, but it can be challenging at first, since you need to be quick with the dials and buttons to establish the settings for each shot. Keep practicing. And keep autofocus (AF) on: Most DSLRs' AF systems are so sophisticated that they'll adjust perfectly as you shoot.

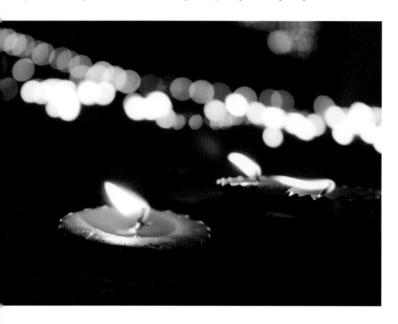

007 LEARN YOUR CAMERA'S LIMITS

When you acquire a new camera, your expectations are naturally high. Yes, it'll behave much better in low light and focus much faster than your old camera, but it can't do everything. Test it by taking a shot at each of its ISO settings—a high ISO setting makes it more sensitive to light, and a low ISO renders it less sensitive. Then find a differently lit setting, and do the same thing.

When you look at these images later, you'll learn how the camera performs and which ISO settings work best. Check, too, how the autofocus handles low-light situations, and find out just how fast the high-speed burst mode really is. Exploring these functions prepares you for serious shooting.

006 GET ORGANIZED

Filing definitely isn't glamorous, but if you don't have your ducks in a row, things can get messy fast. Before you start shooting, choose a central location to store photos and a standardized naming convention for folders and images. The software that you use to import images from camera to computer can help with file arrangement and naming, too. Tag images with useful details so they will be easy to find.

Back up your favorite images in more than one place. Online cloud storage services (see #326) are a good option, as are portable drives that you store at, say, your office or mom's house.

QUICK TIP

PROTECT YOUR NEW PURCHASE

As soon as you get it home from the store, write down your camera's serial number and put it somewhere safe. Register the camera, too, in case it's stolen or needs service.

EXPERIMENT WITH CAMERA FUNCTIONS

If you're new to DSLRs, their functions can bewilder you—but learning what they are and experimenting with what they do grants you great control over shots. Below are the key functions of most DSLRs—including color, exposure, and image-quality controls and custom settings that handle many other aspects of a shot, though advanced ones sport even more features. Models vary, of course, and some functions are found in on-screen menus and others in external controls. Study your manual before you shoot.

IMAGE-QUALITY AND RESOLUTION CONTROLS

When you're grabbing casual snaps, choose lower-quality, higher-compression settings so your memory card won't overflow. Save high-quality, high-resolution settings for artful images.

IMAGE-SHAPE CONTROLS

Many DSLRs let you select photos' dimensions—3:2 is the most common proportion, but you can choose other shapes to best suit your style.

AUTOFOCUS MODES

These settings allow you to focus in several fashions: Single works optimally on still subjects, while modes such as Continuous allow you to track a moving subject through the frame. Your viewfinder and LCD screen (in Live View) can show you where the camera's autofocus points are, allowing you to center your focus area, place it in the frame, or activate multiple points simultaneously. In some situations, such as when shooting close up in very low light, it may be better to focus manually.

AUTO-EXPOSURE MODES

A DSLR's one-size-fits-all, fully automated setting is called Program. It picks aperture and exposure duration for you. Experienced shooters might select Intelligent Auto or Auto ISO modes to control their image sensor's light sensitivity (a low ISO—50 to 200—works well in bright conditions; high ISOs are best in dim ones). Tip: The higher the ISO, the more noise your image will contain. Choose Aperture Priority when you require a specific aperture for certain light conditions. Freezing speedy action? Pick Shutter Priority. And full Manual mode allows you complete control over exposure.

SCENE MODE

This mode contains a menu of settings for specific subjects. Portrait mode instructs the camera to use a short exposure but switch off flash, for example; Foliage mode amps color saturation and sets a small aperture.

WHITE BALANCE

Choosing Auto White Balance lets the DSLR define how white areas look in specific lighting conditions, and it corrects all other colors accordingly. Set WB manually when shooting in mixed lighting conditions.

FLASH MODES

In Auto mode, the camera's own flash fires when light is low. Turn it off if you don't like flash's hard look or prefer to use a tripod and a long exposure.

SELF-TIMER

Want to avoid jostling a tripod-mounted camera? Set its self-timer mode, and it will trigger its own shutter after a predetermined period of time.

COLOR-QUALITY SETTINGS

Many in-camera menus offer settings from B&W to pale pastels. Experiment by shooting a subject in several settings to learn their effects.

HOT SHOE

Here you can slot in a flash unit or other accessories; a small cover protects it when it's not in use. Accessory flashes can also sit in L-brackets to the camera's side. Or set them near your subject and fire them via remote trigger.

AUTOBRACKETING

When you're unsure which exposure will work best, employ the autobracketing function to fire off several shots at varying exposures with a single shutter press.

FOCAL LENGTH CONTROLS

When you use a zoom lens, its zoom ring will allow you to set the focal length to control the angle of view and how much of the frame your subject fills.

POP-UP FLASH

Many DSLRs include an onboard flash that pops upward—a convenient option if you lack an accessory flash unit.

LIVE VIEW MODE

This mode lets you use the camera's LCD screen as a viewfinder so you can preview framing and composition before you shoot.

BURST MODE

Also known as Continuous shooting mode, this function lets you choose the number of shots your camera fires over a duration with one press of your shutter button. It's perfect for fast-moving action.

IMAGE-STABILIZATION CONTROL

Sitting on the lens or camera body, this control helps you capture sharp images even when you shoot in low light or without a tripod.

CONNECTIONS TO PERIPHERAL GEAR

You'll likely need to hook your DSLR to a computer or printer at some point (see #062). Follow the camera's menu instructions (and consult its manual) to ensure connections work smoothly.

010

LEARN ABOUT

Any photographer worth her or his lens cap knows a thing or two about light. To join their ranks, master a few basics.

First, remember that the broader the light source, the softer the light it emits will be; the narrower the source, the harder its light will be. Broad light reduces shadow and contrast and suppresses distracting texture because its rays hit a subject from many directions (which is why it's beloved for flattering portraits).

A corollary: The closer that a light source is to a subject, the softer its light will be, because the light source is broad in relation to the subject. The converse holds true as well—as you shift a light away from a subject, its beam narrows and the light that it casts is harsher and harder. Such light plays up texture (as well as flaws) and is a great choice for gritty, moody photos.

011 DISCOVER DIFFUSION

Whether it's natural or artificial, any material placed between an illumination source and a subject scatters the light in an effect called diffusion. Clouds and mist scatter sunlight outdoors; pale fabric scrims and translucent plastic sheets scatter strobe light in the studio. Diffusion softens or eliminates shadows and produces an even, flattering glow because it broadens the spray of a light source's beams.

Bouncing light also produces diffusion. When you aim a narrow light source at a wide, matte surface—such as a wall, ceiling, or a lusterless reflector—the light that bounces back is scattered over a wide area. Try the experiment with a shiny reflector, and you'll see that the light's bounce remains fairly narrow.

PLAY WITH ILLUMINATION

- ASK A PORTRAIT SUBJECT to sit near a large window to make the most of indirect sunlight. A window with good light is a no-cost softbox.
- MOVE LAMPS CLOSER AND FARTHER away from subjects until you've found the most flattering illumination.
- ☐ AIM YOUR FLASH HEAD BACKWARD and bounce it off a pale wall behind yourself for natural-looking diffusion when you shoot in a small room.
- □ TRY HIGH-KEY LIGHTING—with bright lights set to the sides of your subject and bounced off a pale backdrop—to smooth out surfaces and tones.
- GO LOW-KEY with a dark subject, a darker background, and a single figure-tracing spotlight for an evocative, even melancholy, look.
- □ PLACE A LIGHT SOURCE TO THE SIDE OF FLUFFY PETS to bring out the softness and texture of their fur.

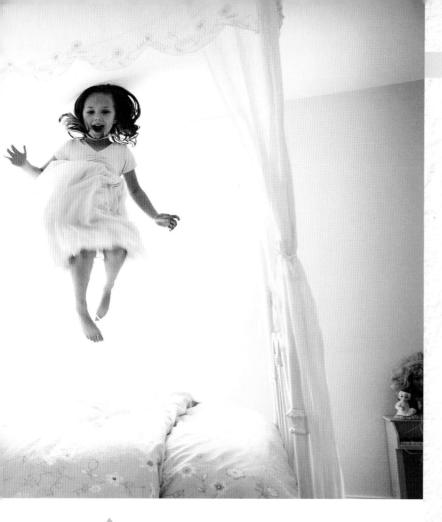

012 UNDERSTAND LIGHTING ANGLES

Frontlighting underplays texture, while lighting from above, the side, or below emphasizes it. Thus, a portraitist might keep his light source near the axis of his lens to suppress skin wrinkles and warts, but a landscape photographer might choose sidelighting to stress the pattern and grain of rocks and foliage. A light set at an angle to a subject reveals still more texture.

Backlighting is a different sort of beast: In essence, it is a technique that's used to create highly diffused lighting. Few subjects are shot in pure silhouette, with all of the light behind them and none in front. Instead, a backlit model shot in an interior receives some light reflected off the wall in front of him, and a model with her back to a sunset catches some light from the darkening sky in front of her. In both cases, increase your exposure to record the light falling on the subject, which will deemphasize his or her facial texture and reduce dimensionality.

014 KNOW YOUR LIGHTING GEAR

Photography is painting with light, so consider expanding your palette. Here are some lighting options that will help you flatter your subject's face, focus underwater, and flash in sync with action, as well as equipment that will help your lighting choices stay juiced and secure on the shoot.

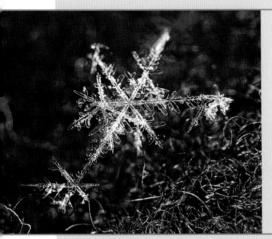

MACRO RING FLASH

A great choice for close work, this provides flash in all directions around the lens to soften shadows.

The macro ring flash's all-over light is great at capturing the shimmer of miniscule snowflakes.

ACCESSORY FLASH

This flash, used remotely or slotted into your camera's hot shoe, syncs with your shutter release.

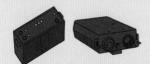

ACCESSORY FLASH POWER PACK

This power source fits on your belt or in your bag and ensures your flash is ready to go whenever you need it.

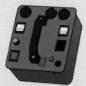

STUDIO STROBE **BATTERY PACK**

A key accessory, the strobe battery pack powers full-size studio lights when you're away from conventional power sources.

UNDERWATER STROBE

This light's waterproof casing permits you to use it for aquatic photography.

Place underwater strobes to the sides of your camera to prevent backscatter and preserve vibrant colors.

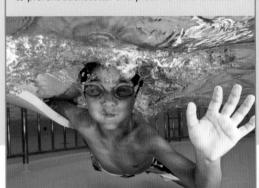

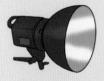

HOT LIGHT

These continuous-output, nonflashing lights are lighter and cheaper than strobes.

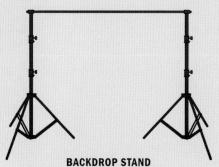

Clamp paper or fabric to this adjustable frame for a smoothly hanging background.

Backdrops—paper, canvas, or fabric—focus attention on a subject and eliminate distracting background.

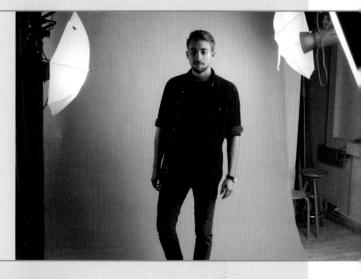

LED RING LIGHT

Fitting neatly around your lens, a ring light provides cool illumination less bright than that of flashes.

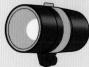

STROBE

A standard studio flash bursts off and on when triggered and can be synced to fire when you release the shutter.

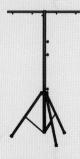

BOOM STAND

This support grants you versatile positioning and can support a strobe head and diffuser.

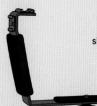

L-BRACKET

Fix an accessory flash to the side of your camera with this tool, giving yourself mobility without head-on flash glare.

An L-bracketed flash lets you cast natural-looking light onto one side of your subject.

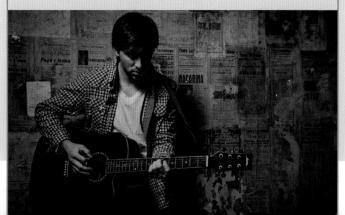

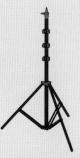

LIGHT STAND

This device gives you sturdy support and varied setups for studio lights and modifiers, such as diffusers and reflectors.

015

SMOOTH SKIN WITH A CLAMSHELL

To get the most flawless possible skin in portraits, try a clamshell. Not one from the mollusk: We're talking about a light-over-light setup, with two softboxes set at angles so their diffusion panels nearly touch, like an open shell. It's very effective in 1:1 lighting ratios. (Standard portrait lighting uses a 1:2 ratio with two frontlights, a main one and a softer fill. It creates pretty shadows but can also emphasize skin flaws.)

Set the main light in a softbox on a boom above your subject, aiming it down at her. Place the fill light below her, under a translucent umbrella, and angle it upward. Dial up the fill until it matches the main light—now you've got shadowless 1:1 lighting for a flaw-free face. For an even brighter look, strip the diffusion panels off silver-lined softboxes before you arrange your clamshell. Your model will glow like the moon.

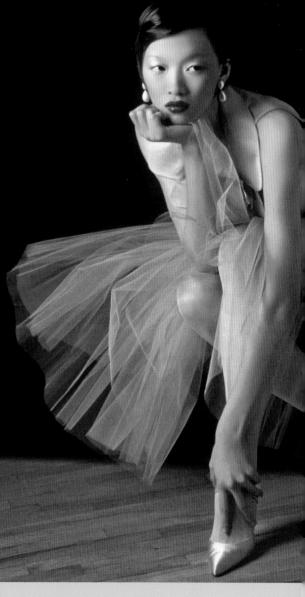

QUICK TIP

USE CLOTHES AS REFLECTORS

The world's simplest reflector? A white T-shirt. It bounces light onto subjects almost as well as the real thing. (Make sure it's clean!) To absorb excess light, wear a black one while you shoot.

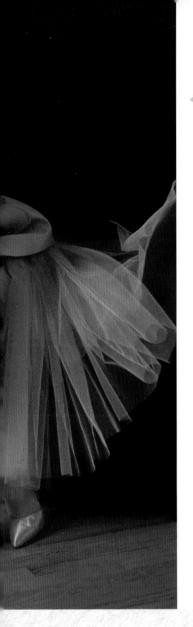

117 TURN A ROOM INTO A PORTRAIT STUDIO

Transform your little-used guest room into a much-appreciated studio with a setup that's ideal for stunning portraiture. There are many great things about having a home studio. For starters, you can invest in heavy, solid equipment that lasts a lifetime, rather than compromising on the modular gear a portable kit requires. Your lights are immediately on hand, so you needn't dedicate eons to setup and breakdown, and you have plenty of room to compose, shoot, and simply dream up inventive portraits. And because you control the room, you can place lights and stands wherever you choose, paint walls white or gray for diffused light (or black for high-contrast looks), then switch things up with frames to hold flattering backdrops, from paper rolls to patterned fabric.

The dreamy dancer here was shot by photographer Carol Weinberg in her home studio. After lighting the scene with a mix of window light and bounced strobe, she placed her model in front of a swatch of black velvet, which hid the chair the model was sitting on, contributing to the dramatic—and slightly surreal—effect.

018 GO WITH A SINGLE LIGHT SOURCE

The allure of the one-light portrait is obvious: It reveals striking shadows, and its setup is almost criminally easy. Place a strobe on a stand slightly to one side of your camera, raise it above your seated subject, and point it downward at a 45-degree angle to illuminate his face (single-source is more flattering if the light is "feathered" to one side of the subject rather than glaring straight at him). Play with position to ensure nothing looks funky (such as a big shadow under his nose) and to get a catchlight (see #250) in his eyes. Now position a reflector—a sheet of white cardboard will do—to reflect light onto your model's other side and brighten shadows. No cardboard? Seat your subject next to a white wall.

CHECKLIST

019 LET THERE BE LIGHT

Lighting kits can cost anywhere from a few hundred to several thousand dollars. As you shop, consider these five options, which all work well for portraiture. All but the tungsten can be daylight-balanced.

☐ **FLUORESCENT LIGHTS** are cool-operating and have long-lasting bulbs.

- ☐ **HMI** (hydrargyrum medium-arc iodide—try saying that three times fast) lights are soft and need little power.
- ☐ **LED LIGHTS** are cool-running and long-lived, but they're too dim to capture action.
- STROBE LIGHTS, which flash at set speeds, are your go-to on shoots with high-speed action.
- ☐ **TUNGSTEN LIGHTS** offer continuous output and run very hot—buy ones with mesh bulb protectors.

020

CARRY A LIGHTING SETUP IN YOUR BACKPACK

Location lighting kits can fit in any space, from large to small. When you carry lighting on your back for field shooting, though, you need compact, easy-to-schlep. bombproof gear and light-modifying accessories with as many features (and almost as much juice) as their studiobound brethren. And all of it should be battery-powered. Sound impossible? It's not. Backpack lighting kits contain setups full of double-duty gear-tripods that also serve as light stands and reflector holders;

> LED flashlights that both illuminate the trail and act

> > as dual-power fill lights. Most compact, battery-operated lighting setups will pack in the glow for prices from about \$700 to \$3,000.

021 MOVE ON UP TO CAR KITS

Traveling by car or truck? Great: Now you can bring sophisticated gear that will expand your lighting options. Dozens of available location strobe kits all fit easily into your car's trunk (the most popular and flexible brands include a strobe, portable battery. trolley, umbrella/softbox, and stand in a compact case). Whichever one you buy, make sure it includes these accessories:

- □ SOFTBOXES IN SEVERAL SIZES AND SHAPES should be part of the package. The larger your subject, the larger a softbox must be.
- □ SOFTBOX AND REFLECTOR ACCESSORIES from grids to diffuser socks help you finesse and fine-tune your light.
- ☐ A RANGE OF REFLECTORS, from big ones for groups to beauty dishes for portraits, are essential for your kit, too.
- ☐ **SNOOTS AND BARN DOORS** help you direct and narrow strobe ouput.
- ☐ A BUILT-IN WIRELESS FLASH TRIGGER that couples with your on-camera transmitter via radio signal is indispensable.
- **FOAM PADDING**, to line your kit, ensures your gear won't smash when you hit a pothole.

022 CREATE A CLOSET LIGHTING CACHE

If you lack space for a full-size home studio, seek a modular lighting option to stash in a closet. Collapsible products are a must, and almost every lighting tool on the market comes in a foldable version. Fold-down beauty dishes? Inflatable, weatherresistant studios for backyard shoots? You'll find them and more for sale, plus hard-sided cases for easy stacking. As for the lights themselves, base purchases on the subjects you shoot most. For still lifes and product shooting, cool-running, easily stowed LED

lights offer continuous output so you can evaluate lighting as you work. Instantaneous studio strobes are your best bet if you shoot speedy subjects such as pets and kids. To hold lights, choose space-optimizing accessories, such as wall-mounted holders that can grasp many stands at once or tripod stand organizers. Other niceties for closet-stored gear: tacky wax to anchor objects to tabletops, flat-folding product shooting tents, and looking-glass paint that turns glass squares into mirror reflectors.

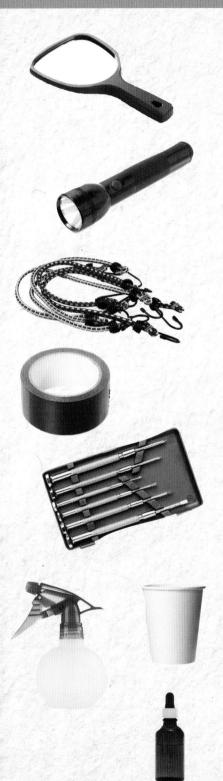

023 BRING EVERYDAY ESSENTIALS

We photographers love our gear. We dream of bags brimming with the latest, priciest gizmos. But gear needn't cost a mortgage payment—sometimes the right tool is in your junk drawer. Open it up and grab these 11 essential gear-bag items.

☐ A SMALL MIRROR is an excellent reflector for outdoor shots: It can open deeply shadowed areas or create bold fill. A cheap acrylic one won't shatter in the field. ☐ GARBAGE BAGS protect gear when the sky opens, and they keep you dry. too (tear three holes and you've got a poncho). Use them in lighting setups—white bags as reflectors, black ones as light-blocking flags. ☐ A FLASHLIGHT is a no-brainer. You need one when you're fumbling with teeny camera controls in twilight. They're aesthetic tools, too: Create delicate light paintings with a penlight, or dramatic background pattern with a wide-beamed light (see #054). Don't want to hold a light? Get an LED headlamp. ☐ **ZIPPER BAGS** are perfect impromptu weather housings (poke a hole and rubber-band it around your lens), and they keep dust off lenses and backup bodies in your bag. ☐ MINI BUNGEE CORDS lash up tripod legs and fix snapped camera straps. Bring lots so you can daisy-chain them into longer straps. ☐ GAFFER'S TAPE will save those sessions when everything from your hiking-boot soles to your focusing ring falls apart at once. ☐ MICRO SCREWDRIVER SETS can help you fix your tripod head, as well as your eyeglasses, on chaotic days. ☐ WHITE PAPER CUPS make fantastic impromptu snoots if you cut out their bottoms, or you can line them with black tape and mount them as backup lens shades. ☐ A WHITE PAPER PLATE is the poor photographer's ring light. Cut a hole in it and tape it to your lens as a reflector for backlit close-ups and facial portraits. Or tape some foil, shiny side out, to the plate to make an extra-bouncy reflector. ☐ A SMALL SPRAY BOTTLE can fake morning dew on foliage and flowers when Mother Nature hasn't done her job, and puts sheen on models' faces and skin.

☐ AN EYEDROPPER AND GLYCERIN give you "droplet control"—place drops
of glycerin precisely where you want them (on a petal or twig, perhaps),

and the sticky globs will wait while you compose and focus.

CHECKLIST

WORK YOUR SHOE MOUNT

Most DSLRs accept shoe-mount flash units, which provide helpful lighting boosts. Oncamera flash can produce harsh, flat, or blown-out snapshot-style light, but a few savvy shoe-mount flash techniques will let you skirt this danger to get subtly lit shots.

- □ ADD A SHOE-MOUNT ACCESSORY FLASH—there are dozens on the market—so you can lift your flash off the camera to generate off-axis directional lighting.
- BOUNCE FLASH OUTPUT off the ceiling or walls in interior shots. Don't aim on-camera flash directly at a subject.
- □ **SOFTEN LIGHT** with shoe-mount diffusers.
- EXPERIMENT WITH APERTURES to adjust the flash's output on a foregrounded subject.
- □ ALTER SHUTTER SPEED TO CONTROL how much background appears in your photo. A long shutter speed captures more background. A slow one shows less of the scene.

024 FINESSE FLASH EXPOSURE

Accessory flash units automate exposure by reading the bounce-back of a speedy preflash through the lens—that's why they're called through-the-lens (TTL) metering flashes. The camera and flash then adjust flash exposure by making its burst shorter for low light, longer for more light. A typical accessory unit on the market today has an astounding range: from 1/1,000 to 1/50,000 sec. To take matters into your own hands, manually adjust flash power by changing duration, expressed in fractions: full power, 1/2, 1/4, and on down to 1/64 power for the briefest flash duration.

026 USE A FLASHMETER

Indispensable for elaborate setups and studio shots, a flashmeter provides exposure readings, determines the relative proportion of individual flashes in the setup, and takes readings of multipop exposures. Some even allow narrow spot flash metering, and you can switch them to ambient readings to balance a range of exposures.

MAKE THE BEST OF PHONE FLASH

To navigate your smartphone's flash options, tap the lightning-bolt icon on your phone screen's top left corner. Choose Auto if you want the phone to determine when flash is needed, or set the mode to On if you want every photo flashed regardless of the amount of ambient light. If you'd like to diffuse your flash, simply tear off a piece of paper from a tissue, napkin, or even a coffee filter and tape it over your smartphone's flash.

028 TURN ON TTL FLASH

A through-the-lens metering flash is basically lightning in a bottle. It can freeze action, tame tough midday sunlight, mimic studio lighting, balance or skew colors, and produce wild effects. As noted, it fires a quick preflash, then uses the bounce-back, plus information from the camera's meter, to determine how much light to emit when you shoot. So once you set your flash to TTL, you're free to set your camera to manual and play with ISO, shutter speed, and other variables until you capture the perfect background. In the meantime, TTL flash will take care of the foreground subject for you. Let's get started.

STEP ONE Set your camera to Manual and its meter to Evaluative Mode.

STEP TWO Set white balance to Flash. Choose an ISO, aperture, and shutter speed. (Each camera has a maximum speed that its shutter can match, or "sync," with the flash. You can set your camera slower, but not faster, than the sync speed. Don't know your max speed? Start with 1/125 sec.) If you get confused, use the Program, Shutter, or Aperture-Priority modes as a guide, and dial the mode to manual.

STEP THREE Take a background shot. If you like it, you're ready to go. If you don't, alter the shutter speed or aperture.

STEP FOUR Turn on the flash. Most flashes default to TTL, but if yours does not, push the Mode button until TTL appears.

STEP FIVE Fire away! The evaluative meter will locate your foreground subject, the flash will expose for it, and the background will look just as you planned.

029 LEARN ABOUT LIGHT FALLOFF

The farther a light source sits from a subject, the more its light falls off, or grows dimmer. Light falls off as the square of its distance: When you move a light twice as far from a subject as its original distance, only one-quarter of the original light reaches the subject. (Or skip the math and just bear in mind that light dims quickly when you move it away.)

You can use falloff to your advantage—to contrast a subject with its background, for example. Placing a light close to a subject makes the falloff from subject to background more pronounced. Move the light away, and the background grows relatively brighter. The same is true for sidelighting. Keep light close to your subject's side for dramatic light falloff across the frame, or pull it back for subtle falloff.

captured by Jason Petersen, combines flash and flour to produce an arresting image of emotion in motion. On a cold, dark night, with an outdoor black backdrop and two strobes (one facing the backdrop, one just behind and to the left of it), Petersen shot dancers as they leaped and arched. The dreamlike aura? Handfuls of strobe-lit flour tossed on the models by assistants. "I dreamed up something with a modern-art feel," he says. "I locked focus and

tracked them until they hit the peak."

This image of a springing dancer,

PUNCH IT UP WITH HARD LIGHT

Hard light is one rough character, but it's also useful. For maximum contrast, unroll a black backdrop as a foil to a hard-lit figure, as Matthew Hanlon did for the shot below. He also used a light for every angle he wanted to highlight.

If you're following suit, think about texture: Hard light picks out every blemish and flaw. But flattery

might not be your goal. Check out the highlighted scar on the boxer's right eyebrow and his callused knuckles—they make him look even tougher.

Want to pull your punch? A single soft source tempers hard light. Hanlon set a softbox behind his camera for fill that retained detail in shadows—a clever feint that produced a powerful portrait.

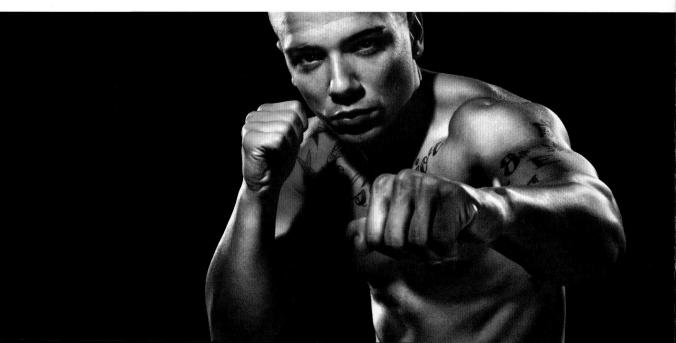

1081 TAKE A LEAP IN THE DARK

Jason Petersen used a tripodmented DSLR, exposing for 1/250 se at f/22, with a ISO of 200, and amped up the crescent shape of this dancer's body with trailing clouds of flour. If you want to dramatize human movement, borrow some of his techniques.

A black backdrop and a well-positioned flash or strobe are essential; so, too, is the patience for multiple shots until your subject and the substance are moving in tandem. Sugar glitter, and fine sand all extend and emphasize movement or blur a body into clouds of light. A helper can sprinkle the substance on your subject as she moves, or the subject herself can toss handfuls in mid and on. See #182 for other pointers on capturing action shots.

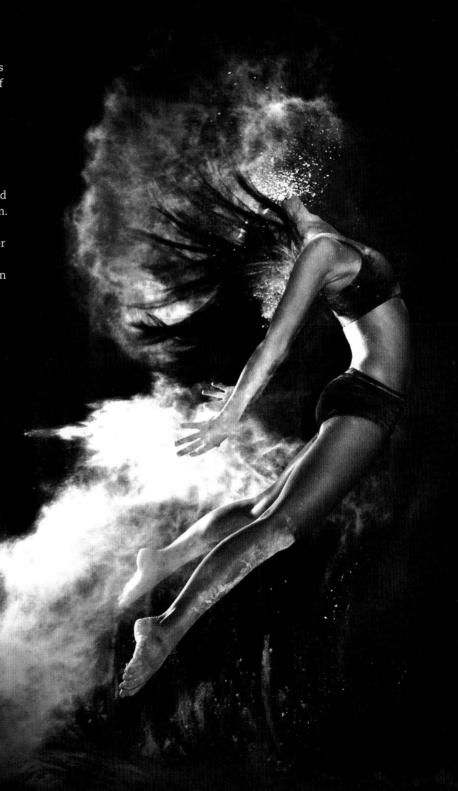

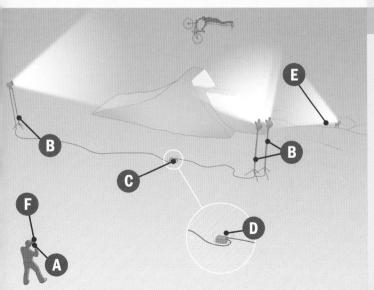

033 SOAR WITH STROBE POWER

Strobe lighting illuminates, sure. But it can also suggest shape and dimension, pull viewer attention to specific details, freeze action, and make a subject seem to leap straight out of the background.

In this can-you-believe-it action shot, strobes perform all these tasks. Professional mountain biker

CHECKLIST

032 AMP UP THE ACTION

Here are four principles for top-flight high-speed action shots:

- □ FOCUS ATTENTION. For instance, here the track and the ramp are vividly illuminated while the foreground and the background are heavily shadowed, a feat achieved by focusing the strobe heads' output through narrow 50-degree reflectors. Using these, photographer Scott Markewitz selectively lit key areas, such as the parabolic approach ramp.
- □ SEPARATE SUBJECT AND BACKGROUND. Markewitz fired up his lights for an output brighter than the cloudy ambient daylight, and set an exposure that rendered the ground and sky dim and the athlete brilliant.
- □ DEFINE SHAPE. Thanks to Markewitz's crafty backlight position, the rocky ramp looms larger than life and its sharply delineated curves make the biker's horizontal flight all the more breathtaking.
- ☐ TRY A SUPERSHORT FLASH-DURATION STROBE HEAD.

 It's pricey top-flight gear, but it kills the faint but visible motion blur produced by ordinary, slower heads.

Paul Basagoitia, airborne in an outrageous "Superman Seat Grab" maneuver, is a spectacular subject by anyone's lights. And action-adventure photographer Scott Markewitz's strobe savvy turned the stunt into an object lesson in how to compose and capture a thrilling trajectory.

He chose an unusual belowground locale for his batteries and lights, and mounted a 70–200mm f/2.8 lens with vibration reduction onto his camera (A). Then he set two short-duration strobe lights (B), with

zippy minimum durations of 1/5120 sec, at the ramp's approach and another strobe to its left—all juiced with battery packs (C). The foreground pack intruded into the frame, so Markewitz got creative and dug a shallow pit in which to conceal it (D). He positioned his right backlight (E) belowground, too, so its output would not reach his lens and produce flare. Balancing this radical symphony of light sources with a high-end flashmeter (F), Markewitz cued the athlete and bagged his soaring Superman.

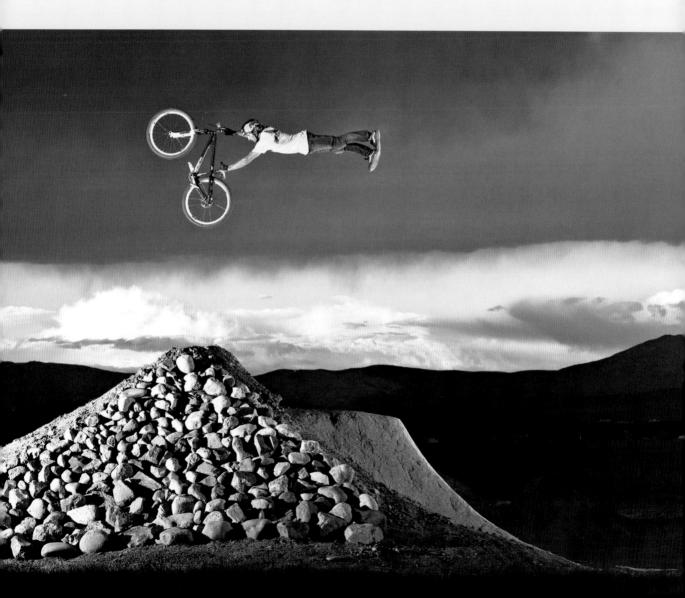

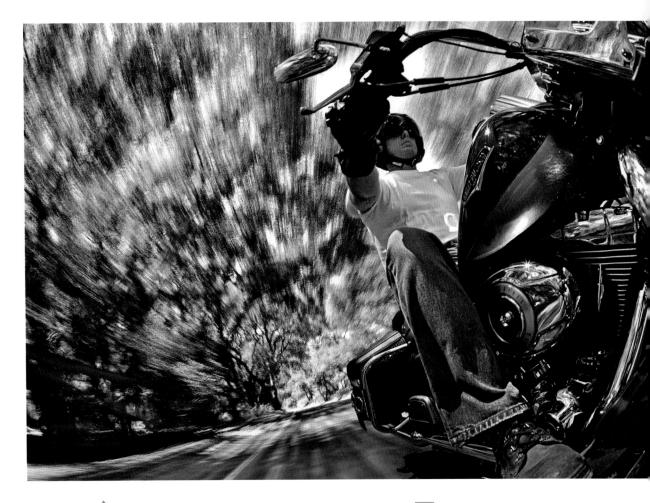

034 SHOOT AN EASY RIDER

For a photo that conveys the scene the way a motorcycle rider sees it—as zooming streaks of color and light—clamp a camera to the bike itself.

For the widest possible sweep of road and bike, your best rig is a DSLR or interchangeable-lens compact with a full-field fisheye lens, but you've got to secure it first. Attach two heavy-duty clamps to the bike's front fender rail. Fasten an elbow-hinged arm—one that's made to grip lights and cameras with a locking lever control at its pivot—to your camera base, and use a Super Clamp to secure a metal stud in its hot shoe. Strap the rig to the cycle with safety cables so it won't bite the dirt.

Now cue the rider to drive slowly: Speeds of 5 to 10 miles per hour (8–16 km/h) are safe but generate thrilling motion blur. Get ahead of the bike—a pickup bed is a good spot to sit—and trigger the shutter remotely. Shoot like crazy, playing with shutter speeds between 1/10 and 1/30 sec for optimal motion blur.

035 SYNC AT HIGH SPEED

Most deluxe accessory flashes offer high-speed syncing, liberating you from your camera's slower sync. Shooting flash at speeds of 1/1000 sec or faster, you can use wide apertures to create beautifully defocused backgrounds, thus spotlighting brightly flash-lit foreground subjects. Or darken or saturate background colors by underexposing with superhigh shutter speed. High-speed sync is often dimmer than conventional flash, but you can beat that problem by adding extra flash units.

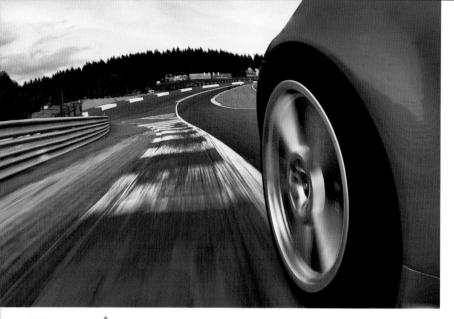

036 CATCH SPEED FROM THE PASSENGER SEAT

Ever snapped a shot while riding in a speeding car? For the shot above, pro racing shooter Regis Lefebure handheld his DSLR, strap wrapped around his arm, as he leaned out of the window of an Audi driven at 80 miles per hour (145 km/h) by Formula 1 racing star Allan McNish. If you're after a similar shot, halve the driving speed and secure the camera to the car with a strong window or suction-cup mount. Finessing the composition is impossible, so use a fisheye lens set to its hyperfocal distance using the depth-of-field scale on the lens barrel. To imply a hurtling pace, you need motion blur: Set your camera to 1/60 sec or slower in shutter-priority mode, and adjust your ISO so that your aperture will be set at about f/11 for depth of field. Shoot in highspeed continuous mode to snag frames in dizzying succession.

037

FIRE UP A **FLASH PARTY**

Using a few off-camera flashes? Why not 20, or 100? Round up a pack of photographer friends, ask each to bring along an accessory flash, and head out into the country to illuminate incredible shots. Fantastic for shooting nighttime action—a BMX bike race, or a fourwheeler rally in the desert— "flash mobs" can light a subject from a wide range of angles.

Keep things organized via careful stage direction. Divide your "flashers" into groups and assign them to provide lighting from the sides, from behind, or above and below, then trigger their flashes with optical and/or radio slaves. Move your friends and their flashes around until you capture the rip-roaring action in the dazzling light you envisioned

138 FREE YOURSELF WITH WIRELESS FLASH

Today's sophisticated accessory flashes let you take lighting off-camera and trigger it wirelessly. Why? To produce intriguing light and shadow that harsh on-camera flash just can't. The setup is simple—a master (or "commander") controller attaches to your DSLR's hot shoe and uses infrared pulses or radio signals to tell your accessory flash (or "slave") to fire. No wires connect controller to accessory, so there's nothing to trip over or clone out in postproduction. You can position an accessory flash anywhere in your scene, hold it, ask a friend to hold it, or stick it on a light stand. Wireless shooting allows you to control the output and firing mode of remote flash units from your camera—perfect when flashes are in hard-to-reach positions. Flash units are compact, light, and battery-powered, unlike costly studio strobes.

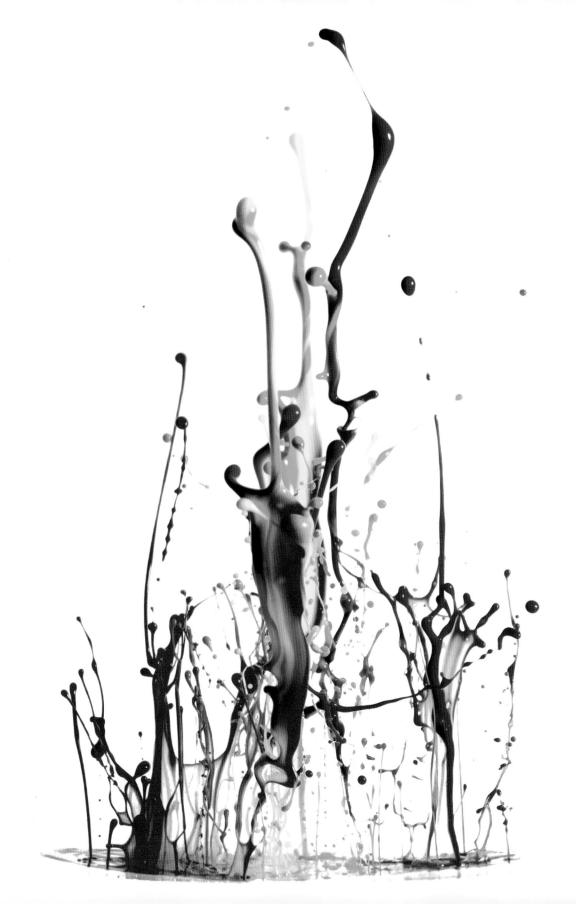

039 CAPTURE DANCING PAINT

How in the world do you get paint to leap up like this—much less catch a photo of it in midair? With a little creative setup, that's how.

Ryan Taylor of Cedar Rapids, Iowa, used sound to activate both his subject and his camera's flash. After stretching a white balloon over an everyday stereo speaker and pouring paint onto it, he rigged an audio trigger that would vibrate and launch the brightly colored globs into the air-and set off his camera at the same time. Here's how he pulled it off.

To generate the low-frequency pulse that sent the paint flying, Taylor downloaded a program that let him create a repetitive oscillation called a sine wave. He played it through a laptop (A) connected to an amplifier (B) and the speaker (C) with the paint-covered balloon (D).

To illuminate the set, he put a light-stand-mounted strobe fitted with a softbox (E) to the front right of the speaker. A second flash (F) to the left of the speaker lit both the subject and the backdrop (G).

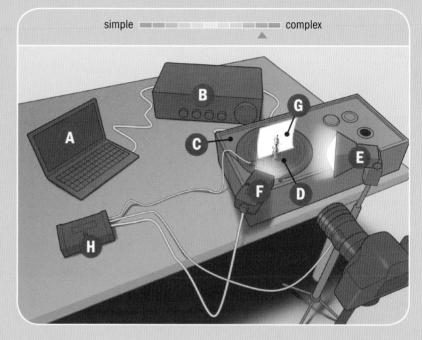

Taylor fired the strobes with a multipurpose flash/camera trigger (H), which fires either when it detects a sound or when its infrared beam is broken. He set a delay of 50 millisec to ensure that the droplets reached maximum height. To render his active subject sharply, he set the strobes to extremely short flashes of about 1/20,000 sec.

He dimmed the room lights, opened the camera's shutter, and hit Play on the laptop. The sound blasted, the paint jumped, the flash popped, and the picture was his.

040 EXPERIMENT WITH AN AUDIO TRIGGER

Let's face it: We don't move at the speed of sound. That can be a problem when you need to push the shutter button quickly to capture a superfast, noisy action. That's where an audio trigger comes in handy. This specialized

gadget can be used to open the shutter when it's triggered by sound. Paired with a high-speed strobe, it initiates an intense but brief burst of light that freezes fast action—such as a paintball hitting a wall or a glass breaking.

041 ACQUAINT YOURSELF WITH LIGHT ACCESSORIES

Beyond your DSLR's built-in flash, there are endless types of lights and accessories available to help you control the color, intensity, distribution, and directionality of light in your images. Use them alone or in combination to create photos that capture any mood you desire.

BEAUTY DISH

This accessory's bowl shape gathers light toward a focal point to create an effect like that of a paired softbox and direct flash.

With their dramatic, skin-flattering light, beauty dishes are beloved by fashion photographers.

GRID

To crisply define and direct light toward a subject, fit this honeycomb-patterned disk over your light source.

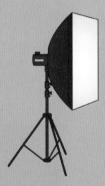

SOFTBOX

This accessory fits around a light; its reflective walls and the diffusing material at its front broaden and soften the light's beam.

BARN DOORS

This device's four metal doors open and close around an attached light source to control the light's spill.

Barn doors allow you to artfully control the amount and angle of the light on your subject.

ACETATE SHEETS

These colored gels are attached to a light source so that you can tint and shade light in rainbow tones.

Gels can play up the natural hues of a scene or, as shown here, create wild effects.

LIGHT TENT

A simple box covered in fabric diffuses external light through its walls, evenly distributing illumination across an object placed inside it.

SNOOT

This snout-shaped shield focuses light into a narrow beam for dramatic illumination and maximum light-and-dark contrast.

An arrow-sharp snoot light precisely defines your subject and keeps flash where you want it.

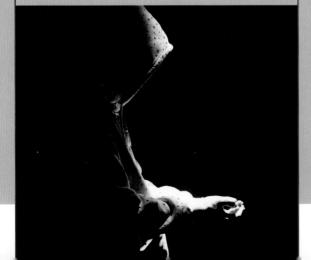

UMBRELLA

Position this diffuser before a light pointed away from your subject—it'll bounce and diffuse the glow to flattering effect.

BAFFLE/REFLECTOR

Sometimes two-faced is a good thing: This versatile tool has a reflective side and a light-blocking one. Hold it, or clip it to your light stand.

042 SHOOT FLOWERS IN A LIGHT TENT

When shooting wildflowers, you want certain conditions. The ideal illumination is the flat, neutral light of an overcast afternoon, when the sky acts as a giant softbox and burnishes the petals' subtle textures and colors. Taming wind is just as important as diffusing light—flowers stir in the gentlest breeze, making it hard to get a sharp photo.

So how do you shoot wildflowers when it's sunny or windy outside? First, buy a lightweight photography tent (A). In the field, choose your bloom (B) and select the best angle from which to frame it. Position your tent over the plant, making sure that the bottom edges are flush with the ground so you can push stakes through grommets (C) in the fabric to secure it. Remove your tent's zipper panel (D) and insert your gear (E), including flash, through your tent's front zipper to increase bounced light. Use a cable release (F) outside the tent to trip your shutter without shaking the tent or the flower.

Consider the backdrop that you'd like to shoot against. To turn your light tent's wall into a pure white background, slightly overexpose the image to blow out the detail in the fabric. Do you want to include a natural background? Shoot from the side: Position the midsize opening around the flower and keep the two larger portals on either side of the tent open, giving you a window to reveal nature in the distance.

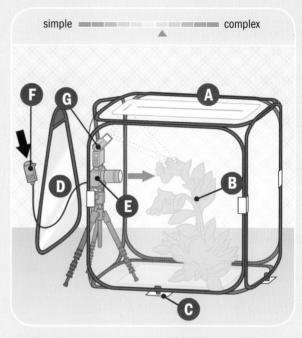

For stronger lighting, use flash (G). Bounce its output inside the tent, away from the blossom. Or attach a card to your flash head, sending more of the light onto the flower to replicate bright overcast conditions. Another option: Use an off-camera flash outside the tent, experimenting with different angles.

To reproduce the flower's colors accurately, set a custom white balance if your camera allows it. Do this inside the tent, using one of its walls as your target (if not, use the Cloudy setting).

043 PROTECT YOUR KNEES DURING FIELDWORK

Your knees can really take a beating during long sessions of outdoor setup and shooting. Protect them by spreading out a yoga or gardening mat before you go to work. Hardware stores also sell mats—ones that are stiffer, sturdier, and designed for construction work.

Consider some add-ons as well. If the ground is wet, set a garbage bag or small tarp under the pad. Kneeling on rocky or really hard ground? Use sports knee pads, such as those made for skateboarding. They're highly durable and protective but allow you a full range of motion.

044

STYLE A FOOD SHOOT

Delicious food shots don't require a fake lacquered turkey. With a little forethought, your meal can look as good as it tastes. Start by choosing the right food "models." Whatever your ethics and taste buds say, meat is murder—at least, it can be from a photographic standpoint. It tends to be brown (or an oozy red), oily, and one of the hardest things to shoot. Focus in on colorful fruits and veggies instead—or at least use them as garnish to distract the eye from that slab of unphotogenic roast.

While you're thinking about the composition of the plate you're shooting, remember that a little dishevelment adds homey authenticity (so don't line up your carrot sticks in size order). But unappealing smears and spills should be nowhere in evidence. As for tableware, plain dishes—in colors that contrast with the food or, better yet, old reliable white—will make food pop in images.

045 RESPECT THE RESTAURANT

Got your smartphone out to snap pics for your food blog? Don't wreck other patrons' meals—not to mention your shot—by using flash. A more subtle solution is to ask a dining companion to use her phone's flashlight app to illuminate the plate you're shooting while you fire away with the camera on your phone. It's a win-win: a better picture and less intrusion.

046 SHOOT DINNER FROM ABOVE

Shoot from an overhead angle—you may want to use a low table, or even climb a ladder—to capture a feast and give the viewer a sense of what the Italians like to call abbondanza. To convey a mouthwatering sense of this-is-your-plate urgency, keep the front edge of the table in the forefront of the picture. That composition also bounces the eye back up to the meal, which, after all, is what food shots are all about.

047 FLATTER YOUR FOOD

Diffuse natural light brings out the best in food. If you're picnicking on a cloudy day, you've got it made in the shade—literally. If you're indoors, set up near a window or switch on some lights. Use sidelighting when you want to shoot from above and emphasize texture. If you want to make the overall effect more even, use a reflector on the opposite side to fill in some of the shadows. And when you're aiming for all-out foodie drama, go for backlighting.

One method for ensuring an attractive plate portrait is to light it the way you would a face. Whether you're using sunlight, accessory flash, or strobe, your primary goal is to illuminate your subject without creating glare. To scatter sunlight, put diffusion paper over a window or just use a sheer curtain. If you're going with artificial light, accessories such as umbrellas, softboxes, or beauty dishes will help soften the effect.

048 CRAFT A V-CARD REFLECTOR

Build yourself a sturdy, light, and versatile V-card reflector out of white foam core, available at art-supply stores. Lash together two sheets, both about ½ inch (1.25 cm) in thickness, at one edge with horizontal strips of strong duct or gaffer's tape. (Cut the sheets tall or short, depending on the size of your intended subject.) This adaptable tool can do it all. Use it to narrow or broaden light by opening or closing its V. Or control contrast by moving your lights toward or away from the apex of the V. You can even shelve your softbox and use your V-card to produce a glow that is broader and smoother than the light that pricier gear can generate. When you're not using your V-card, stow it by closing it up like a book.

simple complex

BIG PROJECT

MIMIC A DUTCH MASTERPIECE

If you make them yourself, lighting reflectors aren't a drain on your savings account. Photographer Skip Caplan arranged this Dutch Masters–style still life using his homemade V-card reflector (the materials cost \$106) to mimic natural window light. Consisting of two foam-core panels and some gaffer's tape, a big V-card

Here's how Caplan snagged the shot. He aimed two strobe heads (A) on stands into a large V-card (B), and propped up a black gobo (C) so the main light would not illuminate the dark background. A white reflector (D) opened up the set's shadowed right side. Then Caplan fine-tuned his light just as a painter would: A little mirror on armature wire (E) bounced light onto the sliced lemon at the left of the composition, popping it

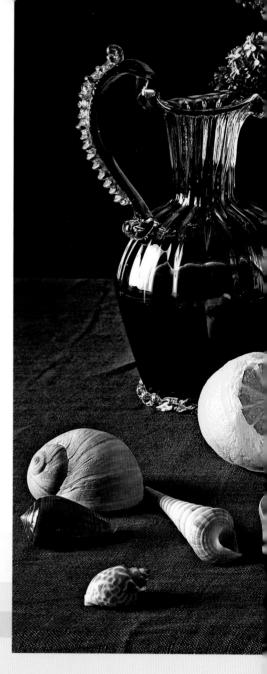

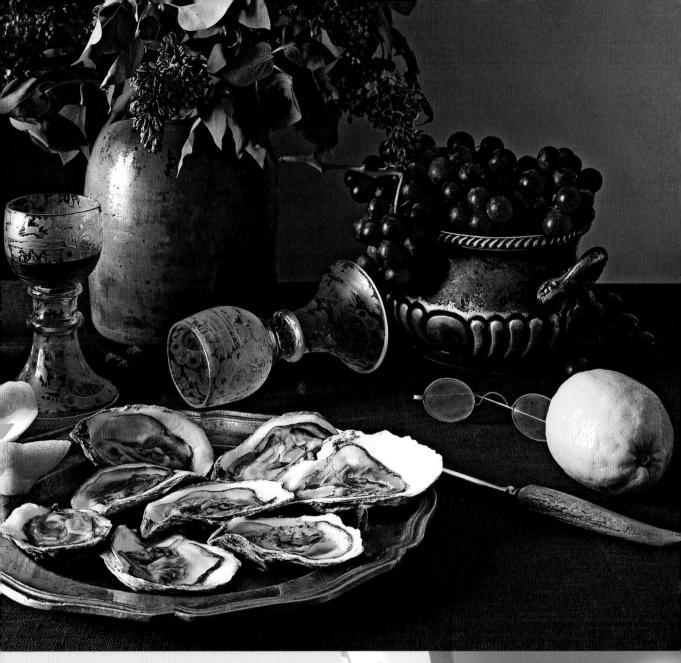

to life against the antiqued objects. A wee white reflector (F) behind the goblet amped the wine's color, and a third strobe head and a softbox (G) provided overall depth and glow to the composition. His tripod-mounted camera (H) sat close to the table edge, centered before the platter of oysters, while Caplan shot the feast at 1/125 sec at f/22 with an ISO of 80.

Why not simply use his studio's real window light? "It took me six hours to arrange everything," Caplan says. "Window light would have changed too much."

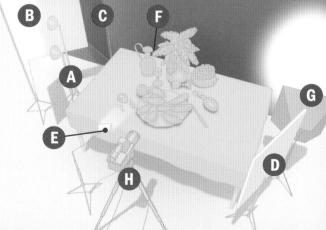

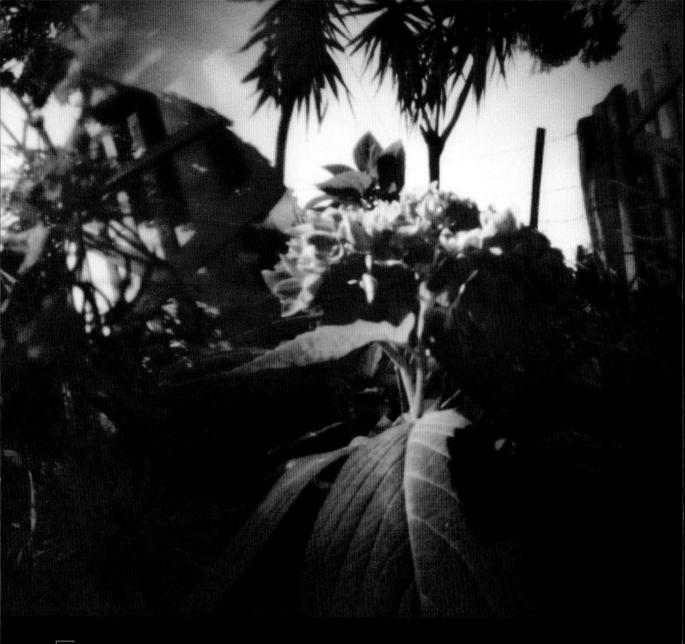

050 CAPTURE COOL PINHOLE SHOTS

Once you've built a pinhole camera, what can you shoot with it? Anything you like, and you can print photos in endless ways to vary and effect. Reminders: Pinhole pics are soft and dreamy, not tack-sharp, and the bigger the camera, the more light will fall off as it travels through the camera to the photo paper. Check out these shots for inspiration.

- Print on different papers. Try a paper negative instead of a cellulose one (such as the shot at left), or try fancy silver gelatin.
- Put your pinhole camera in motion. At near right, it sits on a seesaw's fulcrum.
- Create tiny abstracts. Rotate a matchbox pinhole over a flower for a shot such as the one at center right.
- Play with ghosts. The far-right image's blur is the photographer bending over to close the shutter.

051 BUILD A PINHOLE CAMERA

You don't need a lens to take a picture. A box, photo paper, and a teeny hole do the job very well. This ancient technique produces simple shots with virtually limitless depth of field—and you can make a "camera" out of any opaque container, from a matchbox to a trashcan to a whole room.

STEP ONE Find a cardboard box with flat sides. Gather matte black paint, black duct tape, a no. 10 needle, a thin metal square (cut it from a can or thin brass shim stock), sandpaper, a craft knife, heavy black paper, and photographic paper.

STEP TWO Paint the box's interior black to prevent reflection. If any light leaks in, cover holes with tape.

STEP THREE Poke a hole through the metal square with the needle. Sandpaper the hole's edges smooth. The smoother the edges, the sharper your photograph.

STEP FOUR Cut a small square in one side of the box.

STEP FIVE Tape the metal square into the box, lining up the pinhole with the square hole's center. If the metal shows through the outside of the box, cover everything but the pinhole with more tape.

STEP SIX Cut a small square of black paper. Tape one edge above the pinhole on the box's exterior. This is your "shutter."

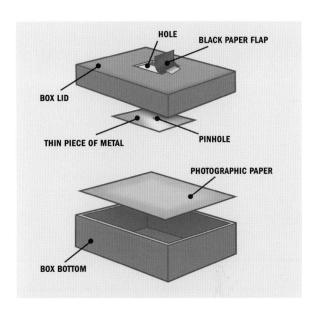

STEP SEVEN Load your photo paper in total darkness. Try a closet, windowless bathroom, or changing bag (see #095). Tape the paper inside the box, opposite the pinhole, with its shiny side outward. Close the box and hold down the shutter. Now you're ready to "shoot."

STEP EIGHT Lift the shutter flap for 30 sec to 4 minutes, depending on lighting conditions. To keep the box perfectly still, tape it down.

STEP NINE In the darkroom, untape and remove the photo paper. Process it in the usual fashion (see #308). Make a contact print from your paper negative with its emulsion side facing the printing paper's shiny side.

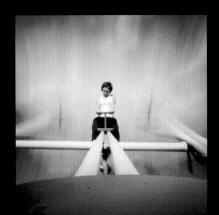

052 GET TO KNOW TRIPODS

Want to keep your shaky hands from blurring images during a long exposure? Dangle your camera over a railing to grab a unique perspective? Capture a moving subject with a mount that swivels at the same speed? There's a supportive rig for your every photographic need and whim.

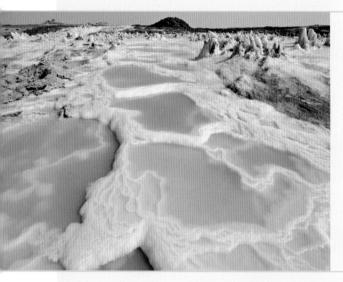

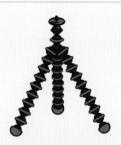

BENDABLE SUPPORT

This prop's flexible legs wrap around objects, so it's more versatile than other tripods.

Difficult-to-capture outdoor shots, such as this hot-springs image, need pliant, reliable field support.

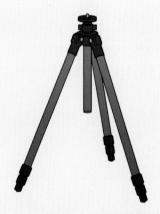

TRIPOD

This invaluable three-legged basic steadies the camera so you can capture a sharp image.

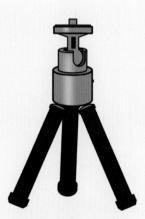

TABLETOP TRIPOD

A mini version of the classic, it sits low to the ground and provides light, portable support.

GEAR GALLERY

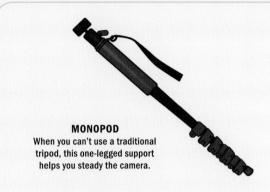

Monopods are ideal for crowd shots: Lift them above surrounding heads to capture the action.

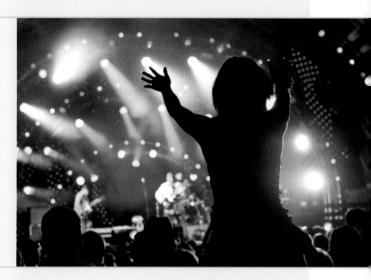

CLAMP

This versatile support latches onto nearly anything—from tabletops to windowsills—to hold your camera or light gear.

PAN/TILT HEAD

Aim your camera up, down, right, left, or in a circle with this head for perfect position.

Pan/tilt heads are a great aid when you're panning to freeze motion against background blur.

BALL HEAD

Thread a camera onto a mounting plate atop a ball set into this head's base, and you can adjust the head with just one action.

GIMBAL HEAD

This head moves in all directions and supports and balances a camera and heavy lens at their natural center of gravity for worry-free stability.

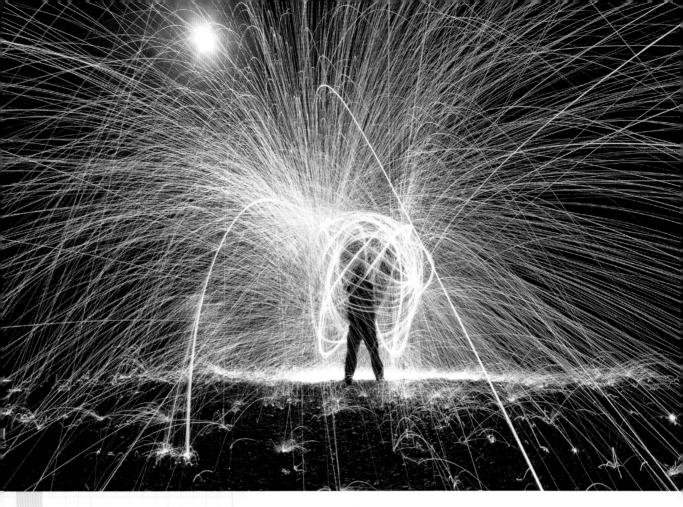

We drove for hours to Deception Pass, hoping to capture a beautiful sunset. The weather began to go south, so we switched gears. This was the first time any of us had tried "spinning"—the biggest challenge was not catching on fire. A ball of flaming steel wool came flying at me and set the backpack next to me on fire. I focused on the shot while my friend stomped out the blaze.

-LISA MOORE

053 PAINT WITH LIGHT

Cook up phantasmagoric light paintings with simple ingredients: a ball of superfine (grade 0 or lower) steel wool, a kitchen whisk, a long but lightweight chain, and a nine-volt battery—plus a bit of bravery. Choose a calm, dark night and an isolated spot free of flammable litter, leaves, and bystanders. Lacking that, stand on a wet tarp or even in shallow water. If you're feeling adventuresome, try an abandoned tunnel for maximum spark bounce and glow. Don a protective brimmed hat, long sleeves, and gloves, and turn your attention to your camera.

Set it on a tripod and start with a slow shutter speed—try 30 sec—an aperture of about f/8, and an ISO of 200 (play around with effects as you work). Use an LED or flashlight as your stand-in so you can focus on its light. Then switch the camera to its manual setting, stuff the wool inside the whisk, and hook the whisk's handle to the chain end. Rub the wool with the battery, and watch sparks erupt. Now it's show time, so hit the spot you prefocused on. Spin the chain around your head, carve flaming circles in the air, or experiment with angular and curving movements. When you're done, put out errant sparks.

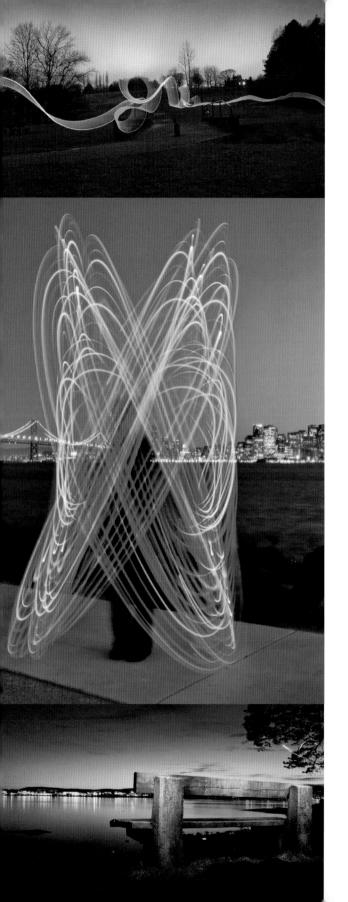

054 DRAW WITH A FLASHLIGHT

To create scintillating tapestries of lights such as the ones shown here, you need a tripod-mounted camera, a flashlight, and a dark spot where passersby won't blunder into your long-exposure shot. (If you're inside, turn off the lights and draw the drapes tightly to stop light leak.)

First focus on your subject, then stop down to a medium aperture in manual exposure. Shine the flashlight on the subject and check the meter reading for a rough exposure time, then set your camera to Bulb or 30 sec. More time produces brighter lights; less makes for darker ones. Now trip the shutter and go wild.

Run your flashlight over your subject, "painting" it with lines and loops of light. Moving quickly produces a brushlike streak, while going slowly or revisiting a spot produces interestingly blown-out blur. You can even draw on your sensor by aiming the flashlight directly at your lens, tracing shapes in the air or spelling out words. Make like a kid with a sparkler and have big fun with light!

055 KNOW YOUR LIGHTBRUSHES

Various flashlights generate different colors of light. Most are quite blue, but those with tungsten bulbs emit yellow-red streaks. Mix and match them, or tape colored gels over their lights if you hanker for a hue a flashlight can't produce.

Once you've got the hang of light painting, experiment with LEDs instead of flashlights: Wire them onto a moving model, or tie them to strings that an assistant can swing in smooth, painterly arcs in front of your camera. You can also play with your locations: Try running your lightbrush around the inside of a tunnel, "write" a caption over a landmark such as a skyscraper or bridge, or paint a colored glow on stationary objects such as the bench at left.

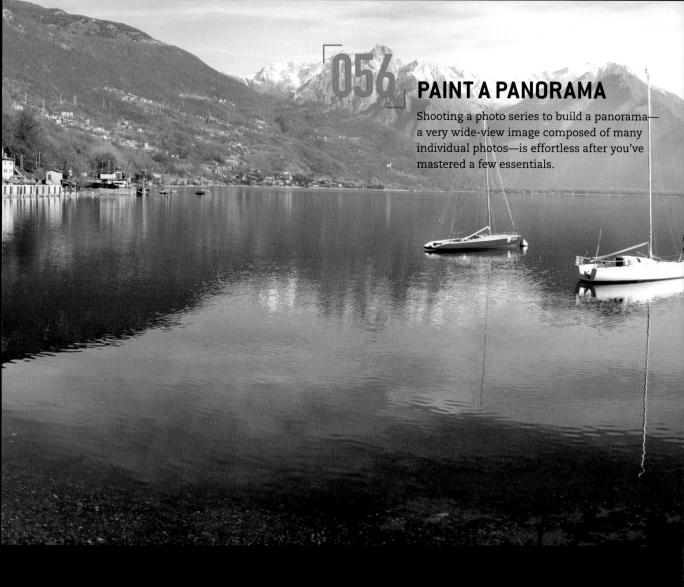

057 FIND THE NO-PARALLAX POINT

Finding the no-parallax point (or nodal point) of a lens is key to panorama creation. Parallax occurs when a camera and lens don't rotate properly around the lens's entrance pupil, shifting fore- and background among images—a problem hard to fix in software. Most lenses have one point around which you can rotate a camera without parallax, and some photographers locate it by trial and error. Others use a nodal-point adapter on a tripod. It moves a camera backward till the no-parallax point aligns with the tripod head's axis of rotation.

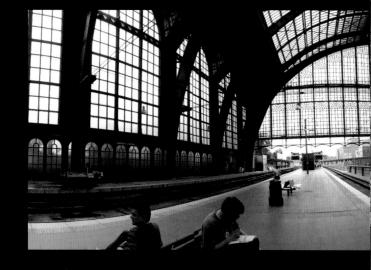

TURN OFF AUTOEXPOSURE. Shoot in manual mode, or your camera will automatically readjust exposure for each shot. Subtle changes in light can make corresponding areas of overlapping photos look quite different.

SHUT OFF AUTO WHITE BALANCE. Set it manually, or it, too, might readjust with each shot.

CHOOSE A SINGLE EXPOSURE SETTING. Determine the shutter speed/aperture combination that works for your full range of shots. Again, your goal is even exposure across your series.

USE ONE FOCAL LENGTH. Each shot in your series should have the same point of view. Setting your lens to a long focal length minimizes distortion. Keep nearby foreground objects out of frame, as they're usually the

ones that warp most and cause problems when you're combining shots.

AXE THE FLASH, which is another cause of inconsistency among photographs.

TRY A TRIPOD. Not strictly necessary, tripods do help the camera remain on the same plane throughout the series. In a 360-degree panorama, a tripod ensures that your first and last shots line up with each other.

OVERLAP SHOTS. Shoot each photo so that it overlaps from one-quarter to one-half of the area of the prior photo. The wider your lens, the more area you will have to overlap to avoid distortion once the series is combined. For guidance on assembling panoramas with photo software, see #342.

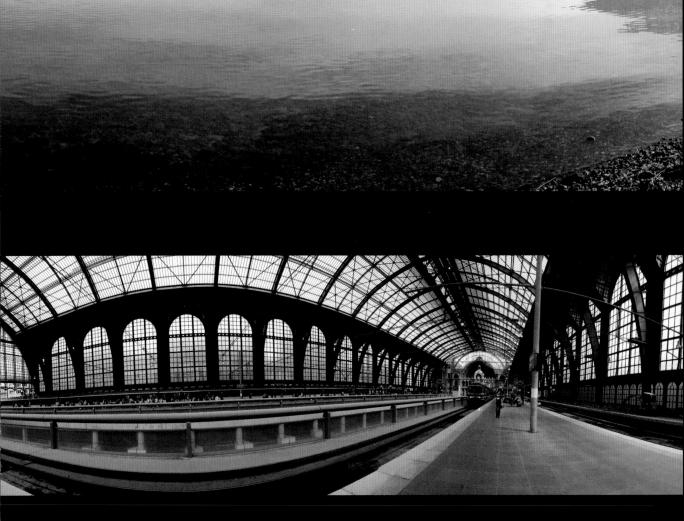

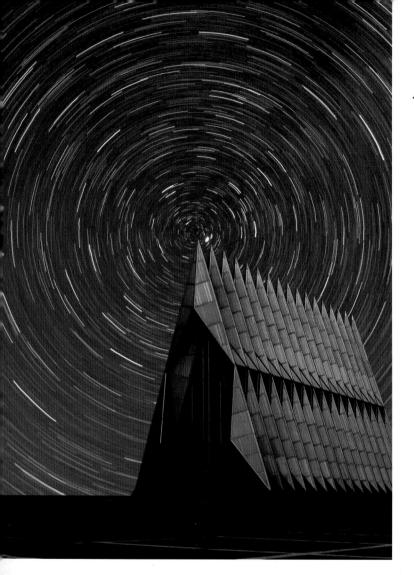

058 PHOTOGRAPH STAR TRAILS

If you use a sufficiently long exposure, the rotation of the earth makes stars, planets, and the moon seem to spin in the sky. To capture the celestial ballet of star trails, you need a dark, clear night far from city lights. You also need a camera capable of long exposure (one with a B, or Bulb, setting, or long exposure settings from 30 sec to several hours). Bring new or freshly charged batteries—keeping shutters open for hours sucks batteries dry.

Then head out into the night. Set your camera on a fixed tripod that you secure in place to defend against squiggly star trails. A wide-angle lens produces the best results. To show scale, compose a shot that includes a foreground element such as a barn or tree. and set ISO between 400 and 800-high enough to record dim stars, but low enough to prevent graininess. Choose a medium aperture, f/5.6 to f/11; smaller ones reduce "sky glow" from nearby towns. Use a cable or remote release, set focus manually, focus on infinity (put a bit of masking tape on the lens's focus ring to hold it in place), and open the shutter. Leave it open as long as you like. Remember: Long exposures produce long star trails, but also pick up more sky glow.

059 SHOOT THE MOON

Planning is everything when it comes to great moon shots—of both the NASA and the photographic kind. Start off by picking the phase that beguiles you most. Are you after an artful crescent? Or the wow factor of the full monty? Do some research to pick a night with the kind of moon you seek.

While you're at it, check the sun, too. The best time to capture the moon is 10 to 20 minutes before sunrise or after sunset. The moon is distinct if it is visible at all then, but there's still enough light to capture detail in the foreground. Not sure in which direction you should orient your gear? A full moon will be opposite the sun (in the east at dusk and the west at dawn).

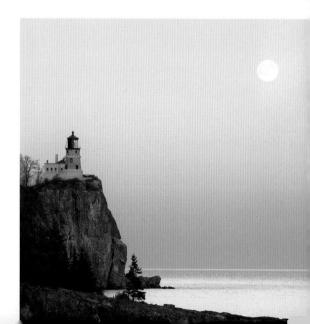

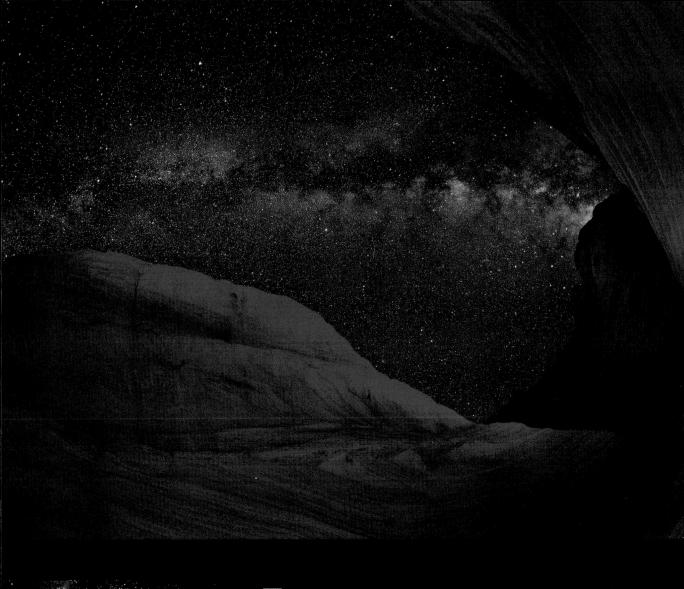

CAPTURE STARS WITHOUT TRAILS

Sometimes you'll want to take an image of stars as we actually see them in the sky, without any trails. To do so, use a fast lens, one with a large (f/1.4, f/1.8, f/2, or f/2.8) maximum aperture. As with star-trail images, include an intriguing landform or structure in the foreground for scale and contrast. The same setup rules apply, too: Use a sturdy tripod, a remote release, and an ISO of 400 to 800. For the best illumination of your foreground, shoot when the full (or nearly full) moon is just beginning to rise in the east. Aim your camera west, away from the moon, so the moonlight will light up foreground objects without washing out the brilliant stars.

061

COMPREHEND CROP FACTOR

If you put the same focal-length lens on eight cameras, from a full-frame DSLR to a pocket compact, then position each camera identically and aim them at the same subject, will the images they record be identical? No. The cameras' sensors are differently sized. Sensor size changes angle of view—small sensors take in less of the image that the lens projects onto them, and larger ones take in more. Thus you get progressively smaller framings from full-frame to compact. This is why you can't use a digital-only lens on a full-frame DSLR: The image circle would be too narrow for the camera's sensor.

The photo industry has adopted equivalencies to relate various angles of view to one reference standard: the 35mm film frame. Its 24-by-36mm dimensions are those of the full-frame digital sensor. Use a multiplier known as the lens factor or crop factor—to determine equivalencies (this is especially convenient for interchangeable-lens systems). Multiply the focal length of your lens by these figures to find the full-frame equivalent: For a non-Canon-brand Advanced Photo System type-C (APS-C) image sensor format, 2X; for a Canon APS-C, 1.6X; and for Olympus's and Kodak's Four Thirds system, 2X.

Remember that as sensors grow smaller, you need progressively wider-angle lenses to maintain the full-frame equivalent.

1062 TETHER YOUR CAMERA TO YOUR COMPUTER

Tethered photography—shooting with a DSLR hooked to a computer—is a versatile way to preview, save, and tweak photos as you work. You need a camera that you can connect to a computer via USB cable, plus compatible software such as Adobe Photoshop Lightroom. Onscreen you'll see a true preview of color and tone (if your monitor is color-corrected), and because the screen is bigger than any camera's LCD, you'll have a broad canvas to check focus and ensure you've properly captured your subject. Tethering also lets you save photos to both hard drive and memory card as you shoot, so you're instantly backed up. Better still, you can process all RAW files in real time. First try tethered shooting with a simple setup at home. Later, you can venture into the field, where accessories from laptop-supporting tripod mounts to daylight-cutting screen hoods are real boons.

063, TRY A TETHERED STILL LIFE

Tethering allows you to view labor-intensive compositions, such as the eerie gummy-bear picnic at left, on your computer screen as you shoot.

STEP ONE Hook your DSLR to a computer with a USB cable, Launch Adobe Lightroom. Go to File > Tethered Capture > Start Tethered Capture. Fill in the session name and destination and choose a metadata template. Add keywords to tag shots, and click OK. The tethered toolbar will appear first.

STEP TWO Click the toolbar's shutter button (not the camera's), and the image zips into Lightroom on the computer. (The toolbar also shows exposure and white balance settings, but change them only on camera.)

STEP THREE Shoot until your exposure settings and lighting look right. Don't worry about composition yet; just develop an image that will help you create the final product. Now click to select the last properly exposed photo you've shot, and switch to the Development module. Process the image as you would a RAW file—pump up vibrancy, tweak white balance, or add vignette. Hide the tethered toolbar as you work via Ctrl + T.

STEP FOUR Create a preset with your current settings: Click the plus sign at the Presets panel's top right, then Check All so all adjustments you made to your image will apply to subsequent ones. Name and save the preset.

STEP FIVE Type E to go into Loupe View in the Library. Ctrl + T restores the tethered toolbar. In Develop Settings, pick presets via the pulldown menu. Lightroom applies these settings to any new images, so you'll easily see how framing and lighting alterations will affect your final, ideal photo.

BUILD A SMARTPHONE TRIPOD MOUNT

You can buy a zillion tabletop and pocket tripod accessories, including mounts and adapters, to steady a smartphone for clear shots. Many let you clip your phone to just about any tripod out there. But making your own versatile mount is easy and fun, via DIY tricks that range from simple to complex. One basic method, if you have access to a soldering iron: Remove the back of a cassette case, melt off one of its side flanges with the iron, and then burn a small screw hole dead-center in the case's edge. Slide in your phone, mark the point where its lens touches the case, remove the phone, and use the iron to melt another hole at the contact point. Now screw the case, edge side down, to your tripod, and slide in your phone. Presto—you've made yourself a free mount.

MOBILE TIP

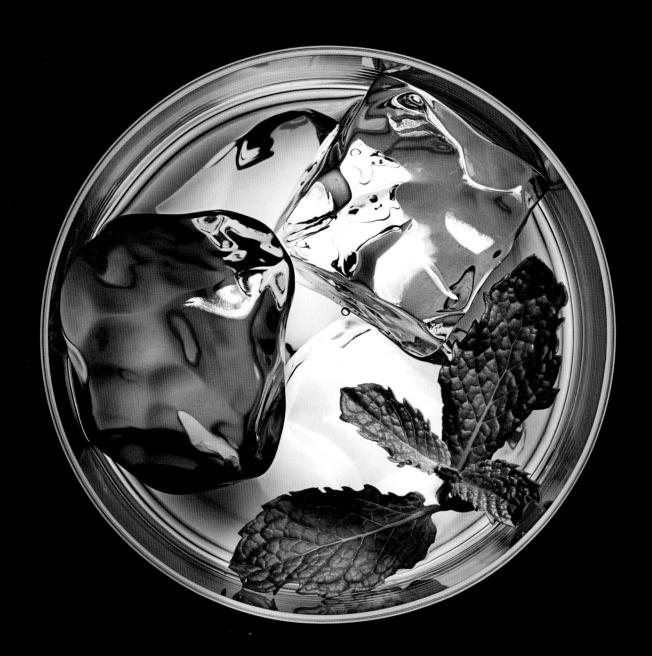

065 MIX UP A DRINK SHOT

This whiskey smash, shot by liquids specialist Teru Onishi, looks good enough to sip, doesn't it? And this photograph is even more intoxicating when you know that he styled and shot it—one of 25 he photographed for a magazine cocktail roundup—in under seven minutes. (The whole shoot took just five hours.) As a kicker, he did almost no postprocessing work.

Two-light simplicity helped Onishi hold his liquor—and turn it into an artful shot. First, he sliced a tumbler-sized hole in a sheet of black cardboard (A) with a craft knife and placed it on a table topped with translucent acrylic (B). Setting the tumbler (C) on the hole, he put a strobe (D) under the table, almost touching it, to emphasize the brilliantly hued beverage. Then he adjusted the strobe's angle until he captured an appetizing yellow-to-amber color gradation. Left of the table, he attached a top strobe (E) to a light stand (F) and positioned another translucent acrylic square (G) on a second light stand (H) just below that strobe. To minimize flare and produce the shortest possible flash duration, he dialed in the lowest output on the power pack (I) fueling both strobes.

Onishi carefully studied the distance between the cocktail and the diffusion panel above it, tweaking

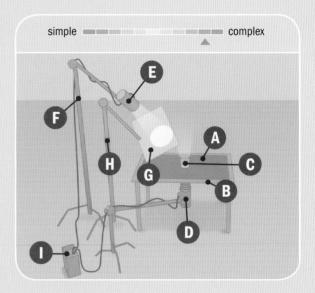

position for nicely sized reflections in the ice cubes, as well as the distance between the panel and the strobe over it to adjust the intensity of light falling on the drink. Finally, he angled the top strobe to cast hard light on the cubes and generate strong reflections.

Want to try some light mixology at home? Aim for straight-up success by carefully observing how a light's placement affects your subject, and then adjusting its position patiently and methodically. Cheers!

066 FAKE ICE CUBES

Most of us can't whip up a drink shot as fast as Teru Onishi. One of the pitfalls: Ice cubes melt quickly under hot lights, especially when a complex setup takes time to construct.

That's where fake ice comes in. You'll find acrylic cubes in stores, but making your own is far cheaper. Buy clear plastic beads from a craft store and pour them into a metal (not plastic) ice-cube mold until each slot is three-quarters full. Ensure that no beads slop from one to the next. Melt the beads for 15 to 20 minutes in a preheated 375°F (190°C) oven. Remove the tray and let it cool. Pop the cubes free, scrape off unsightly edges, and plop them in a drink.

067 USE TREATS TO PHOTOGRAPH PUPPIES

For the best picture of your own pooch, he should be sitting still and fixing a loving gaze on you and your camera. Yet the younger the dog, the harder it is to coax out that look. One way to rivet his attention is by rubber-banding a strip of cooked bacon around your

lens (protect it with plastic cling wrap first so things don't get too messy—and make sure the bacon's not too crispy, or it'll crumble). A dog whistle works, too, but prepare focus and exposure in advance: Most dogs pay attention to whistles for only about 15 seconds.

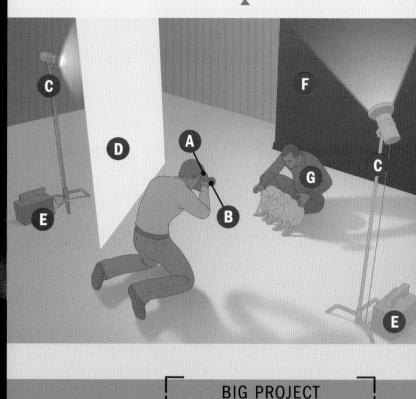

068 CAPTURE THE SHINE OF CREATURES' COATS

Snapping adorable puppies is simple. You know what's hard? Making a portrait that conveys the color and sheen of their fur. Especially if you're shooting Weimaraners—made famous by photographer William Wegman, but notoriously nervous and subtle-hued. Pet pro Harry Giglio tackled the challenge with careful setup and lighting. If you'd like to do something similar, follow his example.

He mounted a flash trigger (A) on his camera (B) to wirelessly fire two strobe heads (C) framing the scene. He chose fast-firing, short-duration strobes to freeze the springy pups, mounting the lights on stands so they'd be out of the dogs' way. He placed one strobe behind a spun-glass diffusion panel (D) and shifted that strobe back and forth until he caught the fur's soft texture. He then bounced the other off the ceiling for fill. Power packs (E) drove both strobes, and Giglio selected a background of simple black fabric (F) that wouldn't cast a competing color on the dogs. Finally, a handler (G) helped with doggie wrangling.

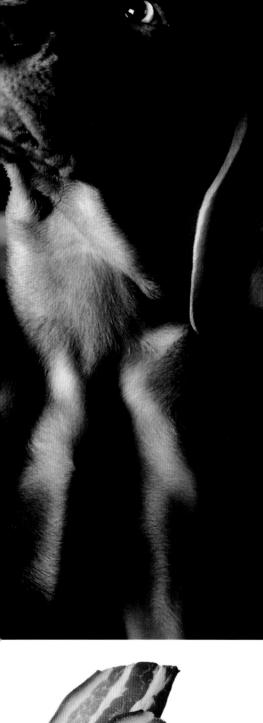

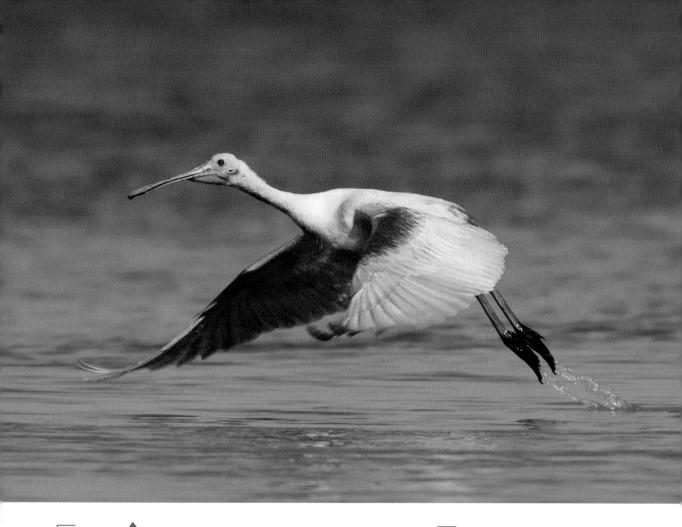

069 WADE FOR THE SHOT

To capture waterfowl, sometimes you have to splash right in among them. Wading allows you to shoot scenes of avian life that are impossible to get from dry land—but don't just jump in the lake. Check current, depth, and weather before you wade. Water shoes or more substantial foot protection are a good idea, since chances are you can't see where you're stepping. If the water is even slightly chilly, dress in insulated hunter's waders to protect yourself from hypothermia.

Ensure your gear is water-worthy, too. A carbon-fiber tripod resists corrosion and comes in handy for sounding out stable bottom in murky water. Keep other gear to a minimum, securing what you do take along with cords or lanyards and placing water-vulnerable gear above waist level in waterproof containers. Once in the shallows, advance slowly toward waterfowl. Let a bird adjust to your presence, and, with luck, it might take you for part of the scenery as you click away.

070

WATCH YOUR GARDEN GROW

With planning and patience, you can document a flower or vegetable garden's journey from dirt patch to leafy abundance. First, scout out the space and pick intriguing angles that offer an overview of the garden. Take notes on the vantage points you choose, then revisit them every day, shooting from the same position. At the end of the season, make a time-lapse sequence, and voilà!—you and others will finally get to see how your garden grows.

071 SHOOT DESERT FLORA

Timing can be everything when it comes to shooting plants. Sure, autumn leaves are popular photographic subjects, but if you can make it to a desert in early spring, you'll find a very different kind of seasonal drama. Do your research to pick the right time and place (remember, conditions vary from year to year), and pack a range of filters (polarizing and split-density neutral-density filters may all come in handy to tame the strong light and contrast you'll encounter—see #194) and, of course, your trusty tripod.

Keeping your gear sand-free may be a challenge, especially if the wind kicks up, so stow it in a tight-closing bag and bring along a blower bulb to knock sand off your lens.

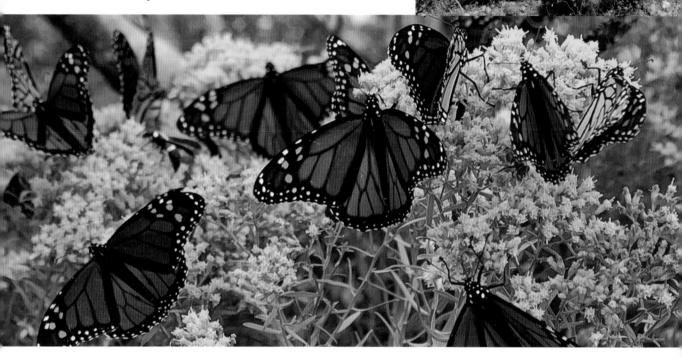

072 SYNC UP WITH MONARCHS

It's cool to shoot a butterfly in your backyard—but it's way cooler to shoot a tree dripping with thousands of monarchs. To do that, travel to butterfly-wintering sites such as Monarch Grove in Pacific Grove, California, or El Rosario in the Mexican state of Michoacán. Time it right, and the payoff will be huge: Migrating monarchs linger for hours, sometimes days, in the same spot, providing ample opportunity for

dramatic groupings and close-ups. (Check out monarchwatch.org for updates on routes and timing.)

If you shoot early in the day, dew on wings slows flight and adds glisten. Or wait until late afternoon, when low-angle sunlight enhances color. If you have a macro lens with a focal length of 105mm or longer, bring it along so you can stay at an unobtrusive shooting distance from these skittish creatures.

Two years ago I saw an image of fog rolling over the Golden Gate Bridge and became determined to capture it in that state. I monitored the weather and drove up there more than 20 times. There were always obstacles—the fog was too thick or thin; too many boats—so I used the time to scout. One morning I returned to a favorite location. I wanted a long exposure to smooth the fog, and the hills would prevent empty space. As the sun was about to appear, I released the shutter.

—JAVIER ACOSTA

073

SCOUT SITES

You've got to be at the right place at the right time to capture a compelling nature shot. And that requires both luck and research.

Before visiting a new locale, tour it on Google Earth and look at others' shots on photo-sharing sites. If possible, head out in person to get a sense of the light and traffic patterns. Consult forecasts, pack food and warm clothes, and go early to avoid crowds at popular sites. Meter off the sky, then shoot in RAW to fine-tune colors afterward. Bracket shutter speeds (see #162) and play with angles, compositions, and croppings until you ID the ideal shot.

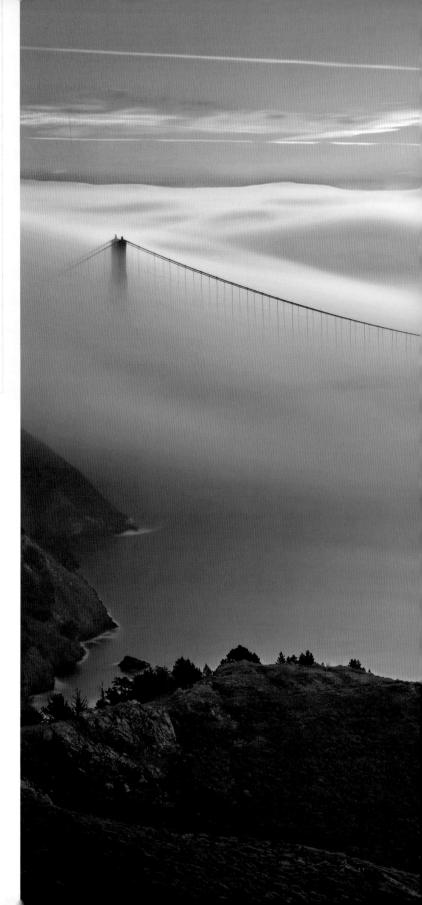

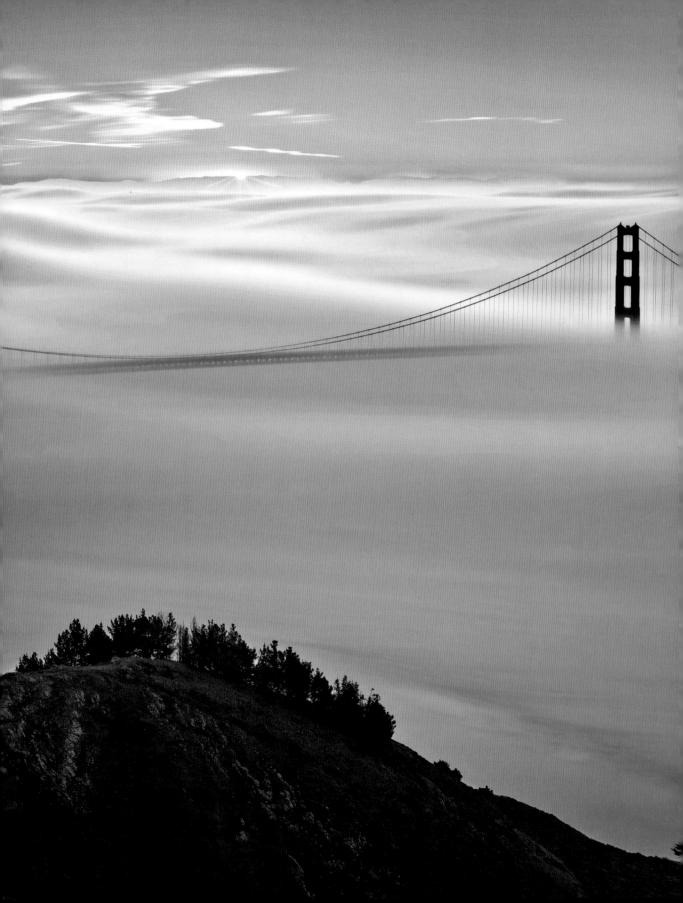

074 SHOOT A GORGEOUS JELLYFISH

Photographer Paul Marcellini captured this Portuguese man-of-war using a simple setup and process that you can borrow when photographing any small aquatic creature, from fish to frogs. aquarium and line three of its sides with translucent white plastic, which will transform the tank into a water-filled softbox (leave the front pane clear so that you can shoot through it). Take your rig to your site, then ready the tank by filling it with the water the creature prefers, be it fresh or sea. Cloudy water will wreck your shot, so be sure it's clear. Marcellini filtered seawater through a T-shirt to extract particulates.

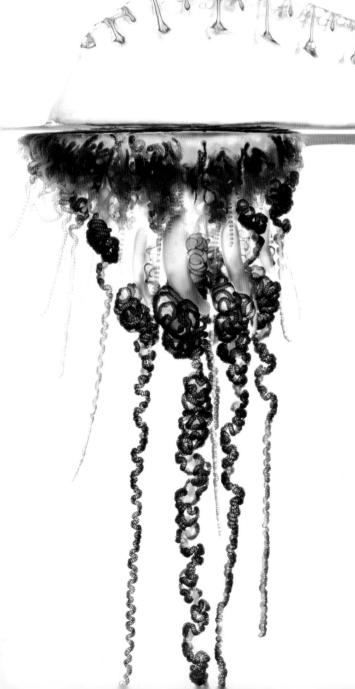

STEP TWO Collect your animal. Marcellini carefully netted this jelly from the sand, avoiding its stinging tentacles. Tuck an extra, freestanding transparent pane in the tank to nudge your subject close to the front pane—for a sharply rendered image, you can't have much water between you and your subject. Let the creature float around in its new environs while you set up your gear.

STEP THREE Mount two accessory flash units—which you'll fire wirelessly—on light stands, and place one behind the tank and the other in front of it.

STEP FOUR Determine exposure. Set your shutter to maximum flash sync speed, and choose a low ISO and small aperture for depth of field. Start your flash units at full power, and find the rear flash's exposure by lowering its power until its light blows out the tank's white background. Then lower the front flash's power until it illuminates the subject without sacrificing color and detail.

STEP FIVE Shoot! Attach a macro lens to your camera so that you can sit some distance away from the tank. Otherwise, your rig could throw shadow on the animal. Keep your camera parallel to the tank's front pane to avoid distortion.

STEP SIX Release. Gently net your animal out of the tank and return it to its watery home.

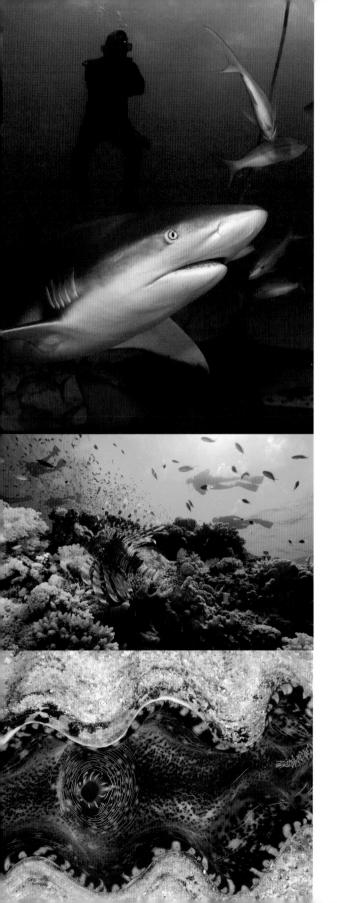

075 SWIM WITH SHARKS

Big carnivorous sharks are among the world's most intimidating photo subjects. If you're courageous enough for a potentially chewy photo session, pick a dive operator that's been in the business a long time, and ask about novice-friendly clear-water sites where you'll enjoy a dive cage's protection.

Not up to a photo-stalking a great white? Sweeter sharks make astonishing models, too. The endearingly polka-dotted (and huge) whale sharks that gather annually off Mexico's Yucatán coast are approachable filter feeders. Innumerable dive trips run you out to their grounds; most permit snorkels but not scuba gear. An ultrawide or fisheye lens helps your camera capture the majestic sweep of these gentle giants. Shoot near the surface so you don't need a flash.

076 PREPARE TO GO DEEP

Deepwater pros shoot in a tough environment and plan accordingly. Saltwater and high pressure eat up equipment, and light and color vanish speedily as you dive downward. But even nonpros can finagle fine scuba shots without costly gear.

PACK THE RIGHT STUFF. Bring a compact, but a DSLR with fast autofocus and a large sensor to admit maximum light is your best bet. You can buy or rent watertight housings: Top-end ones can cost thousands, but even entry-level versions often have protective O-rings, snap latches, external strobes, and interchangeable lens ports.

USE THE RIGHT LENS. Wide-angle lenses capture beautiful sweeps of sea, and macro lenses let you zoom in on tiny sealife. Bring both, and swap optics on the boat.

GET THE LAY OF THE SEA. Hire a guide to show you creatures' hidey-holes. Be patient—wait for shy animals such as eels to emerge, and shoot as many frames as you need to adjust lighting and angle. (See #256 for deepwater shooting tips.)

077 PROTECT YOUR GEAR IN EXTREME CLIMATES

Don't just outfit yourself for wilderness adventure—take care of your camera equipment as well. These items will help you get through a wildlands excursion with your gear intact.

FOR HOT SPOTS

- ☐ SILICA GEL PACKETS are great for absorbing humidity. Use the desiccant envelopes that come with cameras and other electronic equipment.
- A SOFT INSULATED COOLER is a better choice than your camera bag to protect your gear from the heat.
- □ A BLOWER BULB is a must to keep sand off your lens.

FOR WET PLACES

- WATERPROOF CASES protect both cameras and gear when you're transporting them.
- SPORTS AND RAIN SHIELDS protect your gear while you're shooting.
- RAINSLEEVES are good for boating and other watery activities, too.

- □ A BUBBLE UMBRELLA offers protection without limiting visibility. Buy a large, clear one.
- ☐ FOG-CLEARING CLOTHS in individually wrapped pouches are easy to transport.

FOR CHILLY CLIMES

- □ TRIPOD SNOWSHOES prevent your tripods from sinking into the snow just as ordinary snowshoes keep your feet topside.
- ☐ CHEMICAL HANDWARMERS are great for gear as well as fingers. Put one in your pocket along with a spare battery, and if it's really cold, attach one to the base of your camera with a rubber band.
- NON-RECHARGEABLE LITHIUM BATTERIES are your best bet when you're out in truly frigid weather.

078 TRACK LIGHT WITH A COMPASS

Not only is a compass nifty for figuring out where the heck you are, it's also useful for photography, since you can use one to anticipate where the light will be at different times of day. Eastern-facing features will be lit early in the day; western-facing ones will glow as the evening closes in. An old-fashioned compass is perfect, or use the one on your smartphone or other newfangled device.

079 EXPLORE A CAVE

One of the most exciting realms a photographer can explore is the one below. From a photographic standpoint, there are two main types of caverns: well-lit "show caves" and undeveloped ones where you have to bring your own lighting. Show caves are easy to get into and often have dramatic lighting that gives you built-in special effects. But that access often comes with limitations on tools such as flash and tripods, so check in advance. (Caves.org and cavern.com are good places to start your research.) With luck, you may find a cave operator willing to make special arrangements for photographers.

Undeveloped caves require a more adventurous spirit (you can walk into many, but you'll have to rappel into others) and a lot more lights, because they are usually totally dark. If you can, pack in multiple slaved flash units to illuminate deep into the cave. Chances are you won't be able to move too far from your subject, so a wide-angle lens may be all you'll need.

080 SEEK OUT A SHERPA

When the going gets tough, the tough (or at least the smart) photographer gets a guide. If you're venturing out of your comfort zone to photograph glaciers, newly formed lava flows, or other unpredictable terrain, do yourself a favor and hire an expert to take you out on your own or with a group. A good guide will not only keep you safe—she'll help you find the right place and get there at the right time so you can snag the most amazing pictures.

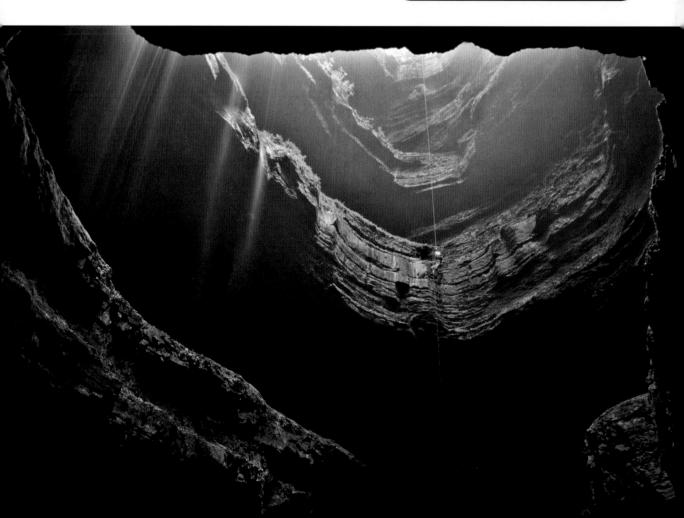

CHECKLIST

081 SHOOT SKY-HIGH PHOTOS

If you're lucky enough to soar above a lovely landscape in a light plane or helicopter, bring along a DSLR to capture the beauty below. Seek out pilots accustomed to photographers: They'll probably be willing to fly a bit low or slow for a good shot.

- ☐ OPEN A WINDOW (OR COPTER DOOR). Your shots will thus be crisp and you needn't fight flare, scratches, or reflections. But before you lean out, securely wrap your camera strap around your arm so your expensive DSLR won't bean some poor earthbound soul (or smack an engine or tail rotor).
- ☐ GO WIDE. Depth of field is a nonissue here, so use the widest possible aperture.
- ☐ TACKLE TURBULENCE. Tripods are useless at altitude, so wrap both hands around your camera and lens and prop the back of one hand on the seat cushion in front of you.
- ☐ SHOOT PLENTY OF FRAMES. Air pockets will scotch some shots no matter how well you prop your camera, so keep firing.
- ☐ CARRY BACKUP MEMORY CARDS. You'll quickly fill them shooting RAW.
- ☐ LOOK ON THE SUNNY SIDE. Last, don't despair if your tour day is cloudy. Sunshine enables the most precise earthside images, but clouds soften light and are themselves fascinating subjects.

082 SHOOT THROUGH A WINDOW

On commercial flights, you can't open windows to shoot. But just look at that beautiful countryside and cloudscape unscrolling below you—who can resist a photo? Preflight, book a front-of-cabin window seat for views unimpeded by the wing. Avoid sitting behind the wing, as engine exhaust warps images. And consider your clothes: Black is best, since bright clothing reflects off windows. As for your camera, preset it so you're ready to shoot when you cross dramatic vistas. (But don't shoot during takeoff and

landing. Cameras count as the kind of electronic gear you must shut off.) Superwide-angle lenses capture great swaths of ground and clouds, and a lens hood deals with inevitable window reflections. Don't press the hood against the window—vibration will blur your shot. No hood? Cup your hand or drape an airline blanket over the lens. Polarizing filters (see #194) produce color banding from the windows, so leave them in the bag unless you like their effect. Autofocus can zoom in on window scratches, so use manual.

083 GO FLY A KITE

Keep your feet firmly planted on terra firma while a kite captures dizzying aerial photos, looping, zipping, and diving to carry your camera through a funhouse of views. Rigs range from the staggeringly complex to the soothingly simple; we suggest you start your kite-photography capers with the latter.

Buy a stable, single-lined kite. Parafoils are nice: They pull strongly on the line yet are modestly sized.

Now you need a camera rig to stabilize and protect your camera. Buy one if you're not a DIY geek. But if you are, head to your workbench. Basic rigs consist of sheet-metal strips bolted into open squares. Bolt your camera (choose a light one that you don't mind crashing) via L-brackets to the square's bottom. Atop the square, bolt on a horizontal X made of two sheet-metal strips. Attach an eyehook at each of their four ends. Thread extra line through these hooks and attach the whole thing 4 feet (1.2 m) below the kite via a carabiner clipped to the kite line.

Wait for a gusty day, and program your camera to take photos at set intervals or remotely trigger it from the ground. Now hold on tight, send it aloft, and grab yourself an aerodynamic artwork.

184 BAG A BIRD'S-EYE VIEW

For an unusual (and heart-stopping) view of the earth, charter a plane with clamshell doors. Set in the floor and intended for cargo loading, they open for a straight-toground view. Muster your courage and lean over for vertical shots of frame-filling wonders, from natural features such as coral atolls and volcanic caldera to manmade creations such as highway cloverleaves and skyscraper tops.

This was taken in Mallick Ghat, West Bengal, India, during an ancient Hindu festival called Chhath Puja. It's to thank and pray to Surya, the Hindu sun god. I was photographing the crowd from a rooftop, watching people move about as they prayed. At last one woman became totally still, capturing the right sense of divinity.

—SUBHAJIT DUTTA

085 SHOOT OVERSEAS

A fantastic travel photo shows more than an exotic locale—the most meaningful subjects are a land's culture and people. In a new country, think as a photojournalist, not as an observer with a camera. First, don't play tourist—avoid tours and well-trafficked sites; hire a local guide to take you to out-ofthe-way places and translate for you. Bring minimal gear—you'll be less of a mark for thieves and won't barge in with a big setup. Research local etiquette so you know how to dress, how to greet people, if it's okay to talk to women, and, of course, if photos are permitted at all. Once there, keep your camera under wraps until you befriend residents. Later, if you explain which shots you want, most people will let you shoot them. If a small tip is customary, oblige, and let people see shots in your LCD as you work (kids love this). If people ask you to mail photos after you return home, keep your promise.

100 LOCATE LOST SITES

Ghost towns, archaeological sites, shuttered factories, forsaken roads and railways-all are magnets for photographers eager to record places on the verge of vanishing forever. The best way to uncover them? Befriend other photographers, especially members of urban explorers' clubs. (Be patient and learn as much local history as you can before you ask anyone to discuss his favorite shooting sites, though.) Open houses, walking tours, and preservationleague websites are other good ways to scout out ruins. Once you've chosen a site, investigate it via GPS and satellite mapping technology, including such free online research tools as Bing's Bird's Eye View and Google Earth, to plan out precisely how you'll access the place.

087 EXPLORE SAFELY

If you're shooting ruins, take some basic precautions. Check the weather forecast, dress accordingly, and wear sturdy clothes. Boots and work gloves will protect you from broken glass and rusty metal. A face mask will help shield your lungs from dust and hazardous particles. Always carry a first-aid kit and flashlight, and be alert to signs warning you of hazards such as rotten stairs and unstable floors. Some ruins are havens for illegal activity, from graffiti tagging to drug dumps, so bring a companion and a cellphone that's been programmed to speed dial for help.

088 GET THE OK TO SHOOT RUINS

Exploring privately owned abandoned sites is considered trespassing, and shooting in civic ruins such as old subway stations and other decrepit infrastructure is usually against the law. But you needn't trespass to take shots of ruins, such as the abandoned turbine hall at left shot by Justin Gurbisz. Just ask permission first. Property owners, park rangers, and caretakers might welcome you if you're candid and able to chat about site history and photography.

"Once security guards understand you're going in there to photograph, not to steal or vandalize or drink—the first things that they'll think—they generally let you go," says ghost-town veteran Troy Paiva. If you must sneak, do your best to get in and out of there inconspicuously. And if you're caught, don't run. Be polite and maybe you'll get only a slap on the wrist. "Grovel, if necessary," Paiva advises.

089 LIGHT UP HIDDEN SPACES

Many ruins are, by their nature, very dark. Combat the lack of ambient light with long exposures—from a few seconds to a few minutes—and a DSLR with image stabilization and good performance at high ISOs. Most cameras' auto settings can't cope with such difficult conditions, so manually control aperture and shutter speed. You also need a light field tripod or beanbag supports for lengthy exposures.

Sometimes these lighting strategies aren't enough, especially in underground or windowless spaces. Use a flashlight or a smartphone flashlight app to illuminate parts of the ruin and give viewers the sense that they're exploring it alongside you. Flash or off-camera strobe can blast away details. Use them with caution.

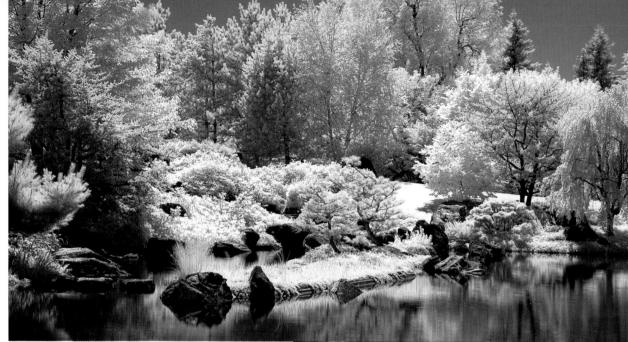

090

CONSIDER THE REALM OF INFRARED

Infrared (IR) light falls outside the narrow band of the light spectrum visible to human eyes, but some digital cameras, especially older ones, can detect it. IR photos reveal a dreamlike alternative reality of dark daytime skies, snow-white foliage, and ice-colored grass.

If you want to explore the mysteries of IR, you'll need special gear. Most camera sensors have IR-blocking filters, but some older models' filters are weak or nonexistent. Unsure if your camera has one? Aim a TV remote control at your camera and click the shutter while you press one of the remote's buttons. If the remote's signal light appears in the picture, you're set to shoot in IR. If not, buy a cheap used digital camera with a wimpy IR-blocking filter. If you shoot with that filter in place, dribbles of infrared will make it through to your sensor. To let more IR light in, get an IR-pass filter for your lens: It blocks visible light so only IR strikes the camera sensor. You can also use an IR-filter removal service for a few hundred dollars.

091 SHOOT WITH IR FILM

Yes, it's still on the market, and beloved by many for its eerie vintage look. Each brand has a particular level of sensitivity to IR as well as visible and ultraviolet light. In general, it is more sensitive than other film, so use a changing bag to load and unload it, and never put it through airport X-ray machines.

092_{\perp} set up the ideal ir shot

Landscapes are perfect for infrared shots. Because of the contrast between what we expect to see in the natural world and what the camera actually "sees," landscapes make the strongest IR subjects.

STEP ONE Ponder your composition. Set your camera on a tripod, as your exposures will be lengthy ones—1/2 to 30 sec or longer at about f/5.6, depending on your camera. (Don't add the IR-pass filter yet. It's dark, so you can't focus through it.) Compose per standard

landscape-photo rules: Employ the Rule of Thirds (see #110), ensure you have strong leading lines, and choose a potent focal point. Now you can thread the IR-pass filter onto your lens.

STEP TWO Set manual white balance. For phantom-pale foliage, set it using a green target, such as grass.

STEP THREE Set exposure. Meter in evaluative mode (see #160), erring toward underexposure. Use a midrange aperture and low ISO. High ISO will make shots noisy.

CHECKLIST

093 LEARN THE BENEFITS OF FILM

Digital photography has taken over the world, but film is the elder statesman—distinguished and a bit finicky. You might want to go with it for numerous reasons:

- □ ULTIMATE IMAGE DETAIL is film's greatest gift, as long as you shoot in large-format with a 4-by-5 or 8-by-10 view camera. And a medium-format camera with interchangeable backs lets you shoot digital and film with the same body to compare them for yourself.
- ☐ IT'S GOT OLD-SCHOOL APPEAL. There's something truly magical about watching an image emerge from a chemical bath in the darkroom (see #308). In B&W, you'll experience this directly; most color printers use a machine that keeps these more toxic chemicals away from your skin.
- □ YOU CAN USE OLD CAMERAS AND LENSES. High-quality gear that you inherit or buy second-hand connects you with photography's past and may also offer fabulous image quality at a much lower price than the digital version of the same camera.
- ☐ IT MAY HELP YOU LEARN THE BASICS. Working with film requires more planning and careful attention to each exposure—after all, you're paying for each frame you shoot and print.
- ☐ YOU CAN GET UNPREDICTABLY FUNKY LOOKS such as blur and irregular color that are trendy now when you use a cheapo vintage-style film camera (see #154).

BACKSTORY

These are my sons, Milo and Seth. It was Saturday morning, and they were just doing what they usually do, though it was a lucky coincidence that they were wearing those PJs while playing with a paper airplane. I really like the simple mechanical feel of having a Leica in my hands, so that's what I used for this shot. Learning how to develop my own film and do lots of experimenting without sending it out made it easier, too. I thought I'd be using digital by now, out of convenience. But I don't feel any real need to switch. This is just for pleasure, and the Leica is what I feel like using.

-BUD GREEN

094 KNOW YOUR FILM

Manufacturers don't make much film these days (even old king Kodachrome finished its 75-year run back in 2009). Online retailers and labs are now your best sources for all film types, as well as for processing if you lack a darkroom (see #305). Before you shop, learn which kind of film your camera takes, and how to load it.

The standard is 35mm, sold in 24- and 36-exposure rolls in cylindrical cases. Load it in daylight, but rewind it before opening the camera so you don't expose it. (This isn't a problem with disposable film cameras.) Stick it in the fridge until you're ready to develop it.

Medium-format film is usually two to six times larger than 35mm film. Most is sold in 6cm 120 and 220 sizes. Medium-format cameras wind film from one spool to another as you shoot, so you can open the camera to unload it yourself. Use its little tape tab to keep it spooled.

Most large-format view cameras shoot 4-by-5-inch (10-by-12.5-cm) images—that's 13 times the area of a 35mm film frame. Load each sheet of film into the holder on the camera back in complete darkness.

095

HAVE FILM IN THE BAG

Changing bags are wearable darkrooms: light-proof, double-sleeved pouches. Insert your arms to remove film from a canister or load or unload sheet film holders. They're zippered and roomy enough to hold your camera, gear, and tools.

096 PRESERVE PUPILS

Eyes are often the first features we notice in portraits, and, subliminally, they strongly influence our emotional reactions. But as important as the eye is overall, the pupil is the real power player. In fact, a science called pupilometrics demonstrates that our pupils dilate to mimic the pupil diameter of anyone we see in person or in photos. Tests also show that people prefer photos—whether of animal or human eyes—in which pupils are dilated.

So if you're after a pleasing portrait, avoid bright, pupil-contracting lights. Instead, try sidelighting or place your lights above or below your subject, which both produces a subtler, more flattering portrait and protects the alluring look of a widely dilated pupil. Of course, you can always adjust the diameter of a pupil, or emphasize the pupil-to-iris contrast, in post-processing work (see #329), but it's less work to preserve attractive pupils while you're shooting.

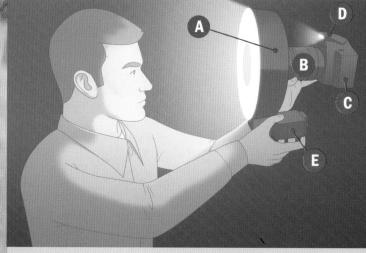

BIG PROJECT

098 MAKE YOUR OWN RING FLASH

The foundation of your photography—your eye—can also make for a compelling subject. For excellent eye shots, a macro ring flash may be your best choice: Mounted around the lens, it evenly illuminates the eye so every detail is bright and shadow-free. But ring flashes can be pricey, so resolutely self-reliant photographer David Becker crafted a homemade one that cost less than \$10 to make—and produced this awesome portrait of his own blue iris.

To immortalize your peepers, follow his lead. Becker lined an angel-food cake pan (A) with tinfoil, and then taped wax paper over the pan's front for diffusion. The hole in the pan's center was big enough to admit the macro lens (B) on his DSLR (C), which had a built-in pop-up flash (D). Using tin snips, he cut a hole in the pan's side, lined it with duct tape, and poked a shoe-mount flash head (E) through the hole. When he was set up and ready to shoot, the camera's pop-up flash triggered the flash head's optical slave to illuminate the ring light. He shot at 1/60 sec at f/13, ISO 200. Patience was key: Becker took dozens of autofocused test shots to position the circular catchlight on his pupil. Afterward, he worked in Adobe Lightroom to enhance contrast, adjust cropping, and finesse the image.

097 AVOID RED-EYE

Many cameras use a flickering flash (the anti-redeye function) to control the way flash tends to turn human eyes demonic. But the flash can be more annoying than useful. If you must use it, keep it off camera and as far away from the lens as possible. The closer a flash is to a lens's optical axis, the more likely red-eye is to occur. Another tip that may help: Ask your model to look slightly to the left or right of the lens, not directly into it.

099

POSE A NUDE PORTRAIT

Whether you're shooting a friend, partner, or model, nude portraits require you to be both professional and casual. Talk with your (clothed) subject before a shoot to build trust and let him or her know which poses you'd like and the mood you wish to capture (artistic, abstract, suggestive, or downright erotic). Supply a quiet, warm room with a private changing area, plus a few pieces of furniture upon which a tired model can rest.

Once you're set up, run through the classic poses as you shoot: reclining, sitting, kneeling, and standing. All poses depend primarily on leg position, so begin by arranging legs and feet, and then concentrate on arms, hands, and head. Back views—which expose few intimate areas and help keep you on the side of good taste—are great choices for novice models, as are close-ups of features such as hands and the neck. Your subject's glance is also essential. Put psychological distance between model and viewer by directing her to look slightly to the camera's side, or create intimacy by asking her to gaze straight at the lens. (If she's shy, you might crop out her face altogether.) Finally, ask your subject for her own pose ideas. She probably knows which stances make her body look best.

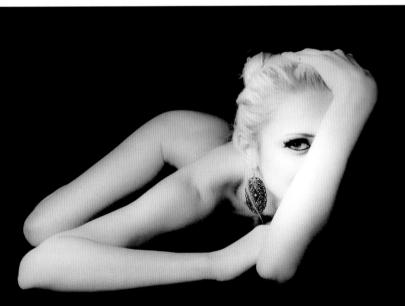

100

LIGHT THE BODY'S CONTOURS

People have painted and photographed the human body for eons because of its sculptural qualities. Make the most of them with canny lighting strategies. Soft, diffuse light, such as that produced by a softbox, window, or (if your model is willing) an open, overcast sky, flatters most bodies. But hard, directional light, such as that from strobe or even snood- or barn-door-modified light, is arresting, too. Especially when used with a black backdrop, it casts muscles and flesh folds into sharp relief via strong shadows and reveals skin's texture. Backlighting generates striking silhouettes (see #172), and angled sidelighting accentuates muscles and curves. In any lighting setup, ask your model to slowly and completely turn around so that you can shoot several frames and decide which lighting angle is most compelling.

101 ALWAYS GET A MODEL RELEASE

Technically you need a release only when you use a photo for commercial purposes (advertising, posters, cards, endorsement, or trade). Even if you sell a fine-art photo or use it in an editorial context (such as newspapers, magazines, personal websites, or books), you don't need one. But if you sell a photo to stock agencies or commercial websites, you do. Otherwise an agency or publisher might decline it—and your subject could take legal action against you. Especially when shooting a nude, you should play it safe by getting a release and establishing the model's proof of age.

CHECKLIST

102

WRITE A BASIC MODEL RELEASE

Photo agencies offer free, downloadable release forms, and you'll find them in consumer legal publishers' guides as well. Smartphone model-release apps are easy to carry and let you customize, modify, and store releases on the spot. Whichever you use, ensure the form covers these points:

- Explicit permission. For example, "I [model's name] hereby give permission to [your name] to use my photographic likeness and name in all forms and media for all noncommercial, lawful purposes."
- ☐ Model's printed name and signature.
- ☐ Model's stated age.
- □ Date signed.

More complex forms delve into topics such as compensation received by the model, how the image itself can be treated (for example, no distortion or overprinting), and other matters. But a basic release will cover you in most situations.

COMPOSING & SHOOTING

103 LEARN THE ABCs OF COMPOSITION

Whether you're a novice or a master of the lens, the time-tested rules of composition can guide you toward well-balanced, vivid images. Here are some of the best ones to have under your belt.

Keep backgrounds clean and crop out distracting objects. Look for strong diagonals (such as the zigzagging ones above) and leading lines you can exploit by changing your position. Ensure that the frame's borders don't cut through key elements.

You can frame your subject without looking through the finder. Form your thumbs and forefingers into a rectangle to determine the frame's ideal placement before you raise your camera. Examine the scene with the Rule of Thirds (see #110) in mind, and fill the frame with your subject. Step closer and shoot tightly to isolate your subject, or step back if surroundings add to the photo's mood.

Your choice of colors can also aid compositions, especially in scenes without many colors. Remember the color wheel in art class? It taught us that certain hues play well together. Red and green, blue and orange, and yellow and purple are complementary pairs that appear bright and saturated next to each other.

104

EXPLORE AN URBAN CANYON

When you shoot in the city, you usually shoot buildings. Instead, try shooting the spaces between them. That's how Tom Haymes crafted the dramatic abstract at right: by focusing on a narrow, bright slot of sky between skyscrapers.

If you're after a similar shot, pay attention to your light meter. If the reading on the building differs greatly from the reading on the sky, expose for whichever element seems to command the lion's share of the frame.

105 MIX UP SCALE

Craft a vertigo-inducing scene by confounding viewers' sense of scale. Take, for example, Guillaume Gilbert's photo at left, in which the model seems to loom above a passing pedestrian and break out of her frame. You can imitate the shot by locating a vivid billboard that contrasts with its streetscape. Visualize your framing, then wait for someone to amble into sight. Twist your camera and shoot quickly to produce an intriguingly scrambled shot.

CHECKLIST

106 BREAK THE RULES

Some of the greatest photos blatantly defy photography's "laws." So now that you know the rules, go beyond them.

- □ DON'T FILL THE FRAME. Students learn to move close and zero in tightly. But there are reasons to leave negative space or wide patches of color in the photo frame: They're powerful elements that make your center of interest pop to life.
- ☐ SHOOT IN DIRECT SUNLIGHT. You might just love those noonday effects everyone warns you about: desaturated color, flare, comet-shaped lens aberrations, and erosion of sharpness and detail. So go for it.
- ☐ **LISTEN TO NOISE.** Photographers avoid noise by setting the lowest possible ISO for their light, producing crisp images. But shoving ISO sky-high can add a gritty, raw mood.
- ☐ TOSS OUT THE RULE OF THIRDS. Set the horizon dead center, not one-third of the way from a landscape's top or bottom. Symmetrical subjects, such the mountain reflected in a lake in the photograph below, are the best candidates for such lawbreaking.

107 PICTURE NATURE'S PATTERNS

Everyone loves a sweeping landscape, but there's more to great nature shots than jaw-dropping scenery. Study natural details to discover an infinite variety of photogenic patterns in subjects tiny and towering, from lichen to thunderheads.

As you shoot, consider a few compositional tips. Think about the emotional impact of the pattern's lines. Towering verticals connote grandeur; spirals, curves, and horizontals tend to impart calm. Avoid highly static, regular patterns. Include some wild

cards—a few tumbled trunks in a treeline, for example—to animate a shot. "Interrupting" elements, such as a sharp-edged rock in a soft dunescape, lend visual interest, too.

When a photo's abstract, color is more important than ever. Complementary hues soften a pattern; conflicting colors throw it into high contrast. On your first pattern hunts, tackle just a few subjects, taking lots of shots and playing with settings to capture a beguiling pattern in all its beauty.

MOBILE TIP

108 MAKE A PHONE MICROSCOPE

Are you a do-it-yourself type with a smartphone? Delight your inner mad scientist by hacking a lens that has the resolving power of a medical microscope—up to 350X. Mount a 1mm spherical lens (\$15 to \$50) inside a small ring of black rubber (cut one out of a medium-density rubber sheet, found at hardware and craft stores), and affix the ring around the camera lens with double-sided tape. Only a tiny area of the subject will be in focus, but the image will be at a mindblowing 1.5-micron resolution.

My grandparents were visiting, and I wanted to show them how my new remote flash worked.

So I decided to photograph a sea biscuit: shells that have an intricate pattern that's difficult to see in normal light. After propping the shell between two stacks of books, I placed my flash underneath it and, using my cable release, exposed and captured it from above.

-DANIEL WHITTEN

109

PICK A LENS FOR PATTERNS

You can use any lens for pattern studies, but telephoto and macro lenses are the most reliable workhorses. Short to medium telephoto zooms in between 70 and 400mm really close in on subtle, small patterns. (Remember that pricey macro lenses aren't absolutely necessary. Inexpensive extension tubes and frontmounting close-up lenses do good work, too.)

Depth of field can be a problem when you shoot at a sharp angle from your subject's plane of focus, so use small apertures to get clear detail across the composition. Live view and DOF preview will help you achieve critical focus and optimal aperture. And remember, a sturdy tripod is always a helpful friend on uneven ground.

The Rule of Thirds gets more ink than almost any other photography tip, and for good reason: It creates dynamic and interesting shots—and it's easy to apply. When you're framing an image, imagine it's divided into a grid of nine squares, then maneuver until the image's key elements are located along those division lines or at their intersections.

Need an example? Look at this shot. The horizon crosses the page about a third of the way up from the bottom, while a small group of trees anchors the image about one-third of the way in from the left edge.

LEVERAGE THE LANDSCAPE

For extra visual impact, make the most of geometry. Pull viewers into the scene by including interesting objects in a picture's foreground, such as the faint vertical lines in the grass found in this image, which draw the viewer's eye up into the landscape.

As any student of the Rule of Thirds knows, horizons generally work best in the top or bottom third of a composition. If you don't keep them straight when you're shooting, you can fix them in postproduction (see #353).

112 GET FAMILIAR WITH LENSES

Understanding the capabilities and applications of lenses—in short, what they can do for your photos—is crucial to taking the best pictures you can. Once you're aware of the full range of possibilities, pick the lens that's suited to the image you're after. Keep your go-to favorites on you and you'll be ready to swap out lenses for the perfect pic—whether telephoto for creature cameos or macro for detail shots.

LENSBABY This selective-focus lens swivels and tilts, and allows manual focus on a small area.

A selective-focus lens allows you to create blurred areas while keeping others crisp.

NORMAL PRIME Choose this model (which refers to a 50mm lens on a full-frame sensor or a 25-30mm lens on a smaller

sensor) for natural-looking perspectives.

TELEPHOTO PRIME To magnify distant objects

using a single long focal length, go with a telephoto prime.

KIT ZOOM

Shoot at many different focal lengths with this lens.

TILT/SHIFT

This lens can be used to correct perspective distortion and to adjust depth of field.

MACRO

Use this lens for intense magnification of small objects and for close-up focusing.

A macro lens allows you to close in on fine detail or tiny subject matter.

TELEPHOTO ZOOM

This lens magnifies like a telephoto prime, but it also offers variable focal length.

A telephoto zoom lens makes distant subjects seem very close—and it's flattering for portraits, too.

WIDE ANGLE

Its short focal length allows you to capture a fuller area of view.

FISHEYE

This lens captures an extremely wide angle of view but makes straight lines look curved.

The characteristic distortion of a fisheye lens adds a compelling quality to very wide-angle shots.

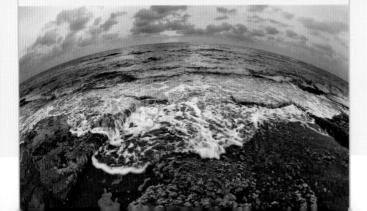

ULTRAWIDE ANGLE

This lens offers you the widest possible angle of view, without distorting straight lines.

ALL-IN-ONE ZOOM

With wide-angle to telephoto focal lengths, often with a small maximum aperture, this lens is very versatile.

113 STAY STRAIGHT WITH TILT/SHIFT

Tilt/shift (T/S) is a superhero. It can straighten tall buildings, give insanely deep focus without insanely small apertures, and limit focus to the width of an eyelash. And it performs its stunts while you shoot.

Architectural photographers love T/S for its "anti-topple" effect. Usually, when you shoot a tall structure, its parallel lines seem to converge as they rise, but because a T/S lens casts a bigger image circle

than conventional lenses, you have leeway to move the sensor or film plane up, down, or sideways in that circle. Keep your lens parallel to the building, shift the T/S lens upward (a bubble level in the accessory shoe squares the camera with the building), and shazam! You've got more structure and less foreground.

T/S works in the opposite direction, too. Shooting from a tower or ladder top? Shift the lens downward.

114 PLAY WITH THE SCHEIMPFLUG EFFECT

This delightful term refers to the apparently infinite depth of field a T/S provides—with moderate apertures and fast shutter speeds to boot. By tilting the plane of focus in the same direction as the plane of a subject, much more of that plane is in focus, from fore-to background. Nature photographers love T/S, since it's a great way to freeze a subject such as a breeze-tossed flower against an in-focus field or forest.

To harness this power for yourself, place a camera on a tripod, zero your T/S, and focus about one-third of the way into the zone you wish to keep sharp. Tilt or swing the lens toward the subject plane, then fiddle with focus again. Check depth of field by stopping down the lens to the desired shooting aperture.

115 REVERSE THE SCHEIMPFLUG EFFECT

This amazing trick confines focus to a single area of a composition. By tilting the T/S lens in the direction opposite the one that would produce depth of field, you limit sharp focus to the narrow pivot point of the plane of focus, while the rest of the image blurs. Street photographers use this loopy effect to turn city scenes into toylike miniatures, and portraitists to zero in on a single facial feature.

As with ordinary Scheimpflug, trial and error can help you master the reverse method. Focus with the lens straight and centered on the feature that you want in focus (here, the cars in the midground). Tilt the lens counter to the subject plane (the plane of the streetscape). Play around for a pleasingly uncanny combination of delineation and blur. You can also fake it in postproduction—see #275.

116 DO THE VAMPIRE TILT/SHIFT

Here's a trick to frighten your friends: Shoot into a mirror without your (or your camera's) reflection showing up in the image. More seriously, it's a useful trick when you're photographing indoors, especially when capturing decor details and real-estate shots.

As is often the case when you're being tricky, you'll need a tripod. Set it and the camera parallel to a mirror, then step yourself and your setup out of the reflection. Shift the lens sideways toward the mirror and your image will look as if you snapped it straight on.

Fangs and black cape? Strictly optional.

117 IMPROVISE A MACRO LENS

Without a macro lens but keen to come in close? If you've got a normal lens with an aperture ring, here's an economical choice that can turn that lens into an extremely powerful close-up tool.

All you need is a reversing ring, a simple adapter that you thread onto the front-barrel threads of your lens. Then attach the lens to your camera's lens mount—backward. You won't be able to focus to infinity, but you're ready for bugs and buds. Of course, you'll need to focus manually, and meter manually at stopdown aperture—turn the aperture ring to your desired aperture for this.

No aperture ring? You can still mount the lens with a reversing ring, but, in most cases, you will be stuck with the smallest (dimmest) aperture. To focus, try live view with LCD brightness and/or exposure compensation turned up.

118

INVEST IN MACRO TOOLS

If you're really interested in focusing on the small stuff, you'll want to make a few investments. For starters, you might want to score a macro lens that allows you to take life-size shots (designated in the lens specs as a magnification ratio of 1:1) of your subjects. If you're keen to delve even further into the tiny world, invest in a macro lens with greater than life-size magnification. And if you're that committed, you also might lust after a macro focusing rail. Without one, you'll have to contend with the tedium and inaccuracy of conventional manual focus at tight distances.

119 DO THE MACRO MATH

Want to know how big you can go? If you have a metric ruler and know the size (in millimeters) of your camera's sensor (or film plane), you can figure out the magnification you're working at for any given focusing distance. Place the ruler where your subject is, focus on the millimeter lines on the ruler, then count the visible lines from left to right. Divide the sensor length by the ruler length visible in the finder, and that's the magnification. So if you see 36mm across, and you're working with a full-frame DSLR (which has a 36mm sensor), the magnification is 1:1.

Count 18mm? You're at 2:1,

120 LEARN FOCUS STACKING

Probably the greatest and most startling advance in macro photography in recent years has been focus stacking. It's a nifty solution to an inherent limitation of macro photography: the greater the magnification, the shallower the depth of field.

Focus stacking involves taking many digital exposures of the subject, moving the focus point slightly from frame to frame. The in-focus points of those frames are then "stacked" in software (Zerene Stacker and StackShot are two popular programs). The result: a single image that's as sharp as a tack—from front to back.

QUICK TIP

121 USE A BEANBAG SUPPORT

Beanbags are great support for when you're shooting at ground level. Not only do they let you go low, they're not fiddly, since unlike a tripod, there are no knobs or levers.

I work on a reconstruction project in Iraq, and on my short visits home, I fit in a photo class. I shot this at the instructor's home. All the setups were very simple: the choice of two studio strobes, a plain black fabric background, a plant, an animal, and a spray bottle of water to draw some interest out of the subject by spraying it just before shooting. I used just one strobe, to the lizard's left. The lizard went to lick off the water I'd sprayed, and I was lucky enough to catch it.

-STEFAN EDWARDS

122

GET CLOSE TO ANIMALS

Reptiles and insects are superb subjects but require patience and a few tricks. Spritz slow creatures with water or shift them into sun to prompt movement. To shoot wild critters, slowly get as close as possible and sit at their level—shots from above can lack dimensionality and intimacy—while holding your camera or adjusting a tripod close to the ground. Wait for eye contact, an interesting facial expression, or another creature (so you can shoot interactions). Compact cameras with optical image stabilization let you focus 1 inch (2.5 cm) or so away from your lens. Capture habitat using a wide-angle lens with a close-focusing distance.

simple complex

MAKE EVERYDAY OBJECTS APPEAR COSMIC

Remember those 1950s sci-fi flicks with pie-pan flying saucers and actors lurching around in rubber alien suits? British doctor Andy Teo does, and he pays homage to them with quirky trompe l'oeil shots of stuff he finds around his house. "My daughters get involved and it becomes a form of family fun," he says. In a series Teo calls "Let's Pretend Space Travel," he

124 TOY WITH ABSTRACTION

You can find delightful ideas for abstract photographs without walking out your front door. Kids' toys, kitchen utensils, the stuff in your toolbox and junk drawer—all are fodder for whimsical photos.

STEP ONE Gather the goods. Assemble intriguingly shaped or colored objects and try shooting them with unusual lighting or close focus.

STEP TWO Enlist an assistant. It's hard to juggle subject, gear, and lights solo. Corral a helper to reposition things while you work the shutter.

STEP THREE Use the right gear. A macro lens can make a little toy seem to tower above the viewer. An ultrawide one can distort or exaggerate an object's shape.

STEP FOUR Play with your subject. You can position it under various lights, fill the frame with it, or add visual weight by including an out-of-focus background.

STEP FIVE Experiment with exposure. Under- or overexposure adds dimension and drama to the most mundane subjects. Make a rubber duck menacing or a kitchen sponge mysterious.

BIG PROJECT

reenvisions the ordinary: Cheese graters become spaceship power generators, cookie cutters morph into metallic snake monsters, and, as seen here, Slinkys transform into time-travel tunnels. As Teo observes, old movies loved to depict time travel "as a journey down a tube with twists, and a Slinky is just that: a long, flexible tube with recurring concentric circles and twists."

To arrange this abstract shot, Teo asked his daughter (A) to hold one end of the multicolored toy (B) up against the dining-room ceiling lamp (C). Teo

held his camera and ultrawide lens (D) at the toy's open end and fired away. The ultrawide lens exaggerated the toy's length, rendering close rings enormous and distant ones small. Teo kept the toy somewhat compressed so the dining room's real-world background could not peek through its eerie rings and spoil the mood. Finally, he underexposed the shot for dramatic intensity and darkened its corners to emphasize that beckoning vortex. Despite the photograph's alien colors, Teo used nary a tinted gel or filter. Dr. Who would be very proud of Dr. Teo.

Photographer Dan Bracaglia spotted a taxi lot in Hoboken, New Jersey, filled bumper to bumper with shiny new yellow cabs. He stood atop a bridge to record this field of automotive gold with a 35mm f/1.4 lens, shooting at 1/3200 sec and ISO 500.

125

PROWL FOR URBAN PATTERNS

The city is as rich a source of pleasing patterns as the countryside: Just scout out repeating shapes and dynamic spacing. Repetitious shapes can be found in details, like brickwork, or by focusing on the big picture, such as orderly rows of rooftops. For dynamic spacing, choose repeating elements that don't touch, or shapes that bunch and merge to propel the eye through the scene. Remember, patterns aren't always static; they can also be on the move, like passing clouds. They can be parallel, symmetrical, or include wild cards—such as the taxis parked at different angles in Dan Bracaglia's composition—that supply surprise and a focal point.

Telephoto and macro lenses are patterns' best friends, as is close command of depth of field, so set small apertures (f/16, f/22, or smaller) to ensure sharp focus throughout the image. Taking pattern photos requires patience and a keen eye for the world's subtleties, but once you get it down, the rewards are worth the effort.

126

CONSIDER ALL THE ANGLES

With its stark, dynamic lines, modern architecture is an ideal subject for photographic abstracts. Capture your perfect shot through careful study and composition.

STEP ONE Pick your perspective and light. Walk around the building. Get as close as you can and examine it from various viewpoints and at different times of day. Look for evocative shapes, curves, and contrasting elements, such as a grid of windows topped by an arching roofline.

STEP TWO Experiment with gear. Choose a wide-angle lens for a vertiginous upward shot of a skyscraper, or a polarizing filter to ensure that interesting reflections don't disappear in ambient glare.

STEP THREE Take lots of practice shots, then delete distractions. For a purely abstract shot, eliminate visual clutter, such as passersby, from your frame or crop them out later.

STEP FOUR Finally, finesse your settings. Bump up contrast to stress shapes, if needed.

CHECKLIST

127

GO ABSTRACT

Bored with the usual subjects? Shoot abstract images—photos that play with pure pattern, line, texture, or color. You'll not only hone your skills as a photographer, you'll stretch your perceptions.

- □ OPEN YOUR MIND. See a chair, and you'll photograph a chair. But view it as a collection of visual ingredients, and you can craft an innovative shot like the one here.
- □ **PICK OUT DETAILS.** Focus on a compelling element of your subject by selecting a long focal length.
- ☐ CROP OUT UNWANTED ELEMENTS. If your gear won't let you fill the frame with your composition, shoot broadly and crop in later.
- ☐ **TRY B&W.** Monochrome alters the colored reality we see, so it is the first step on the road to abstraction.

It was a nice warm day, and my wife and I had all of the windows open. A blue jay was chasing dragonflies, and he flew right into the house and landed on a coffee table. We gingerly picked him up and brought him into the little studio I'd set up in the living room. The light from my ring light was very strong, but it just wrapped around him beautifully. My wife held him, and I managed to shoot a few shots with a DSLR and 60mm macro lens. It lets you focus to a 1:1 (life-size) ratio, which is how I got such a tight shot. Then we let him go. Now he's more careful near the door.

-AARON ANSAROV

128

HIGHLIGHT DETAIL WITH A RING LIGHT

To capture minute detail such as the iridescent plumage in the photo at right, zoom in with a macro ring light that fits on your lens to illuminate tiny objects. These lights, often used in food and botanical photography, heighten detail without shadow interference.

129 FRAME WITH THE FOREGROUND

One of the most striking field techniques is foreground framing, which directs the viewer's eye straight to the photo's star attraction. A foreground frame can also depict a subject in relation to its surroundings. At its most dramatic, as in the shot at left, it produces a 3D effect in which the scene sweeps from front to back. Keep an eye out for anything you can use to frame your subject: tree branches, architectural elements, rock formations, flowers, or even the outstretched arms of a companion.

130 SWITCH THE PERSPECTIVE

When should you shoot a vertical? Whenever you shoot a horizontal—though many photographers overlook the advantages of the vertical shot. This type of shot lets you get a wider angle of view with the same focal length, since it can take in low foreground detail without losing the background. Plus, tall things seem to cry out for the vertical treatment: skyscrapers, redwoods, statues, giraffes—and the intricate rigging of this boat's sails. Try getting up high and shooting down for an unexpected angle on a vertical scene.

QUICK TIP

CLEAN A LENS WITH VODKA

If you're out shooting and discover that your lens of choice is dirty, don't panic. Just stop by the nearest bar and order a vodka. Moisten a clean microfiber cloth with the hooch, then wipe your lens as if you were using cleaning fluid. Avoid flavored vodkas, though—they may leave a residue.

132 ADJUST EXPOSURE ON YOUR PHONE

Here's one trick many smartphones have over your souped-up DSLR: You can tap their screens to improve autofocus and exposure. To choose a focus area, simply double-tap on it. And to adjust white balance and exposure, point your phone at a high-contrast scene, such as a sunset. On the phone's screen, tap the sun, and then tap a dark part of the water—you should see an adjustment in exposure. You can also try your camera's HDR function, which captures images at slightly different exposures.

133 CONSIDER COLOR

Digital photography enables you to precisely control photos' color. But what, exactly, is color? Simply defined, color is our visual perception of various wavelengths of light. Learning to adjust and deploy it for artistic and emotional effect is a key task for every photographer.

Since color is so important, an advanced camera is chock-full of tools that let you capture and adjust it. These allow you to choose specific saturation levels, mimic black-and-white and sepia-toned photography, and set white balance (WB) to record true color in all kinds of light environments.

But the best way to control color is to shoot with neutral settings and in modes that record and store shots as RAW files. These tactics conserve the maximum amount of image data because images aren't compressed or processed as you shoot. That gives you leeway to use software later if you decide you want to alter, amplify, or soften color.

134 WRANGLE WHITE BALANCE

All light has color, even when it looks white. Midday light is blue; sunset and sunrise glow gold and red. Artificial lights have characteristic tints, too (see #174). And of course, all these differences will have an impact on your photographs.

You don't have to manually adjust WB. DSLRs usually get it right on Auto setting. And if not, you can always rescue poorly colored shots in postproduction (see #296). But if you want to get color right the first time, take the reins while shooting.

Zap unwanted hues with preset WB settings: Tungsten cools down the yellow of incandescent indoor lighting; Fluorescent counteracts the greens of its namesake lights; the Cloudy and Shade settings are the ones to use to beat the blues.

When a preset WB can't cope with mixed light, create a custom setting. Snap a neutral gray object in the light you're using, and select that frame in custom white balance (CWB) mode. Your DSLR will correct the frame to neutral gray, then apply the same fix to ensuing photos. The result will be true, cast-free color.

135 COPE WITH COLOR IN MIXED LIGHT

To photograph Scotland's Falkirk Wheel—a rotating canal-boat lift—Kenneth Barker made do with light of four varieties: a low sunset, LEDs in the lift's hoops, incandescent uplighting, and distant city glow. The next time you confront similarly varied (and tricky) lighting, try following these steps.

STEP ONE Select your file format. Shooting in the RAW format is ideal, because it captures the most data and gives you options later. But if your camera can't do it or you need JPEGs (for quick uploads, for example), pick a key object, determine its color temperature, and select a preset white balance or create a custom one.

STEP TWO Bracket color temperature. Dial through your DSLR's scenic presets and select the one that's closest to the scene that you're shooting.

STEP THREE Bracket exposure to control color richness and saturation. Dialing down exposure compensation saturates color through underexposure. Setting it in plus range desaturates it via overexposure.

STEP FOUR Compose for color. When the light is dramatically mixed, color is your true subject. Compose to fill your frame with contrasting and complementary hues, both natural and manmade.

136 LOOK DEEPLY INTO A SUBJECT

Depth of field (DOF) is the amount of space that's in focus in the foreground and the background of a photo—and controlling it helps you craft artful images. A deep DOF captures detail in every part of your composition, from nearby subjects to faraway ones.

If you're striving for the deepest possible DOF, remember that small apertures—those with high f-stop numbers—increase DOF. Experiment with distance from your focal point, moving back to increase DOF. Finally, choose the right focal length for your lens. The shorter its focal length (in other words, the wider its angle of view), the greater your depth of field will be.

137 BE SHALLOW

Using a shallow DOF in your photos allows you to direct your viewer's attention exactly where you want it: on a face, a flower, or a single detail of your composition. To narrow your DOF, adjust your aperture's size. The f-stop plays a huge role in determining DOF—when the aperture is wide open (at a low f-stop number), your image's main focal point will be crisply defined. The rest of the image will be somewhat blurred, an effect often called bokeh (see #155). Your distance from the focal point also determines DOF. For a shallow one, move closer. Lens choice is another factor—a macro or telephoto decreases DOF.

QUICK TIP

138 FAKE DEPTH

To simulate increased focal depth in your photographs, turn your camera vertically to a portrait rather than a landscape orientation.

139 STRAIGHTEN OUT A SKYSCRAPER

When shooting a skyscraper from ground level, what your eyes see as a rectangle will be distorted in the image: broad at the bottom, narrow at the top. You can blunt this effect, called keystoning, with tilt/shift lenses or view cameras (see #113), and you may be able to use software to correct it. But the cheapest and easiest method is simply to use a wider focal length.

Move back as far as you can while maintaining an unobstructed view of the whole building, keep your camera perfectly level, and shoot. (Hot-shoe-mounted bubble levels—see #141—are handy, as are built-in levels for the pitch axis, or up/down tilt.) You'll suck in a big expanse of unwanted foreground at the bottom of your shot; crop it out afterward.

140 GET HYPER ABOUT FOCAL DEPTH

To capture a sweep of precise detail from the foreground to the horizon—especially desirable in landscape photos—focus at your lens's hyperfocal distance. This is the point at which you have the greatest possible DOF that includes infinity. Set your aperture 1 stop below the lens's smallest aperture, switch the lens to manual focus, and then focus to infinity. Now stop down the lens to shooting aperture using the camera's depth-of-field preview button or lever. The viewfinder will be quite dark, so use the camera's live view, if it has it, and lighten the LCD display so that you can see detail in the frame. Now manually focus back from infinity until a foreground detail just comes into focus. If infinity is now out of focus, go to a smaller aperture (larger f-number) or move back. Conversely, if you have leeway in your DOF, move closer and/or go to a wider aperture. The end result? A sharp shot from foreground wildflowers to distant snowy peaks.

141 HOLD THAT HORIZON

Inside your DSLR is a landscape lover's savior: the in-camera leveling guide. If your horizon tilts in a shot (likely when you're on uneven terrain), you could level it in postproduction, but you'd lose some frame edges. Alternately, you could use a tripod or a hot-shoe level, but these don't let you compose and level at the same time. A built-in electronic level, which you'll see in your viewfinder, permits both. Some cameras also have a level for the pitch axis. Built-in levels are a boon when you seek landscapes off the beaten path, but you don't want to lug a tripod around solely for its leveling head.

142 FINESSE TOUR F-STOPS

An f-stop—a ratio describing the size of your camera's aperture—is a lens's focal length divided by the aperture's diameter. Just remember this basic rule of thumb: The smaller the f-stop, the larger the aperture and the more light that enters, and the larger the f-stop, the smaller the aperture and the less light that enters.

Photographers set exposure by combining shutter speeds and f-stops in order to get the right amount of light to hit their sensor. Most DSLRs' f-stops are in whole intervals (in which each stop up doubles incoming light and each stop down halves it). For example, an 80mm lens with an f/8 stop has an aperture diameter of 10mm. Change that f-stop to f/16, and you've got a 5mm diameter.

Most DLSRs now also offer one-half and one-third f-stop intervals. The standard progression of full f-stops on a 35mm camera is 1.4, 2.0, 2.8, 4, 5.6, 8, 11, 16, and 22.

Remember that shutter speed, not just f-stop, determines the correct exposure. For example, if you change a 1/250-sec exposure to a 1/125 one, that shift impacts exposure just as opening up from f/11 to f/8 does. (You shift f-stop via the aperture ring.)

Small apertures (meaning high f-stop numbers) increase depth of field, and vice versa. To keep both foreground and background subjects in focus, pick a small aperture (a high f-stop number). To emphasize your subject by permitting its background to blur, focus directly on the subject, and then select a large aperture. Keep in mind that lens aberrations can show up at low f-stops, and that super-fast lenses (those with very low f-stops) tend to be pricey. Also, know that diffraction at very high f-stops can reduce image sharpness. Seek out that happy middle ground where lens length, aperture, and f-stop combine to give you the perfect exposure—and the perfect photo.

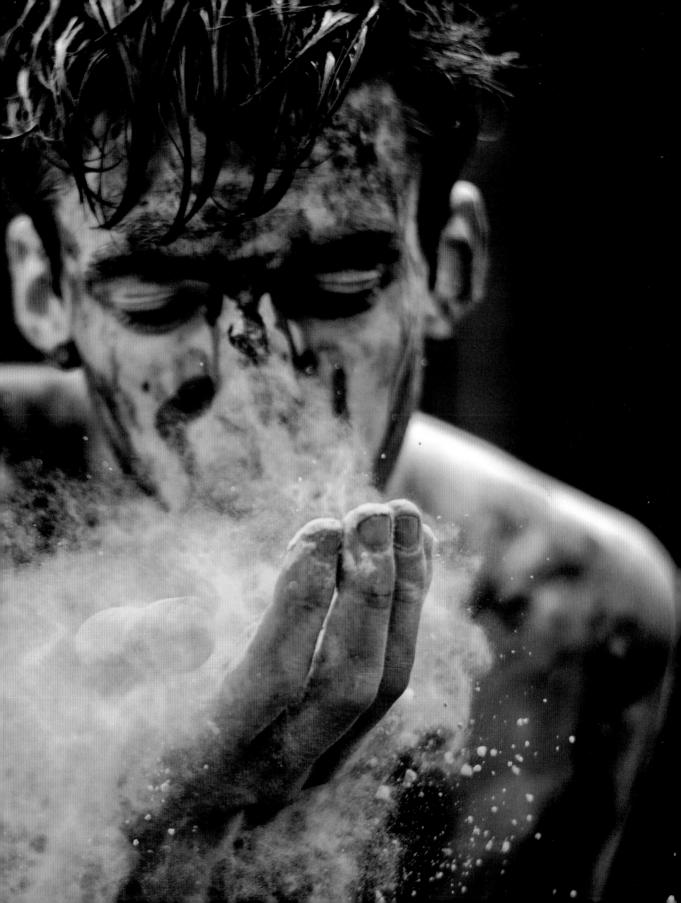

143 SHOOT WITH A MOSAIC IN MIND

Out and about without your high-tech DSLR and favorite filter? You can still capture the magic of the moment—or several moments digitally stitched together into a stunning package. To create a spontaneous but artful array of photos such as the one here, download a mobile-phone app that allows you to create a quick grid of images. Then use the same app to upload your collage or send it to a friend.

144

ZAP SPECKS WITH DUST MAPPING

Your camera sensor shakes to remove dust, and a blower can gently loosen dirt from the glass plate in front of the sensor. Basic camera hygiene also keeps away dust. Change lenses carefully, and never leave a camera body or rear lens element uncapped.

Despite your best efforts, you might still get some dust spots in your photos. To eliminate these bugbears, call on your camera's dust-mapping software. The program photographs a blank white surface, and then an image-editing feature uses that data to fill in dust spots via interpolation.

145 FIGHT ZOOM CREEP

Zoom lenses with loose turning actions often suffer from something called zoom creep. It can be vexing when, for example, you hike with a long zoom lens hanging from a neckstrap and it slowly extends from a conveniently compact state into a longer, chest-thumping log. Zoom creep can also reduce sharpness. With a loose-turning lens, when the camera is aimed up or down, the zooming elements can move during exposure, resulting in a softer image. To prevent creep, some lenses have a zoom lock to maintain a contact profile. Lock it down or (as pros who shoot from the rafters of sports arenas do) use gaffer's tape to tame that creep.

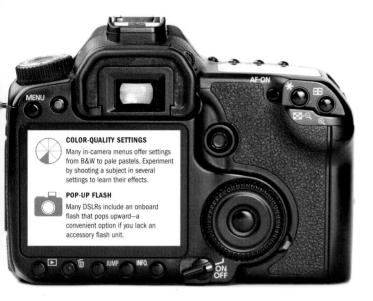

146 CREATE A PORTABLE CAMERA MANUAL

Can't remember what all your DSLR's fancy functions do? Shoot close-ups of the pages in your manual that explain each one. Load them on a memory card and take it along when shooting. In playback, zoom in with the magnifier function so the text is legible. Use the same shortcut to record instructions for any procedure that chronically slips your mind. Presto—a weightless manual for the field.

147

TAKE NOTES WITHOUT A NOTEBOOK

Your DSLR's voice memo feature lets you record voice clips via the camera's built-in microphone and embed them in image files. Thus you need not schlep notebooks or handheld devices to note down stuff that doesn't get into exchangeable image file (EXIF) format data, such as names of people and places, directions to shoot locations. hair-raising or amusing midshot happenings, and the like. Use it to take field notes when location scouting, to create shot-list reminders, or to tag photos for later identification. Presently the capability is the provenance of high-end

DSLRs, but it likely will migrate down the market.

148 PERFECT YOUR OPTICS WITH LENS CORRECTION

There's no single perfect lens on the market, search as we might to find one. Even top-shelf optics can produce distortion, light falloff in the corners, and soft images at certain apertures. Many DSLRs now flaunt built-in fixes that correct barrel and pincushion distortion and corner vignetting. Some can counteract chromatic aberration, too, which robs your images of sharpness and causes color fringing (this

function is found in the RAW conversion menu). Bear in mind that such functions sometimes work only with a camera maker's own lenses, not with independent optics. Remember, too, that lens correction is a default setting in some cameras. Switch the function off in the setup menu if you prefer distortion or want to avoid the frame-edge cutoff that such correction sometimes causes.

149 MAKE THE MOST OF LIVE VIEW

Live view on DSLRs lets you use your LCD to set up shots, not just review them after the fact. You can experiment with exposure and white balance before you shoot, and most cameras can display your histogram using exposure simulation. If you adjust exposure compensation, the LCD immediately shows you the result. All that means you don't need gobs of test shots, which is great when you're working in fast-changing light. Live view's brightened LCD display is terrific in low light, too—when the viewfinder is too dark for accurate manual or autofocus. Menu settings turn the auto-brighten feature on and off, or you can simply increase exposure compensation to brighten the LCD image. That way, you can shoot in shadows and shade without shooting in the dark.

QUICK TIP

150 FIGHT BATTERY DRAIN

Losing natural light and battery life at the same time? Don't despair: Preserve power by changing the way you shoot. Pump up ISO as high as you can, and don't use flash, if possible. Switch to aperture-priority mode, setting it to a wide aperture (low f-number). Finally, turn off the LCD so you can snag a few final pictures before it's lights-out on your shoot.

151 GO TO EXTREMES WITH YOUR HISTOGRAM

Common wisdom preaches that to obtain optimal exposure, you set shutter speed, aperture, and ISO so that the bell curve of data on your histogram is centered, not falling off the left or right edges. But in truth, perfect exposure—and perfect histogram data arrangement—depends on your subject. A histogram's shape represents the percentages of light, dark, and midtones in an image. Thus, when a subject is

composed primarily of dark tones and shadows (for example, a moody portrait against a black background), histogram data should skew toward the left edge to preserve detail and prevent black from turning gray. When a subject has many light tones (highlights), data should skew toward the right. Of course, the bell-curve shape is your goal when shooting subjects with average tonality, like the picture in the center above.

152 KNOW YOUR LIGHTING RATIO

A lighting ratio describes the quantity and quality of light in a shot. It uses increments known as stops to indicate the amount of light in highlights compared with the amount in shadows. The ratio's first number describes the key or main light, while the ratio's second number describes the shadows or fill light. The closer those two numbers are, the flatter the overall lighting. The farther apart they are, the higher the contrast. Knowing the ratios—and compensating accordingly—lets you heighten or mute detail, depending on your artistic objectives. For example, if your camera's sensor can capture only a 6-stop range of highlight-to-shadow detail and your ratio reads 7:1, you should drop light levels in highlights or add light to shadows until you reach a 6:1 ratio. In-camera spotmeters show you ratios, but handheld flashmeters are often easier to use.

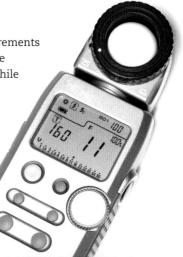

153 GET THE LO-FI LOWDOWN

Lomography, another term for lo-fi film shooting, is mostly a process of happy accidents. But a few tips come in handy as you make your way through the wild world of lo-fi. For starters, shoot in color to exaggerate the bright hues of flowers, neon, and storm-lit skies. Cross-processing slide film (getting it developed in the wrong solution) further distorts color and heightens oddball contrasts. Color effects vary among films: Cross-processing Fuichrome Astia or

Sensia gives you a red effect, Provia and Velvia, a green one. Konica films give you yellow, and Kodak, blue.

Have fun and be sure to shake things up as you shoot—unlike with your fancy DSLR, feel free to vibrate the camera, hold it over your head, or lie on the floor. Remember, it's the serendipitous "flaws"—such as the double exposure in the portrait at near right, the light leaks in the center image, and the color shift at far right—that make long images so arresting

154 TRY LO-FI

Lo-fi film photography is the ultimate in retro chic. Its unpredictable, intentionally poor-quality aesthetics—light leaks, weirdly rendered colors, blurs—are best produced by cheap cameras old and new, including toys and pinhole creations (see #051).

One lo-fi staple is the Holga, a medium-format toy camera invented in Hong Kong in the 1960s. It's a simple beast with two light settings, two shutter speeds, and four focusing modes. Shooting with its plastic 60mm f/8 lens, you'll get images with soft focus, blurred or trailing colors, and heavy vignetting.

Or try a similar gadget, the Diana. Another plastic roll-film snapper, the Diana fell out of production in the 1970s, but it has been resurrected as the Diana Mini-35mm and the Diana +. The latter boasts a panorama mode and can even be turned into a pinhole camera.

For modern takes on retro photography, check out new plastic cameras such as the Blackbird Fly 35mm. Or you might want to look into apps like Instagram and Hipstamatic for camera phones.

Professional photographers love to modify cheap cameras for uniquely peculiar or pretty results. "The more you beat up a Holga, the better the pictures," says lo-fi expert Liad Cohen. "Don't be afraid to drop the camera a few times."

155 GO FOR BOKEH

Most photographers obsess about sharpness, but there's an equally passionate subset concerned about unsharpness. Its holy grail? Beautiful bokeh. This Japanese word translates roughly as "the quality of blur or haze," and it refers to defocused areas in front of or behind a sharp subject, usually formed from defocused points of light. Desirable bokeh shows these circular highlights as creamy soft and smooth-edged.

To get a bokeh effect, find a subject dotted with small light sources, then screw on a lens with an aperture made up of many blades. Put your camera on a tripod, set a large aperture, and opt for shallow depth of field to render your subject sharply. It will contrast nicely with the heavenly blurry background.

156 FLOAT ABOVE

When Sandy Honig was 17, she learned to levitate for a high-school project. Or at least to look like she was floating in midair. Wondering how she created this seemingly magical self-portrait?

As most magicians will admit, it's all about props. Honig's was a chair, which she set up in her yard so she could capture two images of the scene. One contained nothing but foliage, trees, and the setting sun; the other was of her lying across the seat of the chair. She then layered the images in Adobe Photoshop, and finally erased the chair from its layer, revealing the foliage in the layer below. Presto!

To put on your own photographic magic show, find a suitable background with great light (A). Mount the camera on a tripod (B), as the camera must remain absolutely still between exposures. Compose the scene, then place your chair (C), manually prefocus on it, and take test shots to determine exposure. Focus, then set the exposure and white balance with manual settings to prevent them from changing between shots. For the first exposure, set the self-timer, fire the shutter, and then lie rigidly on the chair (D). To nail identical lighting, take your second shot right after the first: Remove the chair and shoot only the background.

Later, combine the exposures in image-editing software. Check out entry #347 for specifics on making a confounding composite like this one.

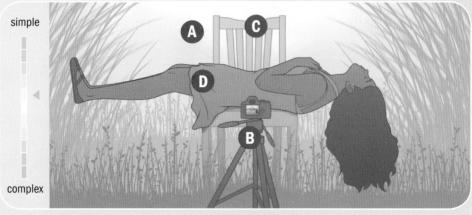

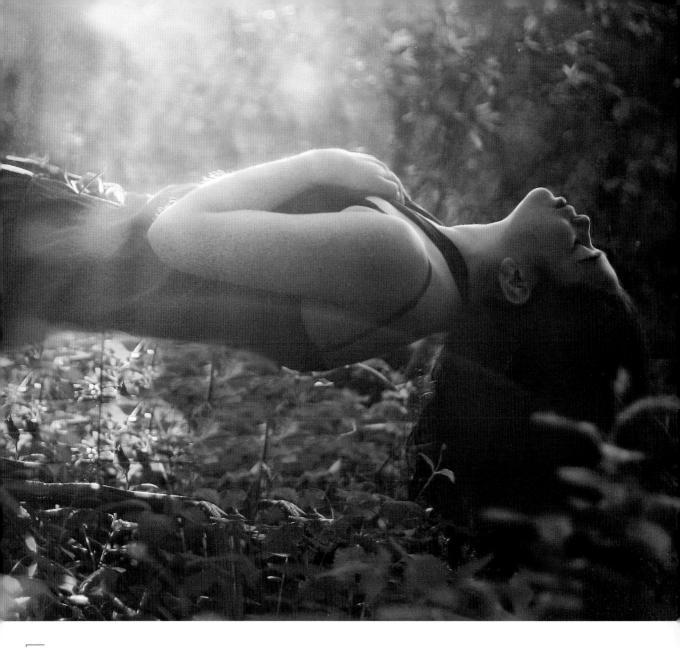

157 EXPERIMENT WITH FLASH EXPOSURE

It sounds odd, but it's actually true: Any photograph that you shoot with a flash is in fact a double exposure. The scene's own ambient light produces the first exposure, while your flash illumination produces the second. Use the exposure dial to tweak ambient exposure for intriguing effects, making it equal, slightly unequal, or wildly unequal to your flash exposure. Or adjust shutter speeds so that one

exposure is motion-blurred and the other appears razor-sharp. You can also give each exposure its own color balance.

Here's an experiment: The next time you shoot a subject against a background of foliage or a sunset, turn off auto settings and separately set ambient and flash exposures to create a range of looks. Such games make flash photography fun—and versatile.

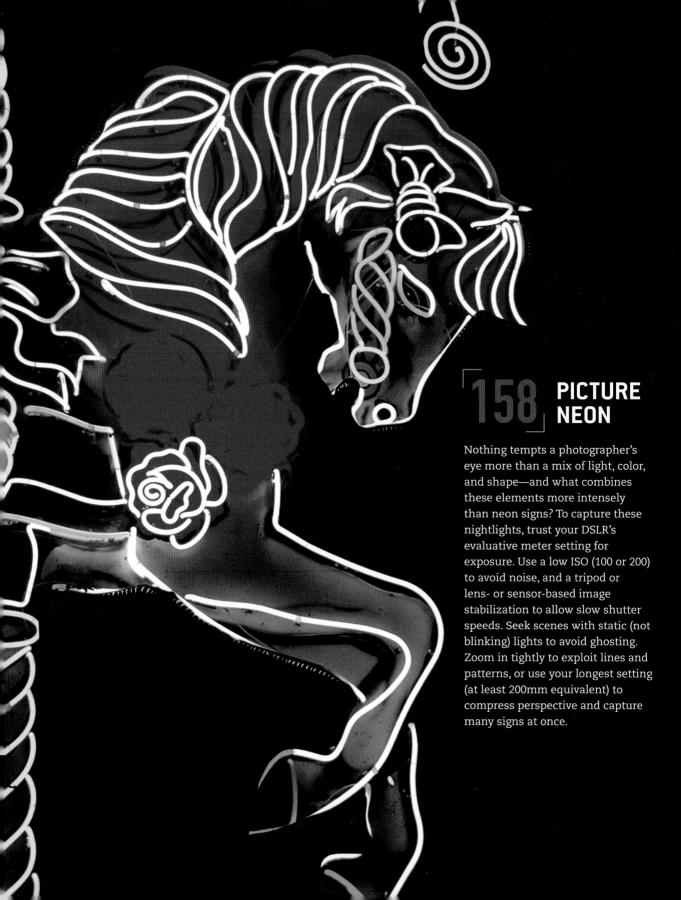

159

SHOOT FAIRS AT NIGHT

The thrill of the carnival at night: bright lights, shriek-inducing rides, and campy merriment. Here's how to capture it.

- ☐ PREPARE AHEAD OF TIME.

 Scout rides in daylight. You also might want to take some shots at twilight, when you can catch a sapphire-blue sky behind the rides' lights.
- □ SET UP THE SHOT. Pick a dark, out-of-the-way vantage point to avoid lens flare and jostling crowds.
- □ EXPERIMENT WITH
 SHUTTER SPEED. Add
 creative blur to moving
 rides by using a tripod and
 long shutter speeds (1/4
 sec to 30 sec).
- □ ADD SPEED. Zoom during long exposures to add an extra element of motion.
- ☐ **TIME YOUR SHOT.** Let rides get going before shooting. Or, for sharper shots, wait for the pauses when rides are loading or unloading.
- BOOST TONE. For HDR, bracket shots widely.

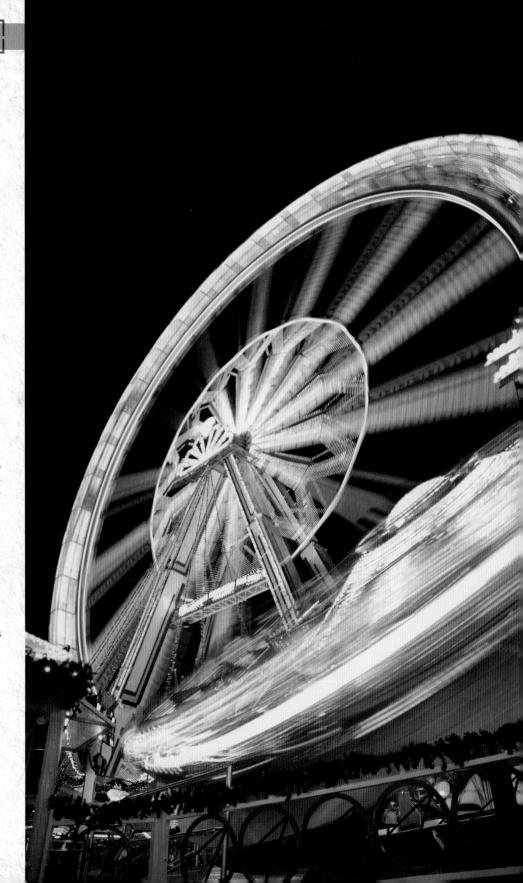

This shot was taken a few blocks from downtown Cannon Beach. Oregon. It was very windy and rainy and I went out to watch the sunset. There were an unusual number of birds around—mostly pelicans and seagulls—and they were all gathered on the beach. Just as the sun was setting, the clouds opened up, and the birds all took off at once. I crouched down to capture it, setting my camera to evaluative metering and underexposing a bit. Fortunately, the weather had kept everyone away, so I had a clear view. It was amazina.

-PHILIP WISE

160

EVALUATETHE SCENE

Evaluative metering is a great way to properly expose an entire scene. Use center-weighted metering when the subject's surroundings aren't too bright or dark and there's an even distribution of light and dark tones in the scene.

Go for spot metering to key the exposure on the most important subject in the image or on a highlight, shadow, or midtone. It's ideal with longer telephoto lenses, subjects with tricky lighting, or when you want to dramatize contrasts in light and dark.

161

EXPAND DYNAMIC RANGE

Oh, those contrasty scenes. If you expose for the shadows, highlights get blown out, and vice versa. Can't cameras stretch this dynamic range?

Chances are that your camera—like most on the market today—can do exactly that. The name of the control that expands dynamic range differs in manufacturers' menus, so peruse the manual. Some are single settings with no adjustments; others are adjustable or auto-adjusting. When you increase dynamic range, use a low ISO to keep noise out of shadows and fine-tune exposures with an autobracket. Postcapture, use your camera maker's software to apply dynamic range controls during RAW conversion.

162 PLAY AROUND WITH AUTOBRACKETING

Autobracketing automates the process of shooting numerous images at varying exposures to find the "correct" one. The autobracketing control is usually a menu option, though sometimes you'll find it on the drive-mode button. Use it to instruct your camera to take image brackets at specific exposure values (EV):

say, 0.3 EV, 0.5 EV, 1 EV, and so forth. The camera will then shoot them all in a burst. For exaggerated effects, as in the underexposed alligator below, set autobracketing, then go into exposure compensation and shift exposure up or down (in this case, down) to move the bracket in the desired direction.

163 FLATTER WITH FLASH

Want outdoor portraits, even those taken in blah light conditions, to look fantastic? Turn to your old pal, the pop-up flash. Turn on your camera's fill flash (also called forced flash), which makes the flash fire even in bright sun. If your camera has a flash-exposure compensation control, set it to about –1.3 EV. That should give you a subtle kiss of flash, just enough to open shadows. The trick works in backlight, sidelight, and harsh overhead sunlight. Don't forget to keep your ISO low so you can shoot at a wide aperture, giving your portraits a pleasingly shallow depth of field.

165 JUMP-START JPEGS

Save yourself postproduction work by fine-tuning JPEGs while you shoot. Camera manufacturers give their JPEG profiles different names, but all let you set a specific profile (for contrast, color saturation, sharpness, and even skin tone) for JPEG capture. These profiles often go by user-friendly names such as Neutral, Portrait, Vivid, and so forth. Remember, JPEGs give you less leeway for postcapture processing than shooting RAW, but you can still apply a profile when you convert from a RAW to a JPEG file.

164 GET THE WHITE RIGHT

Most DSLRs have a built-in white balance (WB) control, a nifty tool that adjusts the tone of your picture's light with the spin of a dial. You can always rely on auto WB, but this cooling/warming filter allows you to fine-tune your hues.

To compensate for your scene's actual color temperature, go into the WB menu and select the Kelvin (K) setting. Kelvin degrees are a measurement of the tone of light. A low number (2,500 to 3,500 degrees) pushes colors toward blue, which tones down yellow incandescent lighting. A high one (8,000 to 10,000) heats hues up toward amber, which balances the icy blues in the shadows of a winter day. You can also use WB to heighten the natural color of a scene: Try turning a fireside into a study in deep reds at a high K setting, or shoot a snowscape at a low K for a chilly symphony of glacial blues.

166 GET FIRED UP ABOUT FIREWORKS

Literally dazzling when seen live, fireworks can fizzle out in photos. To avoid that, crank up the color saturation in your camera's setup menu. And make sure you don't go too wide while shooting. Yes, shorter focal lengths capture complete bursts, but they can appear mighty puny in your shot. Instead, compose to include a bit of foreground material (trees, people, and architecture) to provide a sense of scale.

Don't worry if you have to crop out some of the airborne action—you'll still capture plenty of fiery light. Shoot in manual exposure, turn off autofocus, and manually set the focus to infinity. Put your flash to bed; you won't need it.

Keep shooting. Pyrotechnic photos have a low keep-to-delete ratio. For every great shot, you'll get 20 duds, so get that shutter finger clicking!

167 SNAG MANY SALVOS IN ONE SHOT

The easiest way to get multiple bursts in the same photo is to shoot the finale—but its smoke might mar your image. Instead, try a long exposure that fills your frame with overlapping bursts. Use a tripod, and focus and set exposure manually. Set the shutter to Bulb, which lets you hold the shutter open (a cable release will keep you from jostling the camera). Hold a black card in front of the lens. Open up the shutter and, as a rocket bursts, remove the card for a few seconds. Cover the lens again when the burst subsides, keeping your shutter open. When the next firework explodes, pull the card away again. Repeat the process several times, for a total exposure time of about 15 to 20 sec.

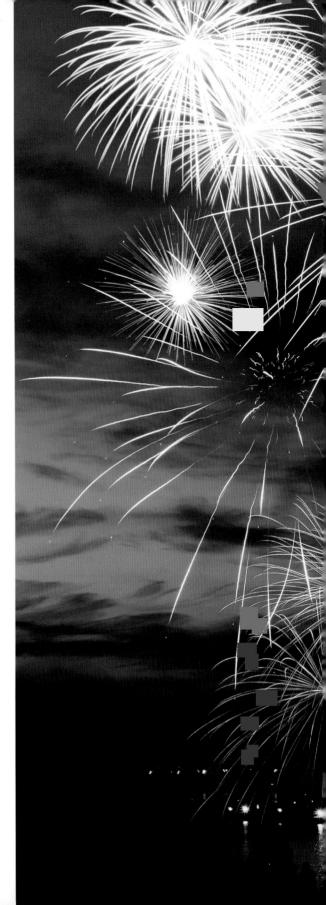

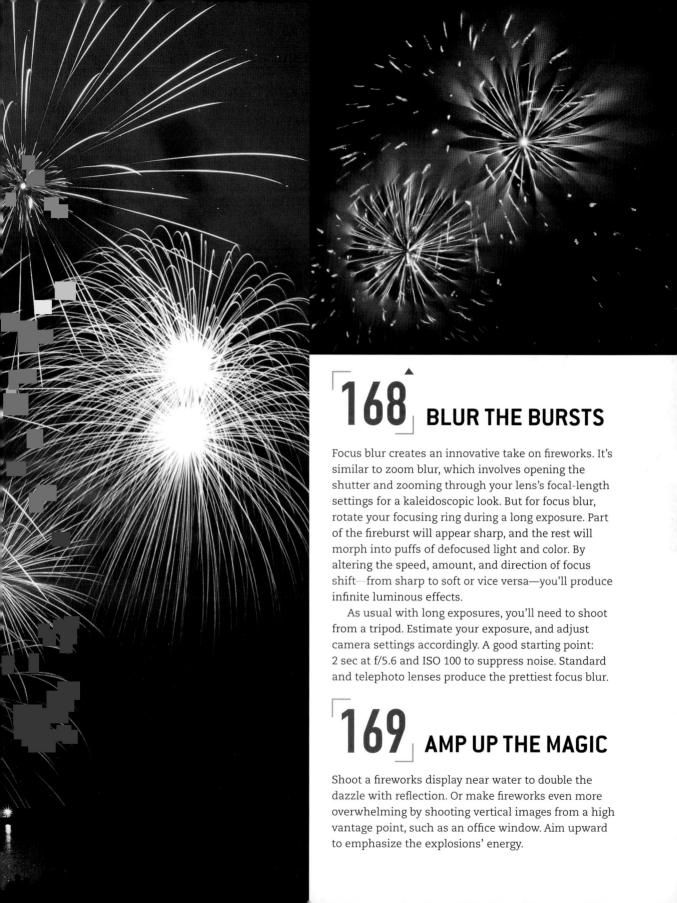

CHECKLIST

170 LIGHT THE WAY WITH CANDLES

Candlelight produces evocative photos, lending still lifes a golden glow and warming up portraits. Here are five tips for making the most of the flickering glow.

- ☐ USE A SLOW SHUTTER SPEED and a tripod or a self-timer to avoid blur. If you can, employ image stabilization.
- ☐ SET YOUR WHITE BALANCE TO DAYLIGHT, as candlelight is red.

 Otherwise your camera will cancel out the very tones that you want.

 If your shots turn out too red, try the incandescent light setting.
- ☐ AMP UP THE MOODY FEEL by underexposing shots. Your digital camera's instant feedback will guide you to the right exposure.
- ☐ SHIFT THE CANDLE CLOSER TO YOUR SUBJECT if your shots prove dim, or you can arrange more candles around it.
- □ COMPOSE SHOTS WITH DARK, distraction-free backgrounds. Whether you're creating a still life or photographing a child's face, foreground is the key to a classic candlelit image.

171

SHARPEN SHADOWS

When you photograph delicate, small, or highly detailed objects, pinpoint light sources can solve the vexing problem of blurred, imprecise shadows. Positioning a penlight to the side of your subject and using a long exposure will help you capture an intricate play of solids and shadows.

Other light sources—from small flashlights to sunlight streaming through holes in an old wall or pierced fabric—can also produce patterned or repeating shadows. Photograph those—or use them to highlight portions of a model's face or body, adding mystery to a straightforward portrait.

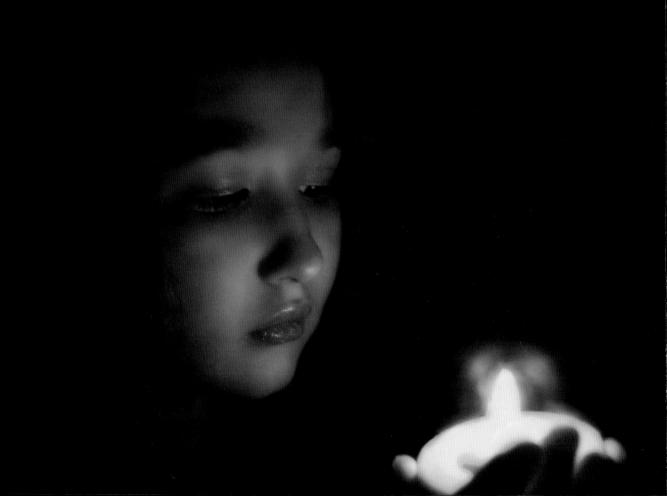

172 EXPLORE THE DARK SIDE

Photographers tend to think of shadows as things to manage and wrangle, forgetting that they can be the subject of potent photos. Wherever you find yourself, chances are you can find—or create—stunning shadow photographs. If you have a willing model and a frosted glass sheet, backlight him and shoot through the glass to produce an eerie, surreal silhouette with areas of both

precise detail (fingers pressed to the glass's surface) and evocative blur (the head inclined away from it). Find frosted glass at home stores, or put your shower door to use. Outdoors, choose a compelling object—flowers, rock formations, a length of translucent fabric—place it on a texturally intriguing surface, and shine light on it. Shoot the shadow itself to give darkness center stage.

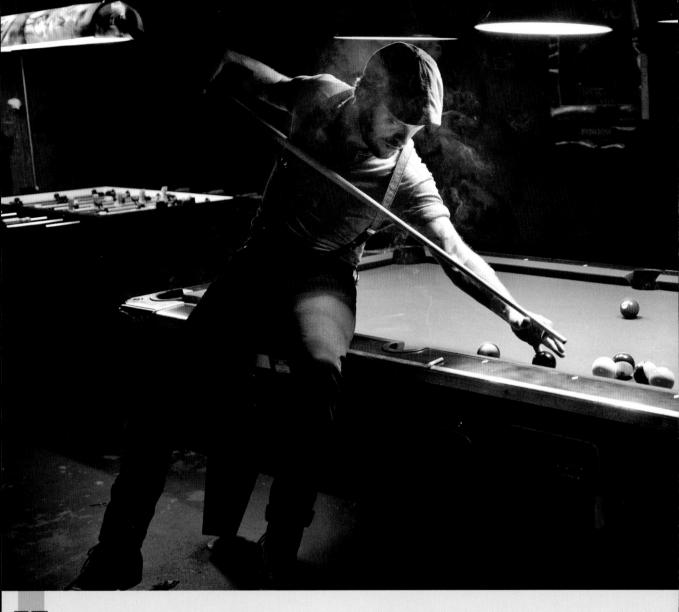

173 WORK WITH AVAILABLE LIGHT

Why drag around strobes, snoots, and umbrellas to create the right light when the stuff may be on the scene already, just waiting for you to notice it?

Complex setups have their place, but for Cary Norton's gritty, Southern-flavored shot of rock star Matthew Mayfield, the lights of an Alabama dive bar provided the perfect down-home color and contrast. Working with available light isn't easy—you must have the skill to spot it, as Norton did when Mayfield's cigarette

smoke emphasized the three cones of light streaming down from the lamps above the pool table. Norton used both the fluorescent lights (A) over the foosball table and the three shaded incandescents (B) above the pool table. He handheld his camera (C) and used a high ISO to capture sharp detail, choosing an angle that created a dynamic diagonal composition of tables, pool cue, and player. Later, he fixed the fluorescents' and incandescents' conflicting color temperatures in postprocessing. "I enjoy finding good light instead of making it," Norton says. "I tend to shoot from the hip." With practice, you, too, can achieve high drama from low lights.

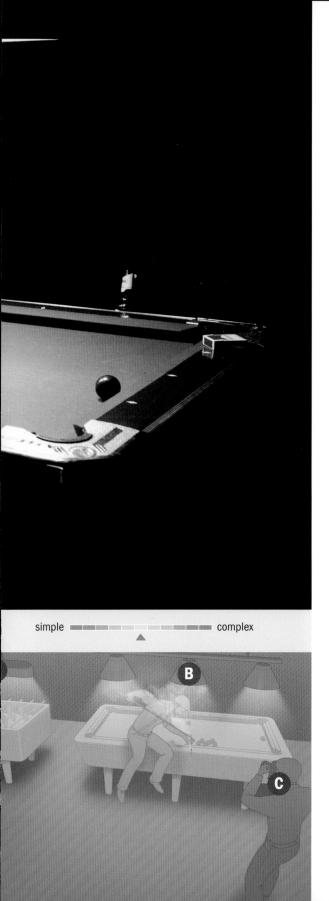

174 FACTOR IN COLOR TEMPERATURES

To wrangle the light in your photos, you need to know a bit about bulbs. Fluorescent bulbs (3,200 to 5,500 Kelvin, or K) emit whitish light. Electronic flashes imitate midday sunlight (which hovers around 5,600 K). Tungsten (2,700 K) lights, be they halogen or incandescent, are amber in hue. You can compensate for competing light sources by setting your camera's white balance manually while you shoot, or capture RAW files and work it out later using conversion software or other programs.

175 SHOOT OUTDOORS WITH AMBIENT LIGHT

Cost-free and hands-free, ambient light comes in all varieties: flat, high contrast, bright, and dim. Outdoor photographers who work without supplementary lights often stalk a site, revisiting it many times to nail the ideal light. Prized as "golden hours" by painters and photographers, sunset and sunrise tend to yield more nuanced shots than the hard light of noon.

Dramatize an outdoor subject with elements that direct ambient light, such as a filtering screen of leaves or the angle of a wall. To avoid blown-out or black areas, search for light that's reasonably even across a composition. Finally, don't sweat a little blur: It makes outdoor scenes look more natural.

176 SEE THINGS IN BLACK AND WHITE

Photographers revere B&W because it emphasizes form and heightens drama. Today's DSLRs can produce digital monochromes as beautiful as those created in wet darkrooms—but first you need to select and shoot the right subjects.

Learn to "see" in monochrome by visualizing tones, or degrees of brightness, rather than colors. Even contrasting hues—red flowers against green leaves, for example—might be the same gray when they're rendered in B&W. With practice, you'll be able to anticipate how elements of a composition will appear relative to one another once the color's gone.

Photographers describe tonal differences in terms of separation and contrast. If one element is significantly brighter or darker than another, contrast is high and the elements will be well separated when rendered in B&W. When contrast is low and elements are similarly toned, they'll mesh together in B&W.

Search, too, for compelling elements such as lines, curves, and patterns. The interplay of soft white

clouds and snow with jagged dark rocks makes the mountainscape above a monochrome masterpiece. And the B&W treatment of the mother and baby giraffes emphasizes their otherworldly grace—not to mention their beautifully busy spotted coats.

178

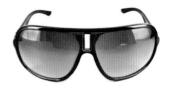

BLOCK OUT THE BLUES

Blue-blocker (amber) sunglasses are magic specs when it comes to shooting boffo B&W images. You'll see the scene crisply and in near monochrome, so that the shapes and textures essential to powerful B&W photography will jump out at you.

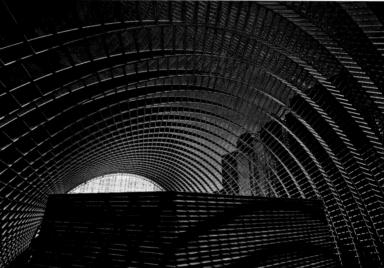

177

MASTER MONOCHROME **METERING**

When it comes to B&W, heed your meter. If it tells you that your composition's range of tones won't fit in a single exposure, you'll have to decide whether to favor shadows or highlights. Preserving highlights is the more popular approach.

To sacrifice shadow detail and protect highlights, keep your histogram bunched to the right, without clipping it off. The image will be quite bright, but with the most detail possible. Check the RGB histograms, too, to avoid clipping in any color channel. It sounds odd, but channels are key to B&W: A clipped red channel, for example, can drop shadow or highlight detail once you convert the image to monochrome.

179 SHOOT IN COLOR FOR THE BEST B&W

Another contradictory-sounding B&W rule is that you get the best images by shooting in color. So ignore the camera's B&W mode and shoot in RAW. RAW files contain all the data from the DSLR's image sensor, but they're not yet processed in any way. They let you, not the camera, decide on brightness, contrast, and tone.

With all that original RAW color data, you can create tonal separations and make modifications such as darkening blue skies or softening skin tones. You can judge all these factors better on a color-calibrated monitor than on your camera's little LCD. See #287 to learn how to convert your color images into B&Ws.

180 PAN LIKE A PRO

Panning is the ace in the hole of many sports shooters: It foregrounds a focused subject against vibrant horizontal blur that expresses swift motion for a gripping action shot. To pan, shift the camera in sync with a moving subject while the shutter stays open.

Sounds simple, but first you must figure out a few things. One is the background: High-contrast, colorful ones produce the zippiest streaks; monochromatic backgrounds make dull blurs instead. As for subjects, it's tempting to start out at auto races or airplane shows, but first try tracking a moving object you can direct, such a friend running past a wall of graffiti. Ask her to start slowly while you learn the art of the pan.

To do that, keep panning's three key elements—subject movement, camera movement, and shutter speed—in balance as you practice. Short shutter speeds produce sharp subjects, but if your speed is too short, you can't capture sufficient motion blur. Start with 1/15 to 1/8 sec, and experiment until your pan is perfect.

Now you're off to the races—where you can't control subject speed. Start following a subject's movement a good distance before your exposure point, and pan until after the shutter closes. Be ready for action by manually prefocusing on the place you'll be aiming when you open your shutter. For motion blur that's parallel to your frame edges, bring a ball-head tripod.

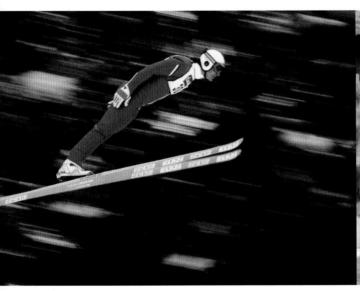

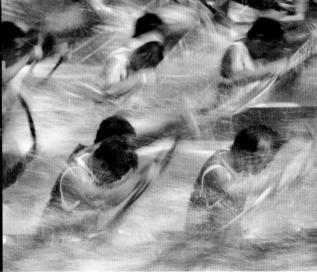

181 SHOW MOTION WITH FLASH

When you shoot flash photos with a slow shutter speed, moving subjects appear as sharp images amid blur in a phenomenon called ghosting. Useful in creating dynamic images of motion, ghosting has one glitch: Sometimes it appears in front of a subject rather than behind it. Since flash synchronization occurs at the start of an exposure, forward motion seems to travel backward, extending the blur in the wrong direction. Luckily, there's an easy remedy.

Set your flash to trailing sync (also called second-curtain sync), which fires the flash near the end of the exposure and blows ghosting out behind your subject. Experiment with 1/8- to 1/30-sec shutter speeds: The faster your subject, the longer his blur trail. Slow shutter speeds also elongate ghosts. To capture truly frenetic action, pan with your subject at a speed slightly slower than his own speed, and a streaky, smeared background will appear.

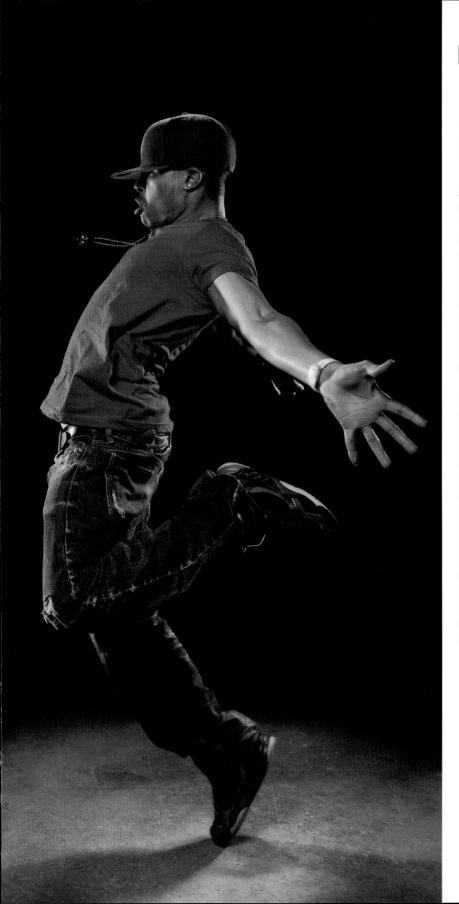

182

FREEZE MOTION WITH FLASH

Jacking up shutter speed isn't the only way to freeze action. Your flash—the built-in unit or, even better, an accessory shoe-mount unit—can do it, too. Plus, it's the go-to choice in low light (indoors or out) when you don't have the luxury of using high shutter speeds. This is the way to go for motion-stopping exposures of dance, gymnastics, and other indoor action.

The key concept here is that the lower the power you set your flash to, the briefer the duration—accessory units can fire at 1/50,000 sec or even faster. To get the fastest possible flash bursts, turn up your ISO as far as you think reasonable, and position your flash as close as possible to your subject—a remote trigger with an offcamera flash will permit you to do this. If you have sufficient space and time (and, of course, permission), set up a multi-flash arrangement for more threedimensional lighting.

I've been through Chicago's
O'Hare Airport many times,
and I'm always amazed by the
lights in this tunnel. I wanted to
photograph it on a recent stopover
with my fiancée, though we had
only 30 minutes between flights.
So I put my camera on a little
tripod, stepped onto the moving
walkway, set my camera for a
10-sec exposure, and shot
the scene in one go.

-BYRON YU

183

MAKE POETRY WITH MOTION

Rolling along a moving walkway, Byron Yu used a tripod-mounted DSLR and a leisurely exposure—10 sec at f/4, ISO 100—to capture this kinetic neon ceiling sculpture and blur its lights into dynamic, converging diagonals.

Follow these rules to get great long exposures: Turn down ISO, since high ISOs generate more noise in your images. Select a small aperture to capture light trails—an f-stop as high as f/22 allows scant light to strike your sensor but still catches plenty of detailed motion. And for long exposures in daylight, bring a variable neutral-density filter, which you can set in stops to cut light entering the lens and enable longer shutter opening.

184 EXTEND EXPOSURE IN ACTION SHOTS

A long, carefully planned exposure is the key to this atypical photo of Boston Marathon runners—and the water cups left in their wake. Photographer Laura Barisonzi captured it with a 10-stop neutral-density (ND) filter that cut light and lengthened exposure time—a departure from the crisp shot of peak action that's typical of sports photography. To take your own unusual shot of an athletic event, follow these steps:

STEP ONE Plan a few creative images that focus on background (or in this case, foreground) as much as on the athletes. To get this shot, the photographer set up at a heavily used water stop, since that guaranteed there'd be a colorful array of discarded cups.

STEP TWO Gather gear. Since you'll need a generous shutter speed for this shot, use an ND filter and a tripod. Compose and focus before adding the filter.

STEP THREE Prep the site. For instance, the photographer rearranged these cups into an interesting pattern before she started shooting.

STEP FOUR Find the angle. To catch the foreground that's all-important to a photo like this, you'll have to lie down flat on the asphalt.

STEP FIVE Experiment with exposure. In this instance, holding the shutter open for 4 secs produced the dramatic line of runners, smudged but still recognizable.

185 BEAT MIRROR SHAKE

Even if it's on a tripod, your DSLR can shake due to "mirror slap": the vibration produced when the camera's mirror flips up and down. Another source of possible shake is your hand on the camera as you trip the shutter. You can lock up the mirror to fix the first problem, and fire with a remote or the self-timer to solve the second, but there's another solution. Most DSLRs feature a combined control with both mirror lockup and a two-second delayed release. You'll find it in the self-timer menu or drive-mode selection. The tool works without a tripod, too: Rest the camera or your elbows on a sturdy surface, and hold the camera firmly against your face. Breathe in, trip the shutter, and stay very still until the mirror drops down again.

186 MAKE PEOPLE DISAPPEAR

It doesn't require a magic wand. All you need to make crowds vanish from congested landmarks and landscapes is a long exposure time and an overall ND filter: an often inexpensive, gray-tinted accessory that cuts light while preserving a scene's color. Your exposure must be long enough that anyone in the frame blurs completely away—which could take anywhere from 30 sec to several minutes—so you'll definitely need to use a tripod.

Set the smallest aperture (i.e., the largest f-number) that you can. Each 0.3 of density eats up 1 exposure stop, and each stop doubles exposure time. So, if a scene's correct exposure without an ND filter is 1 sec, a 3-stop reduction in light lets you shoot at 8 sec. Manufacturers make ND filters up to a staggering 3.0 density. That's 10 stops, which expands a 1-sec exposure to 17-plus minutes. Compose and focus with the filter off the lens, take a meter reading, and double exposure time for every stop of light your ND filter will gobble up.

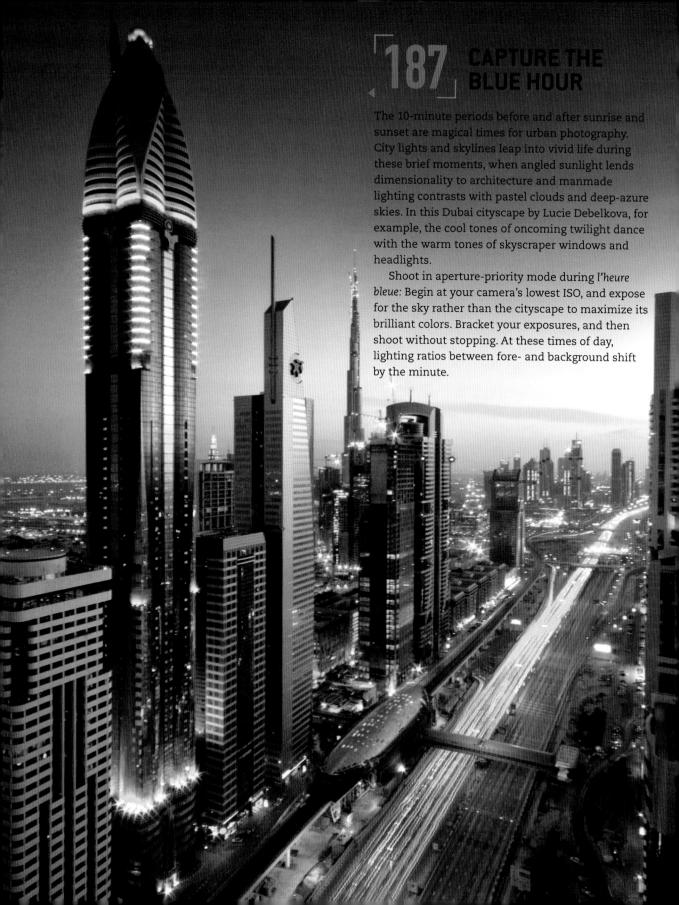

188

FAKE MOTION

Motion zoom—which means zooming in or out during an exposure—creates bright, colorful streaks that rush inward toward a vanishing point. This effect can be either cool or cheesy, so boost your odds with a few sure strategies.

Pick brightly hued and contrasty subjects (holiday lights are always a sure bet). Deepen the scene's natural colors by setting your DSLR to its top saturation level. Experiment with both long and short shutter speeds, too. Speeds of 1 sec or longer let you use the whole zoom range, and that produces brilliant abstracts that lack clearly identifiable subjects. Speeds under 1 sec preserve the subject but halo it in dreamy rays of color. Aperture is another motion-faking technique small apertures generate narrow streaks, and large ones create broad smears. Structure can also produce an impression of motion: If you want straight streaks and physically powerful structure, bring a tripod. If you desire some creative chaos, handhold your camera. Shift it up, down, left, and right as you zoom. To shape your image into a vortex, twist the camera around as you work.

CHECKLIST

189 FACTOR IN BLUR

"Is the picture crisp?" "How sharp is that lens?" Photographers ask such questions all the time. But remember the alluring flip side of sharpness: softness, which is the perfect treatment for many subjects and moods. Apply blur to areas of your image—or brush it across the whole thing—with one of these methods:

- ☐ **MOVE THE CAMERA.** Shift it at slow shutter speeds to produce blur in scenes with contrasting tonalities.
- MOVE THE SUBJECT. Shooting a moving subject produces motion blur with long shutter speeds of 1/25 sec or more. This tactic charges your image with kinetic energy.
- MOVE BOTH. Pan the camera in the direction opposite subject movement to produce a pure abstraction. Pan it in sync with subject motion to capture a sharp subject against a soft, blurred background.
- ☐ CHANGE ZOOM SETTING. Zooming during exposure produces fascinating kaleidoscopic effects that work beautifully with colorful, high-contrast scenes.
- □ USE SOFT-FOCUS FILTERS. Whether they're glass or digital, filters let you decide where and how much image softening you'll apply.

190 SHOOT WITH OUT-OF-DATE FILM

So you're cleaning the attic and discover rolls of unexposed film marked with ancient "use-by" dates. Don't toss them out—instead, use those antiques to create breathtaking nostalgic shots.

Photographer Chuck Miller used a roll of Kodak Super-XX 120 high-speed panchromatic film—which expired in May 1959—in a Rolleiflex to get the image above. The film's lightproofing was too weak to keep ambient light and radiation seepage out of the film wrapping over the decades, so light leaks painted on intense fogging and vignetting before any photos were shot. Those effects imitate the natural aging process of an old print, but here the film is aged, not the paper. Shots on old film resemble lomography (see #154), and there's a satisfying randomness to old-film shots that digital retro-photo applications can't quite capture.

SHOOT WITH A FILM CAMERA

If you've been shooting with a DSLR and would like to try (or get back to) the film experience, there are many options available. Recent and current film SLRs have autofocus, autoexposure, autowind and rewind, and auto setting of ISO—everything a DSLR has, except the instant gratification of seeing your photos on the spot.

On the spectrum's other end are vintage and modern-classic film cameras that are strictly manual focus and exposure. Try one (whether new or a usedmarket find) for the experience of making all settings yourself, rather than leaving it to an electronic brain.

Start with color-print films, which give the most leeway and are forgiving of errors of up to several stops. They also allow you to scan them to a digital file

that you can share, edit, and print. B&W films give good latitude, too, while color-slide (or reversal) films offer the least latitude, but capture crystal-sharp images and rich saturation. Frame carefully, and pay attention to depth of field—there's no LCD to check your work after the shot.

192

MANUALLY FOCUS YOUR CAMERA

Virtually all digital cameras, and many film cameras, sport autofocus. But when you're shooting some subjects—such as dark ones in low light—manual focus is your friend.

Many film SLRs, and a few digital SLRs, have split-image focusing that breaks your viewfinder's image in half. You adjust the focus until the two halves line up perfectly. Most DSLR focusing screens today have matte screens; with these, shift the focus until the image looks sharpest. But don't do it slowly-instead, quickly turn the lens's focusing ring until you are roughly in focus, then slow down to make it sharp. Practice helps, as does diopter correction. The latter is correction adjustable to suit your eyesight; it allows eyeglass wearers to shoot without their specs. Look through the viewfinder and adjust the diopter (a small knurled wheel adjacent to the viewfinder eyepiece) until f-stop settings and other text in the finder are sharpest.

193 USE OLD LENSES ON YOUR DSLR

Got old film-camera lenses but a new digital SLR? If they're the same brand, the old lenses will likely fit on the digital camera. Depending on their age, they may not have full functionality, such as autofocus. Different brand of lenses? Try to find an adapter, but shoot in all-manual mode if your DSLR can't "talk" to your lens.

QUICK TIP

194 ADD YOUR FILTERS

Once you've picked a lens, fine-tune its effect with filters and other add-ons. Filters screw or clamp on to the lens front so you can alter color, exposure, and other elements. Other task-specific accessories fit between the camera body and lens to add effects such as magnification.

POLARIZING

Perfect for forest, sea, and sky shots, this option cuts glare and reflections and deepens greens and blues.

A polarizing filter helps you capture the true hues of brilliant foliage and sunny days.

TELECONVERTER

This secondary lens, mounted between camera and lens, extends focal length.

UV

This filter blocks ultraviolet sunlight and protects the lens front from scratches without affecting images.

INFRARED

This intriguing option blocks visible light and passes only subspectrum light to create dreamlike, eerie images.

REVERSING RING

Use this ring to mount your lens to the camera backward so you can magnify without a macro lens.

FILTERS AND HOLDER

Interchangeable special-effects filters fit into a single adjustable holder so you can use them with all sorts of lenses.

GEAR GALLERY

NEUTRAL DENSITY (ND)

This filter cuts the light passing through your lens to allow you slow shutter speeds or wide apertures.

A basic tool of landscape photography, light-limiting ND filters are available in many different densities.

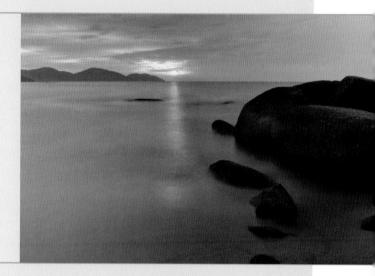

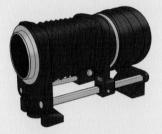

MACRO BELLOWS

This system allows intense and precise magnification even without a dedicated macro lens.

SPLIT NEUTRAL DENSITY

This handy filter applies the ND's effect to just half the image to balance a scene's light and dark areas.

A split ND filter is the ideal tool when foreground and background need different exposures.

LENS HOOD

Attach this crucial accessory to the front of the lens to shield it from light and thwart glare and lens flare.

EXTENSION TUBE

This tube sits between the lens and the camera body, increasing magnification for close-up shots.

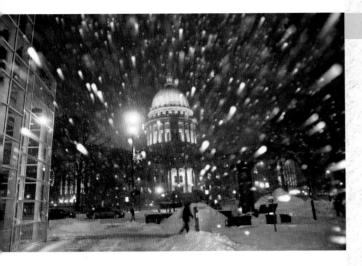

195 CATCH A FALLING SNOWFLAKE

Landscape photographers relish the gifts that snowstorms bring. They reduce visual clutter, hiding rocks and dirt. They isolate foreground subjects such as bare trees. Their wetness intensifies natural colors, and their flat light enables DSLRs to capture a full tonal range. Plus, nearly everyone else is hibernating indoors, so new snow is your own private canvas.

Midwinter yields the most snow and thus the most abstract, simplified shots. But "shoulder seasons" offer treats, too. Autumn snow contrasts beautifully with changing leaves, and spring snowfall with emerging buds and flowers. Whenever you venture out, use weather-sealed cameras and lenses, a lens hood, and a UV or skylight filter—and take an umbrella to protect your setup. Bring a wide-angle lens for shots with few visible snowflakes or a long lens to capture more of them, casting a lacy veil over your scene.

When snowflakes are falling, use slow shutter speeds to turn them into fanciful streaks, or quick ones—say, 1/250 to 1/500 sec—to freeze them in midair. Underexposed snow is a constant bugbear: See #196 for tips on avoiding it. And once you're indoors, you can expand any grayedout shots' tonal range by using Photoshop's Curves, Brightness/Contrast, or Levels tools (see #290, #291, and #293).

196 KEEP SNOW WHITE

It's a sad, familiar story: You spot a pristine snow scene and shoot it, only to discover later that your sparkling snow has turned into gray sand. The culprit: your light meter. It seeks medium gray and always underexposes snow. (The same problem occurs when you shoot pale beach sand.) Here are five tricks to solve the problem.

- ☐ **METER THE SNOW.** Then manually set exposure 1.5 to 2 stops brighter than its reading.
- ☐ **CHOOSE YOUR STOPS.** Set your exposure-compensation feature at +1.5 to +2 stops, and then lock it.
- ☐ FIND SOMETHING NEUTRAL. Aim at a midtoned rock or gray card and lock the exposure.
- CONSULT YOUR DSLR'S HISTOGRAM. If there's no gap between the image tones and pure white, your snowscape will blow out into blank white.
- □ REMEMBER THE CLASSIC "SUNNY 16" RULE. On bright days, at f/16, set your shutter speed to 1/ISO. Moderately overcast? Increase this exposure by 1 stop. Heavy clouds? Increase by 2 stops. In shade, go up by 3 full stops.

197 FIND NICE ICE

Ice is everywhere in winter. The trick is to find photogenic stuff, which can mean venturing off the beaten path. Waterfalls, streams, and frozen cliff seeps—often vividly hued by minerals in the rock—make ideal subjects. And look out for the sculptures ice crystals make of branches and rocks. When shooting

on open ice, search out naturally strong lines, such as the deep crack here, to lend structure to your composition. Shoot ice in the glowing backlight of dawn or dusk if you can. Pack along common sense: Check local forecasts, bring a friend, and don't venture out on ice less than 5 inches (12.5 cm) thick.

198

MAKE THE MOST OF FOG

Some landscape photographers who prize sharpness and saturated color pack up and head home when fog rolls in. They miss a lot.

Atmospheric conditions in which water droplets such as mist (or dry particles such as dust) are suspended in midair can conjure up mysterious, nuanced shots. Fog also provides an exaggerated sense of depth, since it looks darker as it recedes into the distance, accentuating a scene's dimensionality.

Low-contrast fog-blanketed landscapes are also easier to work with than those in strong sun because they diffuse light in pleasant ways. Plus, you can easily tweak shadows and midtones to find the right look for your fogscape. Finally, mist lends body and substance to light beams streaming through trees and clouds. Those diagonal beams, invisible in bright light, take on shape and, seemingly, life when shot in fog.

199 CAPTURE MIST IN B&W

Fog photos often reveal their deepest drama in black and white. Just remember: For best results, shoot in RAW color, then convert your image in software afterward (see #287).

200 FIND FOG

You're eager to make misty magic, but where's a fog bank when you need one? Cold-water coastal areas are your best bet. Here's the science bit: Salt particles from breaking waves form nuclei that attract tiny water droplets. When those build up, especially when hot inland weather coincides with a cold ocean current, thick sea fog will shroud vast stretches of coastline. Inland valleys at night—and virtually any place enjoying a chilly morning after nighttime rainfall—are also prime fog-stalking grounds.

201 KEEP DRY IN THE DAMP

When you're deep in the mist, you need a moisture-sealed camera and lenses. And in truly thick fogs, condensation and drizzle are threats to the quality of your shots and the safety of your gear, so bring a plastic bag to shield the camera, an umbrella (and someone to hold it) to keep moisture off your rig, and a dry rag to wipe down everything both during and after the session.

On the plus side, there's definitely some gear that you can leave at home—fog frees you from the filters, including polarizers, that are an essential piece of equipment in almost every other kind of landscape photography.

202 MASTER THE MIST

Shooting a foggy scene can be tricky, so take these steps to capture misty majesty.

STEP ONE Select a strong subject. Fog dilutes color and masks shape. So only a defined subject, such as an isolated, emphatically contoured tree, can withstand that softening.

STEP TWO Get in close. The farther your subject is from the camera, the less impact it has, thanks to fog's blurring effect.

STEP THREE Avoid underexposure. Fog casts reflections, leading your meter to think that more light is available than is actually present. This can mean underexposure—photos that look like dingy gray smoke. To compensate, increase exposure above your camera's recommendation. If you have an exposure-compensation dial, add an extra stop with +1.

STEP FOUR Go long. A long focal length enhances fog's effect, compressing mist and subjects so detail blurs away.

203 GO SHOOTING IN THE RAIN

Shooting during rainfall opens up creative doors that are locked tight in drier times. So venture into the wet to capture thunderstorms in the woods and reflections in urban puddles. Because mist and water droplets scatter light, rainscapes can be pleasingly pastel and soft-focus. Or, if you want to make bright colors really sing, shoot wet surfaces with a polarizing lens.

Remarkable light shows are another stormy gift, especially when the sun nears the horizon and paints clouds' undersides in Technicolor. If you're really lucky, you may even encounter a rainbow—a pot of gold to reward any soggy photographer.

204 CHASE RAINDROPS

Rain splashing into puddles lets you freeze water in motion, so play with shutter speed for varied looks. To record droplets as streaks, shoot against a dark background with the shutter set to about 1/30 sec, depending on lens focal length. (The longer the shutter speed, the longer the streak.) To home in on the drops themselves, take some macro close-ups at a shutter speed of 1/500 sec. Drops clinging to surfaces add glistening highlights to any subject.

205 CREATE YOUR OWN WEATHER

Hollywood cameramen call it the "wet down": soaking streets so that exterior shoots thrum with sheen and tonal life. When dry, asphalt is a wan gray, but wet it and you get a glistening black adorned with iridescent oil smears. Thanks to the visual drama of streetlamps and headlights, night is the classic time for a wet down, but the angled light of sunrise and sunset will lend your wet shots diffuse yet dramatic illumination.

Pros use water trucks to soak scenes, but an ordinary garden hose gives you the wet look, too. Soak a section of your street (tell the neighbors first!) to create reflections. You can also fake rainfall or mist as you shoot by getting an assistant to set a hose to spray in a wide fan, then aim it high above the scene.

206 HACK A RAIN HOOD

Costly rain gear—watertight yet breathable Gore-Tex rain sleeves, moisture-proof hard gear cases, even underwater housings—can keep your camera dry. But if you're caught without it, there are some cheap and cheerful ways to ward off raindrops, too.

Cut a hole large enough to fit snugly around your camera lens into the bottom of a clear plastic bag, then use a rubber band or gaffer's tape to make sure the seal is tight enough to keep out errant drops. Snip two more holes in the bag's sides to thread your camera strap through. Put your hands in through the open end of the bag to manipulate camera controls as you shoot.

Clear, elasticized shower caps are also decent gear covers. When you're shooting on vacation, you can pick them up for free in hotel rooms.

207 TACKLE SURF SAFELY

Wherever you find an awesome beach, you can get good distant surf shots from shore. But to get killer photos of towering waves, you must dive in. The greatest wave photographers carefully study their favorite breaks—sometimes for years. They scrutinize weather and surf reports to learn what's breaking where and how big it will be. To grab in-the-barrel shots without risking life and limb, take safety seriously. Start small if you're a surf novice—invest in a few lessons on the board, sans camera—and practice holding your body parallel to the tube when a wave breaks so you'll roll like a ball tumbling downhill. If you wind up perpendicular to the tube, the wave could hammer you end over end. Never let a wave break on top of you, and remember that practice makes perfect: Surf shots in the tube require you to be almost as good a surfer as your subject.

208

BRUSH UP ON SEA SHOOTING BASICS

In surf, shoot wide, fast, and constantly. A fisheye lens enhances the drama of breakers and barrels. Use your fastest shutter speed for the lowest ISO possible, expose in shutter priority, and shoot in continuous mode.

To freeze waves, set the shutter to at least 1/250 sec. For soft effects, go longer than 1 sec. Hold your camera close to the surface to enhance waves. And in big surf, do presets onshore so you don't have to fiddle with settings amid walls of water.

209 SOFTEN SURF

Opening up the shutter while shooting surf adds a painterly quality to seaside shots. Use a tripod and set shutter speed to 1 or 2 secs, with the aperture on the high side of the numeric scale. Use your camera's self-timer to minimize camera shake. Check results as you go, and experiment with settings so you can capture an artful blur that evokes the power and beauty of water on the move.

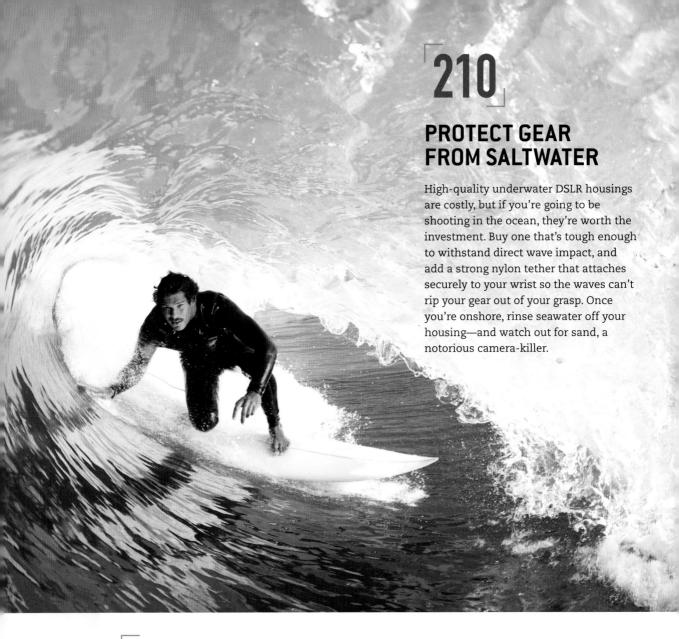

211 PLAY WITH TINY WAVES

A 30-foot (9-m) monster breaker is an inherently impressive thing—even a photographer with sloppy technique can make an awe-inspiring image from such a beast. But with the right tricks up your sleeve, you don't have to tangle with skyscraper waves to shoot imposing surf. A 6-inch (15-cm) breaker can do the job, too.

Search out sandbars or other natural rises where small waves break. Get as close as you can and extend your arm and camera into the waves' minibarrels as they crest and roll. A fisheye lens and low sunlight will amp the wee breaker's effect and, as with any wave, high-speed continuous shooting is the best choice. The result: a shot that evokes gnarly surf even if you snapped it close to the beach on the calmest day of summer.

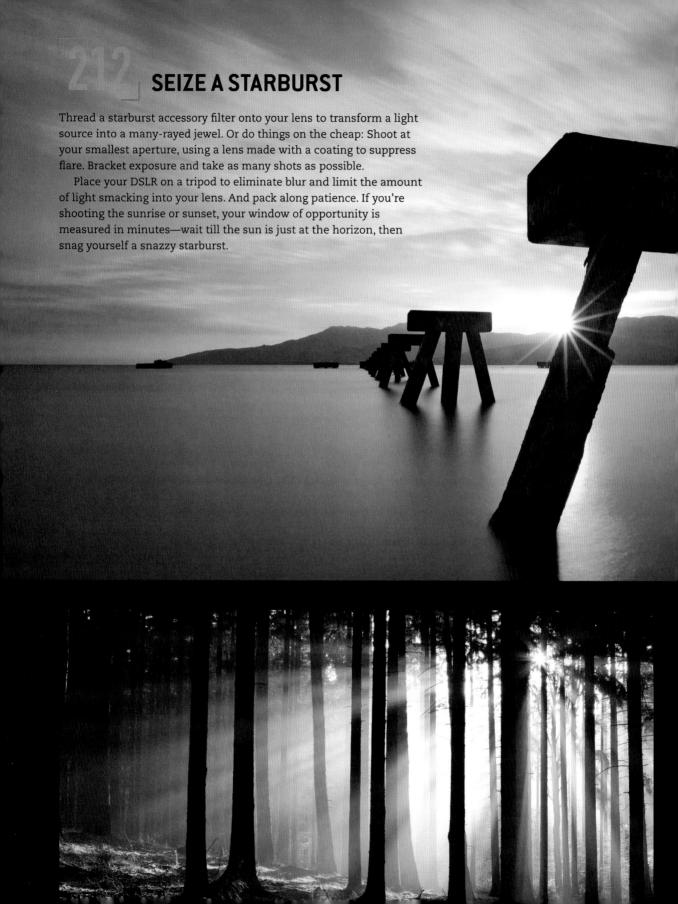

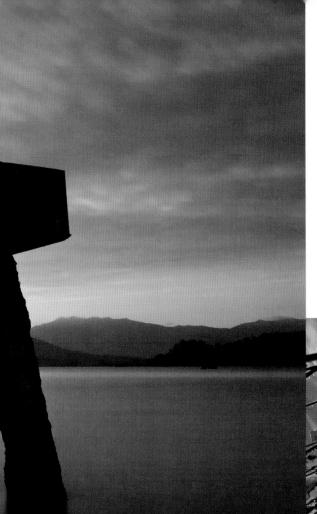

213 SHOOT INTO THE SUN

Using your camera's autoexposure with glaring sun in the frame leads to gross underexposure. So for starters, switch to manual. Then, with an aperture of f/16, set shutter speed to twice the ISO speed of your film. Then bracket, bracket, bracket. And remember, there's no single correct exposure for every shot. Try out a few exposures to find the one that appeals to you—and remember, you can produce high dynamic-range (HDR) composites in the editing stage using imaging software (see #312).

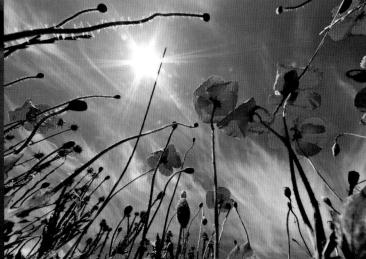

214 GRAB A "GOD RAY"

These ethereal light beams arrowing through clouds or treetops are also called crepuscular rays. Whichever term you favor, timing is all: Shoot in early A.M. or late afternoon, preferably when a storm is brewing or breaking. Fog, too, can produce romantic beams. Expose properly for the beams and check the histogram to ensure highlights aren't clipped. (Clipped areas are blown-out patches of maximum brightness.) If they are, dial down exposure compensation.

215 OUTRUN GHOSTS

Shooting in dazzling sunlight? Watch out for ghosts. Not unquiet spirits, but single or multiple phantom images, usually of the lens diaphragm itself.

Modern lenses' multicoating helps control ghosts and flare, especially if you choose your lens carefully. Single-focal-length lenses are best, but some modern zoom lenses ghostbust effectively, too. Don't want to buy a new lens? Hide part of the sun's disc behind a foreground boulder, tree, or, in the cold glare of winter, an intriguing ice formation.

Photographer Peter Kolonia found much to fascinate his eye—and his camera—at New York's Metropolitan Museum of Art. Because the museum, like many others, doesn't allow flashes or tripods, he fired up his camera's image-stabilization feature. It allowed him to sharply capture these Roman busts with a handheld exposure of 1/13 sec at f/5.6, ISO 400, and a 14–42mm f/3.5–5.6 kit lens, zoomed to 42mm (84mm full-frame equivalent).

216

MAKE ART OUT OF ART

Although they offer a trove of compelling subjects, museums pose logistical problems. Many allow photography—stop at the info desks to check rules—but flashes (which damage canvases) and tripods are usually verboten.

To cope with low light, use slow shutter speeds or high ISO settings. Image stabilization is handy, or just lean against a wall. To avoid reflections from glass-enclosed pieces, set your lens against the display case, if that's allowed.

Let the artwork spark your own creativity. Seek fresh angles on paintings or sculptures by focusing on details. Or shoot museums themselves, making their soaring architecture and dramatic settings your photographic playground.

217 CAPTURE THE CITY'S BUSTLE

Capturing the spirit of a metropolis—with its flashing lights, not to mention the endlessly moving people and vehicles—is an invigorating challenge. Tack-sharp photos that freeze the moment do the trick, but you can also paint impressionistic masterpieces by playing with the speed, light, and space that are the essence of a city.

Stalk your location and know the light. Sunrise and sunset are reliable standbys for fetching blends of ambient and artificial light, and storms add drama to cityscapes, too. Seek out motion wherever people rush in or out of structures (train stations are a good bet). Stay low-key with a handheld camera, and shoot slow and low to capture crowds' movement. Bracket exposures from about 1/30 to 1/8 sec to find the right balance between form and focus. Low ISOs need more light for exposure and enable long shutter speeds. Focus on each interesting figure who passes through your center autofocus point and keep snapping.

218 SHOOT A STRANGER

To ramp up your portraiture game, ask a stranger to pose. Some will say no, but a surprising number will agree, especially if you're polite. Talk to people before you take out a camera, and explain what you'll do with the photos.

Shoot in auto mode first, then finesse exposure as a comfortable rapport grows. People relax as they get used to the shutter's click, letting you capture character rather than wariness. Experiment with accessories, such as wireless lighting gear, remote triggers, and perhaps a cheerful, talkative assistant to hold strobes and extra gear.

MOBILE TIP

219

SNEAK A SMARTPHONE SNAP

Too shy to ask strangers for a shot? Choose a subject, switch on your smartphone's camera, and pretend you're deep in conversation on your phone as you aim, frame, and fire. The trick is especially easy where subjects are seated, such as restaurants, bars, and subways.

220 SNAP A CANDID

Whether you're an aspiring paparazzo or just grabbing unguarded moments among passersby, try the tricks that celebrity photographers use. Catch people by surprise by avoiding the viewfinder and prefocusing a 28 to 35mm lens at 8 feet (2.4 m) and firing away. Compose after the action—crop in postproduction. Pros often shoot at f/8 to f/11, settings that deliver sharpness with any lens. Use with a high ISO for a midrange aperture and fast shutter speed. Look for naturally illuminating pale ceilings or walls to avoid the scared-rabbit expression that direct flash produces. Finally, experiment with black-and-white for a spontaneous, graphic mood reminiscent of old newshound candids.

221 USE WET-WEATHER REFLECTORS

When you're photographing in snow or rain—or around water in any form—non-electrical reflectors are the best, safest, and sometimes the only lighting tool you'll want to have on hand. Battery packs can short out in the damp, and light stands and artificial light sources are a lot of trouble in nasty weather, even with a willing assistant.

Craft your own reflector from foam or poster board (for an example, see #048). Or turn on your creative faculties and search out objects onsite that can serve as ready-made reflectors. For instance, a pale-colored wall or smooth, brilliantly reflective ice on a pond can bounce light onto your subject almost as well as high-priced gear can.

simple complex

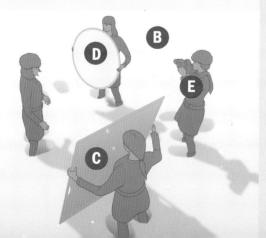

222

SHOOT IN SNOW LIGHT

Like any other art, great lighting doesn't call attention to itself. But it makes all the difference, as demonstrated by the seemingly effortless beauty of this wintertime portrait. It was achieved through a simple yet clever combination of reflectors and ambient light sources. You can work similar magic by following the four-stage setup used by Buffalo, New York, photographer Rhea Anna.

She did not want to lug extra gear such as stands or artificial lights across the knee-deep snow of the farm pasture where she staged this portrait. So instead she used the overcast sky itself (A) as her primary light source. It provided a softbox-like light—large, bright, and very diffuse. The freshly fallen snow (B) served as another broad panel of light. It radiated gentle fill light from below, illuminating the model's lower face and canceling out the shadows that otherwise would be cast by her browbones, nose, chin, and hat.

Then Anna employed two cheap, portable reflectors to really make her subject glow. To add punch and directionality to the dispersed natural light of sky and snow, one assistant held up a 3½-by-6-foot (1-by-1.8-m) white reflector (C) to the model's right. And to balance the inherently blue, chilly tones of snow light, a second helper held a 2¾-foot (82-cm) soft, nonmetallic gold reflector disc (D) to the model's left, which goosed up the subject's strawberry-blond hair for a nice counterpoint of color. Exposing at 1/60 sec at f/2.8, with an ISO of 100, Anna handheld her camera (E) and shot. The model's face and hair dramatically contrasted with the cool background: a no-muss, no-fuss picture of wintry perfection.

The best thing about that setup? The non-electrical reflectors were easy to use. "We had an ambitious shot list that day," Anna says. "I handed my assistant and stylist each a reflector, and in less than 15 minutes, we were done and on to the next shot."

223 SMOOTH OUT SKIN

Problem skin doesn't require postprocessing labor in order to create a flattering portrait. As a matter of fact, you can fix most issues while you're shooting.

Lighting is essential. Fill lights cut down on unflattering shadows—don't exceed a 1:2 ratio between fill and main lights. Zap zits, scars, and wrinkles by positioning your main and fill lights just above your camera—one to its left, one to its right. Avoid side fill, which tends to "moonscape" a bumpy complexion. With older subjects, keeping lights at eye level will minimize crow's feet, laugh lines, and other hallmarks of age.

A pleasantly neutral but nonsmiling expression usually works best, and a subtle soft-focus filter will flatter any model, old or young. Overexposure can be your friend, so don't be afraid to push the histogram far to the right (see #151).

224 SLIM DOWN A MODEL

Be they heavy or wispy, all photographic subjects benefit from the defined silhouette that comes with perfect posture. When you shoot at full length, ask your model to turn slightly toward your camera and place most of her weight on one leg. This technique, called contrapposto, animates her posture and makes her seem slimmer by twisting her waist and hips. Fine-tune her stance by asking her to draw back her shoulders and lift her head and chest to elongate her frame. And maintain some space between her arms and torso so her form remains well defined.

Any face can sprout multiple chins if you shoot it from the wrong angle. To avoid that, photograph from slightly above face level, and ask the subject to lift her chin while looking up at your lens. Lights set as high as possible firm jawlines further by casting contrasting shadows beneath the chin.

225 SCULPT A FACE

A clever lighting angle is a sure way to shape a face in a head-and-shoulder portrait. Several tactics are possible: Lift your camera to the model's eye level, and light his face exclusively so that his neck and body fade into shadow. Or set your main light at a 45-degree angle to your subject's face and turn him slightly into the light. His most prominent features—cheekbones, browbones, nose bridge—will be highlighted, but fleshier parts—such as lower cheeks—will darken as the light falls off. To downplay a feature such as a large nose, direct your subject's gaze straight into the lens and light his face so that his nose casts no shadow.

226 FLATTER WITH COLOR

Shoot against a background that will complement your model's eye, hair, and skin tones. To slim a subject and produce a cleanly defined photo, have her wear a single dark color from head to toe, then photograph her against a backdrop of the same hue.

PACK AWAY EYE BAGS

Most of us have them, even when we've gotten plenty of sleep. To hide them in a facial portrait, use only front lighting, set at eye level. Slightly lift your camera and encourage your model to turn her eyes up toward the lens while keeping her chin down. Men, women, and even kids all benefit from a little bit of concealing foundation makeup dabbed under the eyes.

228 CATCH A FAMILY CANDID

It's easy for you to love photos of your loved ones; it's far more challenging to craft ones that others love, too. Those prime specimens tend to be candid shots that are taken on the fly with minimal gear—the best way to capture your family's personalities, moods, and interactions.

Sure, you'll have to fire off more frames to get a keeper than you would when shooting a posed portrait. But then again, the more you shoot, the more relaxed people will feel. Blend into the background at family events, be patient, and wait for moments when subjects aren't paying attention to you.

229 USE FAST LENSES FOR FAMILY

Fast glass is just the thing to capture your family at their unposed best. Prime lenses are ideal for natural light, and they're smaller than high-speed zooms. That means they're less intimidating, especially to little kids, and help you blend into the scene.

As for focal lengths, go wide—getting up close with a 35mm or wider lens ensures your dear ones will dominate the frame for the right intimate mood. Wide-angle lenses also let you layer background, midground, and foreground in intriguing ways—plus they're the best option for the speedy, from-the-hip shooting that generates the sweetest family images.

230 STAGE MANAGE YOUR CREW

While you don't want to pose people, a bit of staging is helpful. Search out your home's best light and coax your family into it (declutter those spots beforehand). It's also okay to make wardrobe suggestions. When everyone is dressed in similar or unified tones, shots look more coherent. If your framing captures lots of background, make sure it includes objects that say something about your relatives' character and personal stories. Build trust by occasionally showing off particularly nice shots on your LCD, and encourage connections by getting subjects to talk and touch. You'll get vivid interaction rather than nervous grins.

231 LIGHT YOUR KIN RIGHT

Keep lighting soft. Direct flash rarely works because it startles babies and reminds everyone that they're being photographed, thwarting the warmth, spontaneity, and ease that characterize good family photos. Instead, seek out diffuse window light or the angled, warm-toned rays of the setting sun. If you use any light gear, choose an unobtrusive large white reflector, which flatters older subjects by smoothing out wrinkles and adds a bit of glow to everyone's complexion.

QUICK TIP

TRY POSING PRIMERS

Models and shooters alike can be hit with posing block: Your subject wants some direction, but you're drawing a blank. The cure: Find about a dozen photos of pleasing poses, convert them to JPEGs, and add them to the memory card where you save your images. Refer to this cheat sheet via your camera's grid-view image playback. Share the poses with your subject and aim for ones you both like.

233 CATCH THE BAND OFFSTAGE

Shooting rock acts is a photographer's dream—performers hold still so you can work without the anarchy of a concert. To give subjects a commanding presence, have them pose with feet and shoulders squared off, leaving some space among them so they retain individuality but still cohere as a band. To make them look larger than life, crouch to shoot from their waist height, and keep the imaging plane parallel to your subjects. Backlighting separates figures from dark backgrounds and creates foreground shadows that can turn even Mick Jagger into a towering monolith. Bare bulbs or grids work well, especially if you hang them high and aim them down at the musicians. They'll look even taller and cooler than they do onstage.

234 SHOOT A DRESS REHEARSAL

Want to capture your kid singing and dancing her heart out in a recital or play? Ask if you can shoot at a dress rehearsal, not a performance, so you can move around the theater or backstage without disturbing an audience. Rehearsals also give you time to compose the best shots.

235 MAKE THE MOST OF BURST

Burst shooting captures action that occurs so swiftly it's tough to freeze. Start and end your burst as quickly before and after the action as possible to ensure there's enough room in your camera buffer should you need to shoot again before it has cleared. You'll get more shots per burst by shooting JPEGs rather than RAW, and more still by reducing JPEG quality (increasing compression) or the number of pixels you capture. Many DSLRs let you select burst speed. When shooting repetitive motion, such as jump-rope, set a burst rate slower than the camera's maximum to avoid grabbing almost identical shots.

237 PICTURE LIVE PERFORMANCE

A few essential rules win you great shots of live performance, whether it's a rock concert or your kid's football game. First, switch off flash. Venues usually forbid it, and flash will illuminate the heads of people in front of you, distracting from your true subject: the onstage or on-field action. Theater and stadium lighting is often mixed or dim, so use fast lenses and a camera that performs well at high ISOs, with the aperture wide open. Avoid auto white balance (WB), because changing lights can radically shift your camera's interpretation of the scene and produce inconsistent color. Set WB to Tungsten instead. To freeze action, set a fast shutter speed of at least 1/125 sec (and an ISO of 800 or 600 to allow that speed). If dim light forces you to shoot more slowly, time your shutter releases to the natural lulls between your subjects' movements.

236 GET IN THE GAME WITH BASIC GEAR

Shooting fast-paced sports is simple when you don't haul along much besides the camera itself. A small digicam is your best bet: Unless you're press, you can't pass the gates with a big telephoto bazooka mounted to a pro-level DSLR. Many small compact cameras have super-fast burst modes, image stabilization, good high-ISO performance, and great zoom options. Some are even water- (and beer-) proof.

Turn off the flash, set the camera to aperture priority with a wide aperture, crank up the ISO, and let the digicam do the rest. If your images look too dark, push the exposure value setting up to +2/3 or so. Too hot? Dial back to -2/3. And enjoy touchdowns rather than trying to snag them: Quiet moments reveal the spirit of a game—and they're a lot easier to compose.

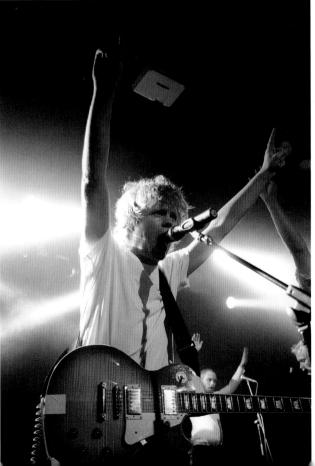

I took this during my first wedding shoot, right before the bride was about to leave the dressing area and walk down the aisle. This photo was totally unposed; I was photographing her bridesmaids when I saw the bride turning to her mirror. I focused on her just in time to capture the small, self-assuring smile that flickered across her mouth in the last moments before taking her vows.

-IEFFREY LING

SPOTLIGHT TRUE EMOTION

Although beautifully composed and posed portraits are key components of any wedding album, the images viewers linger over are often candids that showcase memorable exchanges and the implied narrative of the couple's love: unscripted kisses, misbehaving ringbearers, and quiet embraces are wedding-photography classics for good reason.

How to capture them? Think of yourself as one part friend, one part photojournalist. Show up early to chat with the couple to establish trust and an informal mood. During preceremony formal portraits, occasionally pull the couple aside to relax them and capture tender or silly interaction. Later, during the vows and reception, remain unobtrusive: Shoot quickly with a handheld camera and avoid moodbreaking flash whenever possible, relying instead on fast lenses so you can use available light. Follow the action and focus on the flow of unplanned moments that come together to compose an intimate story of a couple on a very special day.

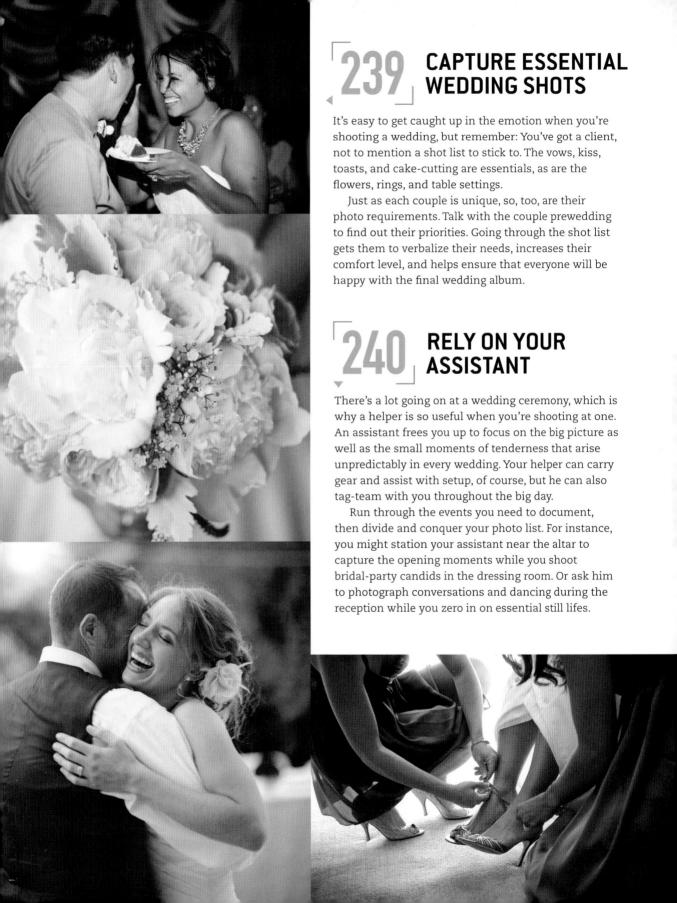

FOLLOW THE FIVE-SECOND RULE

Exposures of five seconds create unique effects—water morphs into mysterious mist and meadows transform into swirling abstracts. That exposure zone "paints" blur onto a photo's sharp canvas, keeping enough of moving subjects' outlines to create dreamlike effects. Five seconds, a tripod, and a polarizing filter on a 28–105mm f/3.5–4.5 lens are all it took for shooter Greg Tucker to capture the streak-and-swirl patterns of these camellia blossoms amid autumn leaves.

The five-second rule works with just about any camera; try it for yourself. Slow and steady gets you the best shot, so brace the camera or use a tripod, and trigger the shutter remotely so shaking fingers won't mess up shots. To reduce the noise that can intrude into long exposures, use a low ISO, set your camera's long-exposure noise reduction feature, and shoot in RAW so you can smooth out problems postshoot. Getting a good multisecond exposure is difficult: Try using an ND filter or polarizer to cut light and enhance blur.

242 LIMIT FOCUS WITH A LENSBABY

If your nature shots feel the same, get your mojo back with Lensbaby selective-focus lenses, the swivel-barreled optics beloved for the funky effects they create. A Lensbaby Composer pivots at the barrel's central ball-and-socket joint (you set focus and exposure manually) to control which areas are sharp or blurred. It locks into position so you can play with depth of field, and its fine-focus adjustment is magical. You can easily shift the sweet spot of focus, zeroing in on a flower's heart while its petals blur. Broaden your palette with wide-angle and telephoto lens adapters, macro lenses, and creative aperture sets.

243 MAKE YOUR FLOWERS DANCE

Vertical flower stems can look dull if they parallel photo edges. Pitch your camera sideways and downward at the same time to make flowertops look larger than stems and lend the flora an offbeat zing.

244

GO FOR BLOOMING BEAUTY

When spring fever hits, take your camera on a hike to capture new wildflowers—and heed these tips to bag the best blossoms. Do your research so you can target peak bloom season in your area of the country. It sounds perverse, but avoid perfect weather: The diffused sun of cloudy days reveals flowers in their best light.

Stabilize low-slung gear with beanbag supports, especially when you use long exposures to capture the pretty smudges created by breezes. Consider a tilt/shift lens, too (see #113), for maximum clarity and depth of field. Use a macro lens to capture bloom detail, and shoot from the flowers' height to maximize their form and fill your frame with their unfolding petals.

245 FIND A FRESH TAKE ON FLOWERS

Flowers are among the most popular—and thus the most challenging—photographic subjects. For a unique twist on the timeworn topic of flora, James Hague shot through condensation on a florist's window, "smearing" the roses' color and form. The result: an impressionistic abstract that suggests rather than literally represents the blooms.

Want to do something similar? First find photogenic flowers: The best ones are big, boldly colored, and well-shaped. Working outdoors on a cloudy day, arrange the flowers (A) in a vase before a black backdrop (B). Next, use a glass pane (C) that's a bit bigger than the arrangement, securing it parallel to the flowers with two gooseneck studio clamps (D). Fake condensation by filling a spray bottle (E) with water and adding one drop of glycerin (available at drugstores) per 8 ounces (236 mL) of water. Spritz the pane until droplets form.

Set a DSLR with a tele lens with speed and macro capability (F) at maximum aperture and check that the flowers look soft and the pane sharp (if they don't,

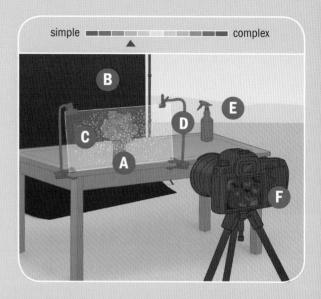

adjust the pane's distance from the flowers). If ambient light levels are too bright for maximum aperture, set a lower ISO or use a neutral-density or polarizing filter. Come in close so that the flowers fill the frame. Now shoot, and plan to tweak both contrast and color (see #291 and #300) in postproduction.

246 GET ARTSY WITH SEAWEED

Cooking up a fantastic image is much like whipping up a fantastic dish: Stir together top-notch ingredients, good technique, and just a little forethought, and you can't go wrong. Professional photographer Kiyoshi Togashi concocted the twinned studio images seen at left out of ingredients he found in his kitchen: kelp and water. His choice of complementary colors—emerald and fuchsia—and his painstaking attention to lighting combined to produce this delicious pair of abstracts.

If you're interested in trying to create something similar, pick up some dried seaweed, which is available

in Asian and select regular markets. Moisten it in water-filled clear drinking glasses until it's saturated and fully expanded. Set the glasses against a seamless white backdrop, light the scene brightly with either regular lights or strobes, and play with exposure readings with a flashmeter.

Get in tight with your camera, and use a close-focusing macro lens. Aim it carefully to capture details such as the tiny air bubbles clinging to the seaweed's fronds and the delicate fringe at its edges. If you want to bump up the jewel tones of the seaweed, consider using a filter in a bright color such as magenta.

247 MASTER FLIGHT FUNDAMENTALS

You can't control a bird in flight, but you can fine-tune your own stance and settings to get the best shot. First, watch the bird's trajectory with your eyes before you look through the viewfinder—this provides a smooth transition from spotting to tracking a bird. Stand with your feet shoulder-width apart so you can move freely when you do begin to track through the viewfinder. With small, quick birds, you'll probably have to shoot handheld; try to maintain a secure but easy grasp on your camera. Keep motion smooth while panning, and follow through: Don't stop when the shutter releases. If your bird is very fast, aim slightly ahead of its path before you shoot. Manual exposure works best for birds on the wing, so use partial or evaluative metering to get a light reading. Shutter speed is vital to freeze motion: 1/1250 or faster, with an ISO of 320 to 400. Even when no bird is in sight, keep your camera on and in the "ready" position at your chest. A fly-by can happen at any moment.

QUICK TIP

PAR FOOL THE BIRDIE

When you're shooting from behind a bird blind, bring a friend along. Birds have fantastic eyesight, so if these observant creatures spot you entering the blind, they'll wait until you leave before they emerge.

Try to trick them by asking your companion to depart first. The birds may assume you've left, too, and they'll come out to play. (This trick won't work on hawks, eagles, and falcons. They can count.)

249 TRY A MEDIUM-LENGTH LENS FOR BIRDLIFE

Wildlife photographers often depend on a 500 or 600mm lens as their tool of choice. But ultralong telephotos are bulky and expensive. Sometimes, shorter and wider lenses work best, especially with approachable birdlife. Moderate zoom allows you to quickly tailor your framing to the avian scene at hand, and handholding lenses in the 70 or 80 to 200mm class makes it easy to track and pan to follow birds, both in the air and on the water.

251 BACKGROUND YOUR BIRD

Sharply focused backgrounds can "fight" with delicately detailed birds, such as the Japanese white-eye above, spoiling an image. To emphasize a bird against its natural setting, experiment with background blur.

Shoot in manual, exposing for the bird itself, to make the background blow out slightly. Bright backgrounds are good choices, such as the cherry blossoms here. As you shoot, pay careful attention to the patterns that emerge in both the sharply focused foreground and the soft background bokeh (see #155).

If you don't get the background exactly right in the shoot, all is not lost. Postprocessing recropping and blurring can redeem clashing or overfocused backgrounds.

250 CREATE CATCHLIGHTS

Bird photos often work best if the subject's face is well lit and at least one eye displays a catchlight, or small reflection that distinguishes the eyes from surrounding feathers and shadows, animating your bird. The problem is that many birds have small, dark eyes that appear black and lifeless in images.

So create your own catchlight. Use a hot-shoe-mounted flash with an extender that lets the flash work with your telephoto lens. Extenders are typically used with lenses that go to 300mm or more. They increase the flash's reach by concentrating the light, resulting in up to a 2-stop aperture gain. Natural light can also produce catchlights, but you need to be patient. Position yourself between the bird and low, angled sunlight, and focus on its eyes. When it cocks its head into the light, shoot.

252 PHOTOGRAPH WILDLIFE SAFELY

Wildlife photos can be breathtaking, though taking them can be risky. First do your research so you know what you're getting into. If you're comfortable with risks, play it safe—or at least safer—by maintaining a distance between yourself and your fiercer subjects. (You can make your shots look more close up by shooting with a telephoto lens or cropping in later.) It's also wise to keep a can of pepper spray on hand. And with certain animals such as bears, make plenty of noise as you track them. If you startle them, you might put them on the defensive. And you definitely don't want to put a bear on the defensive.

Consider photographing at game farms. Purists turn up their noses at the idea, but the controlled conditions provide a safer way to get close to large predators such as mountain lions, bears, and tigers.

253 PLAY TO ANIMAL INSTINCTS

Trainers and handlers can teach you how to leverage an animal's natural inclinations to get the most out of a beastly photo shoot. So ask those in the know about the best way to approach and interact with wildlife.

Handlers can also engage your subjects while the shoot's going on. For instance, two trainers coaxed out the wowing over-the-shoulder glance captured here by tossing a snowball back and forth, drawing and holding the snow leopard's attention while the photographer clicked away.

254

PLUNGE INTO THE POOL WITH A COMPACT

Waterproof compact cameras are perfect for casual pool shots, since they can capture both photos and video while totally submerged. To ensure that they'll produce awesome aquatic shots for you, swim close to your subject—light falls off faster underwater than in open air. A wide-angle lens with close-focus capability is a great pool buddy, but turn off your flash. It will create backscatter if waterborne particles intrude between you and your subject. Choose the right white balance, too—some compacts have several, because the WB that works in a pool flakes out under the sea. Composition underwater is challenging but fun: Aim at the bubble explosion that envelops a diver, or shoot a partially submerged, intriguingly distorted subject from just under the surface. Be sure to use your strap, or your camera might fall below its watertight limit—10 to 33 feet (3-10 m) for most models. Finally, rinse the camera with plain water after you towel off.

255 SNAP EASY SNORKELING SHOTS

So you're planning a Caribbean getaway and packing your camera for souvenirs of some heavenly underwater blue. Carry along some essential tips for open-water shots as well.

Your first secret weapon: Google Earth, which can tell you when the sun will rise perpendicular to your site or mask a reef in shadow. Now time your photo. Water reflects and refracts light, but different hues emerge at different times of day. Shooting in the early morning or late afternoon is a time-honored trick, but the "blue hour" around sunset yields astounding azures and fiery skies from below the water's surface. On a windless day, plunge into the shallows at high noon: The sun's rays dive straight down to illuminate Bahamian blues and the white-sand bottom. (To cut surface glare, keep a circular polarizer on your lens's end.) Finally, always bring a buddy; check your snorkel gear dockside; and never touch or stand on coral.

256 LIGHT AND SHOOT DEEPWATER PHOTOS

The moment you slip underwater, you've entered one of the most difficult shooting environments on earth. Yet the world under the waves also offers incredibly photogenic material, so dive right in. Just make sure that you properly light and shoot your aquatic subjects.

LIGHT UP THE SEA. Underwater accessory lighting corrects the natural color skew of deep water, where reds look green and blues read as black. Paired external strobes—which should be powerful enough to compensate for the 1 stop of output lost with every 1 foot (30 cm) that light travels through water—and a remote trigger will help you overcome lighting challenges. Always bring extra batteries.

SEEK OUT MIXED LIGHT. Shooting underwater is somewhat like studio work: The best shots combine ambient and strobe light. Start off in the shallows, where such mixing is easier, and hold off on depth work until you've found your sea legs. Watch out for excessive light as well, such as that reflected off schooling fish.

EXPOSE PROPERLY. Shoot in RAW so that you can add missing color later via software. If your camera can't shoot RAW but does allow you to set white balance, use a warm setting to amp up reds and yellows. You can buy waterproof gray cards to check white balance at various depths.

HOOK YOUR FISH. Don't chase sealife. It will simply swim away from you. Instead find a feeding or gathering point, and wait for the fish to approach. When you're shooting speedy animals—sharks, rays, dolphins—you'll probably get only one shot. Make it your best by presetting your strobe and camera settings, and then "track" the animal ahead along its trajectory. A good starting point is 1/250 sec. Shooting with a compact? Keep its shutter partially depressed, and pan with the fish so the camera doesn't need to hunt for focus.

257

ZERO IN ON ZOO CREATURES

You needn't jet to exotic locales to bag wildlife—just bring your camera to the local zoo. Follow these fundamentals to capture the beauty of wild creatures in close confines.

DO YOUR RESEARCH. Review zoo websites to learn about feeding times, mating seasons (which often bring bright feathers and big antlers), and inhabitants with photogenic new offspring.

TIME IT RIGHT. Schedule a trip for opening or closing hours in early autumn or late spring, when crowds are sparse and heat-sensitive creatures most energetic.

BE SELECTIVE. Choose only a few sites to shoot each day. Look for enclosures with direct natural light, clear glass (not bars or cement enclosures), and natural rocks and plants.

PLAY WITH FOREGROUND AND

BACKGROUND. Settings with a deep foreground let you use lenses with a long, flattering focal length. And ones with a deep background are good because you can blur it to eliminate that "zooey" look.

PREP FOR ACTION. Preset your camera so you'll be ready when the perfect shot roars into view. That means continuous firing mode, a high enough ISO to let you use a motion-freezing shutter speed of 1/500 sec or faster, automatic white balance, and center-weighted metering.

DO NOT DISTURB. Avoid flash when you can. It scares away the very animals you want to draw near, and many zoos frown on or prohibit it outright.

258 SEE EYE TO EYE

Sometimes the best vantage point on wildlife is the animal's own eye level. With small and slow creatures, huddle down and wait until the animal looks at you, and then take your shot. Bring a foam pad to protect your knees during long low-angle sessions.

But how do you get eye to eye with big, bad animals such as the 1,700-pound (770-kg) hippo here? Search out glassed-in enclosures that get you close to animals at their natural eye level. Place a zoom lens against the glass and await eye contact. Be patient—to grab this hippo's soulful glance, Gerardo Soria spent a half-hour at the window.

259 LURE ANIMALS TO YOUR LENS

An eternal frustration of the zoo photographer—animals that won't come close enough—was solved by Mark Rober, who concocted a nifty way to get close-up monkey footage with a mirror and his iPhone. Make a hole in a small mirror with a carbide-tipped drill. Tape weather-stripping around the mirror's edges to make it easy to handle. Turn the mirror to its back side, align your phone's camera with the hole, and outline the phone with marker. Tape on more weather-stripping around the outline. At the zoo, place the mirror's reflective side against an enclosure, align your camera in its outline on the back side, and wait for an animal to approach and check out its own reflection.

MOBILE TIP

260 DELVE INTO DETAIL

Weary of animal-as-statue shots? Home in on a tiny detail that's intriguing or downright weird—eyeballs, paws, textured hide, whiskers, or feathers all work well—and fill your frame with a macro shot of it. With big animals, zoom in on your chosen part, then open your aperture wide if you want to blur out distracting background. Small-creature details are best captured up close with a wide-angle lens.

Remember: The closer you get to your subject, the shallower your depth of field. A small aperture (f/16 or smaller) keeps things in focus. If you're leaning in to catch a wee detail, you'll probably cast a shadow, so use a reflector to redirect the natural or strobe light. And as always, a tripod or focusing rail prevents slight movements from shaking up your photo.

PROCESSING & BEYOND

261 KNOW YOUR IMAGE TOOLS

After you've composed and captured an excellent shot, perfect the final image with photo-editing software. From sweeping changes to barely noticeable adjustments, such programs' tools allow you to experiment with and control color, composition, contrast, exposure, resolution, sharpness, and image size—all the elements that define your final image. Here's a look at key image tools in Adobe Photoshop 6, the most popular program.

NOISE REDUCTION

New DSLRs have ever-wider ranges of ISO options. This capability makes shooting in low-light situations easy, but it also can make photos look grainy or "noisy." Eliminate or soften noise with the Luminance slider in Adobe Camera Raw.

SHARPENING

Most digital images benefit from light sharpening—which helps to define lines and edges—though oversharpening can create noise.

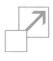

IMAGE SIZE

You may want to reduce the size of an image so that it's small enough to email, but try to preserve image quality by shooting for the right size. For computer screens, you need 72 pixels per inch; 300 ppi is ideal for printing.

SELECTIONS

Photoshop's selection tools let you delineate specific areas that you can then adjust without affecting the rest of your image. An especially useful tool is Quick Selection, which gives you a brush to "paint" a selection onto a photo. The Rectangular Marquee tool selects square or rectangular regions. And the Lasso selection tool ropes off sections of your image and allows you to finesse them individually or delete or reproduce them as you choose. Because you're drawing a circle around an area, you needn't fuss with anchor points—it's as easy as drawing a circle on paper.

COLOR

Color management tools allow you to remove, reduce, or add color casts; adjust saturation; add warmth; and adjust tones. A light touch works best. You can also create monochrome, sepia, and split-tone versions of your shots.

CONTRAST

Adjusting contrast makes a big difference to the impact of a photo. Used properly, it can change the mood of a picture—say, from moody to sunny.

CROPPING

The Crop tool is invaluable for getting the best possible composition and aspect ratio in your shots. Use it to make a horizontal image vertical or square or to straighten out skew. Keep in mind that you do lose resolution when you crop.

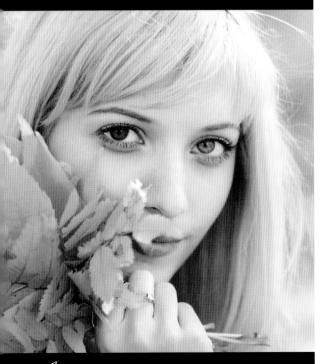

RETOUCHING

There are tools to tackle everything from cleaning up lens dust marks to eliminating red-eye, fixing lens distortion, and shifting depth of field.

CONTENT-AWARE PATCH, FILL, AND MOVE

These tools seamlessly remove image content you don't want and fill in content that you do want, so you can retouch with great precision. And you can use Move to shift entire objects around your images.

MAGIC WAND

The Magic Wand selects similarly hued areas of images with a single tap. The tool grabs the area for you, so you don't have to trace its outline. Then you can fill that area with another color or fill pattern, or turn it black or white.

EYEDROPPER

Pick up a single color in your image with the Eyedropper—it can select down to a single pixel—and then use that color to paint in other areas of your photo.

SPOT HEALING BRUSH

This retouching tool is a fast way to remove flaws and smudges. It paints with pixels sampled from your photo, and then matches the texture, lighting, transparency, and shading of the sampled pixels to the pixels that you're "healing." For more precise control, choose the main Healing Brush tool.

CLONE STAMP

Use this tool to paint part of your image over another section of the same image, or to paint part of one layer over another. It's a great way to duplicate objects and remove image flaws.

GRADIENT

This nifty tool gradually blends colors to smooth out your image. Make sure you select the desired area first, or Gradient will apply its fill to the whole active layer. You can select from preset gradient fills or create your own.

PAINT BUCKET

The Paint Bucket is a fill tool—you simply click a pixel of a color that you like, and the Bucket will fill up adjacent pixels that are similar in hue with the color you've chosen. You can select low or high tolerances so Photoshop knows which pixels to fill.

262

CUSTOMIZE PHOTOSHOP FOR OPTIMAL WORKFLOW

An efficient software work process is everyone's dream—we all have our pet workarounds and shortcuts. Luckily, there are loads of fresh ways to control and customize your interface. Why customize? Because it can make the program faster and even more efficient to use.

STEP ONE If your screen is a large or high-resolution one, Photoshop's default font might seem tiny. To enlarge it, go to Preferences > Interface. Under UI Text Options, choose UI Font Size: Large. (Restart Photoshop for changes to take effect.)

STEP TWO While you adjust Preferences, you can change the background color behind images if that helps you perceive your shots more clearly. Then click OK to save your changes.

STEP THREE You can also enlarge thumbnails. Rightclick on the empty gray part of the Layers panel to see a menu, and choose Large Thumbnails. **STEP FOUR** Display only the panels you use regularly. If you use, say, Adjustments, Layers, and History often, keep only those visible. You can also choose a preset in the dropdown menu in the top right corner of your screen. Essentials is a great place to start.

STEP FIVE You also needn't see every menu item Photoshop offers. To pick the ones you want, go to Edit > Menus and click the eye icon to show or hide a given item.

STEP SIX Create or customize your own shortcuts—click the Keyboard Shortcuts tab to edit them. Choose the menu item that you want to access faster, and type the keyboard command you would like to use to activate it.

STEP SEVEN When you have your interface set up as you want it, save it. Go to Window > Workspace > New Workspace. Name it, and check the boxes to save Keyboard Shortcuts and Menus, too.

263 OPTIMIZE A COMPUTER FOR EDITING PERFORMANCE

From the drive to the display, a high-performance setup is crucial to successful retouching. If you're shopping around, here's what to look for:

THE RIGHT COMPUTER makes photo-editing software sing. Look for lots of processing power, which means plenty of speed, as expressed in gigahertz (GHz), and a multiprocessor, or multicore, system. Random-access memory (RAM) is another crucial factor, since that's where Photoshop performs most of its calculations. Next time you're working on a large image, check Efficiency in the bottom left corner. If you see a rating of 95 percent or higher, your software is running in RAM, and you're all good. But if it drops to 80 percent or lower, add more RAM to your system.

THE DISPLAY OR MONITOR on which you view your images is also essential. Monitors are primarily made using one of two LCD technologies. Most mainstream displays are twisted nematic (TN); higher-end displays use in-plane switching (IPS). With TN, you see color corruption when you view the screen from any angle besides straight on. IPS displays are wide-view and

show more consistent and accurate color across the panel. For improved color accuracy, LED backlight technology is key. Profiling your monitor to get greater color accuracy and accurate black- and white-point balance is also important (use a monitor-profiling package and a calibrating device that attaches to your screen). Some high-end displays have wider color gamuts than consumer-level monitors, which stay calibrated for much longer.

264 PROTECT YOUR PICTURES

If you've ever suffered a computer crash, you know how vulnerable data can be. Get several medium-capacity memory cards rather than one big one. That way, if one becomes corrupted, you won't lose all your photos. Some cameras have slots for two memory cards, which is handy because you can program the camera to store RAW images on one and JPEGs on the other.

SAMPLE A SCRUBBY SLIDER

Besides customization, Photoshop's interface has other secrets. Scrubby sliders are among the coolest. Mouse over the word that precedes a number box, such as the word Opacity in the Layers panel, and you'll see a pointing finger with a left- and right-pointing arrow. Click and drag left or right to increase or decrease opacity without using the pulldown menu. Scrubby sliders are in almost every numerical option that appears in the Options Bar for a given tool.

266 USE LAYERS FOR SUPERIOR EDITING

Photoshop's layers are the key to making myriad editing changes while leaving your original picture untouched. Understand layers, and you're on your way to understanding the mother of all imaging programs.

Layers are basically images laid one atop another, so you can edit while the original picture remains untouched. Software that includes layers preserves all original image data while you work, so your photo doesn't lose quality as you make each successive edit—this is called a non-destructive workflow. Think of layers as transparencies: You can stack up as many as you like, adding information to each one to build the final image's components.

If you're working with numerous layers, organize them into folders for a streamlined workflow. You can colorcode them, too, to quickly identify each layer. This is useful when, for example, you retouch a face—make folders for the eyes, mouth, hair, and so on. If you change your mind about an edit, you can easily delete a problematic layer without starting from scratch.

268 MASTER SELECTIONS

Photoshop's selection tools—such as the Marquee, Lasso, Quick Selection, and Pen—let you make local adjustments to images. There's also the Brush, with which you paint a selection when working in Quick Mask mode. The selection border appears as a line of "marching ants." With the Pen tool, you must convert your path into a selection: Press Ctrl (Command on a Mac) + click on the thumbnail of the path.

Selections are tied to masks (see #269—often, you make a selection so you can turn it into a mask. For example, to change a wall's color, make a selection of the wall via any selection tool. Then use that selection on your mask so that the Hue/Saturation Adjustment Layer affects only the wall. Refine the selection so you can make a precise mask. No old color is left behind, and the new one looks natural.

267 DIVE INTO LAYERS

When you open an image in Photoshop, it automatically becomes a locked layer called the Background Layer. You then can add various layers atop it, including Text Layers, Vector Shape Layers, and Adjustment Layers. When you copy and paste (or drag and drop) a second image into your file, it will automatically appear in a new layer. You can also add empty layers for creating shapes, retouching, and adding background fill to make borders for your picture. When you make any big change, do so on a duplicate layer so you can reduce or intensify its effect by decreasing or increasing its opacity.

Adjustment Layers work differently—there is no image on the layers themselves. They sit atop normal layers, affecting them all so you can tweak exposure, contrast, and colors. To make one, go to Layer > New Adjustment Layer and choose the type you like. If you want it to affect

only the layer below it, link the two by holding down Alt (Option on a Mac) and clicking the line between the layers. You'll see an icon with two overlapped circles. When they are linked, the upper layer displays a bent arrow pointing to the layer to which it's linked.

269

MAKE MASKS FOR MORE EDITING CONTROL

Want even more power when editing your photos? Use masks. A mask defines what is visible or hidden on a particular layer, and it can be applied to any type of layer. This allows you to edit targeted portions of your image without affecting the rest of it.

There are two types of masks: layer and vector. Layer masks are saved as alpha channels (which let you load and save selections). Vector masks are pen paths. A layer mask is added by default whenever you add a new Adjustment Layer. If you try to add another mask to that same layer, it will automatically become a vector mask. These masks will be black and white. If

you get confused, think of this handy rhyme: White areas are revealed, and black areas are concealed.

Generally, you use layer masks to specify where you want an adjustment to be applied in your image. Let's say you are working on the skyline image above; you exposed the sky perfectly while shooting, but the land was a bit dark. If you use an Exposure Adjustment Layer to brighten the land, the sky and towers will look overexposed. Instead, fill the mask on your Exposure Layer with a gradient that transitions from black to white at the horizon line so the sky is unaffected while you bring out detail in the land and buildings.

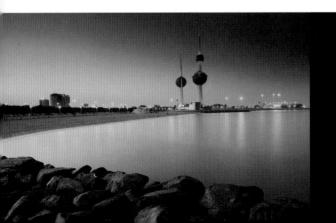

270 DOUBLE UP YOUR LAYERS

If you create an Adjustment Layer in Photoshop to change an image's brightness or contrast and its effect doesn't go far enough, you can double the layer via a quick keyboard shortcut. Select the layer, then press Control (Command on a Mac) + J. The original image here (at left) was overexposed, and an Adjustment Layer failed to sufficiently darken it. So the photographer duplicated the layer to achieve an improved image (at right). If the double layers together go too far, dial down the new layer's opacity until you've reached a happy medium.

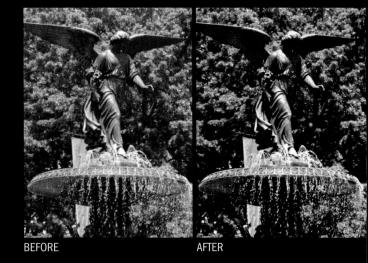

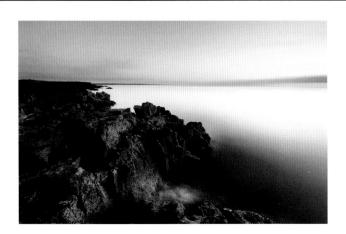

QUICK TIP

271 UNLOCK THE BACKGROUND

If you need to unlock the Background Layer, double-click on the words "Background Layer" and change its name. Then you can adjust its opacity and move it up or down in the stack, just like any other layer.

FAKE A NEUTRALDENSITY FILTER

Landscape photographers rely on split neutral-density filters to help them handle a bright sky and a dark ground. By positioning the dark portion of the filter to match up with the sky, they are able to expose for the ground and come out with a perfectly exposed photograph. If you didn't have an ND filter on hand when you shot, you can mimic its effect with software. The way to do it? Process your photo twice in Adobe Camera Raw—once for the sky and once for the ground—then combine the two in Photoshop.

Start by navigating to your photo in Bridge and open it in ACR. Adjust the colors, contrast, and lens correction. Then expose for the sky, even if this makes the ground look dark. Click Save Image in the bottom left corner. In the dialogue box, rename the file Sky and save it as a TIFF. Then readjust your exposure to brighten the ground. Hit Save Image and name this version Ground. Click Done and return to Bridge.

Select both TIFFs and go to Tools > Photoshop > Load Files into Photoshop Layers. This automatically aligns your images in one file. Make sure the sky layer is on top, and then add a layer mask. Add a gradient to your layer mask along the horizon line, white to black, to hide the ground and show only sky. If you don't get your gradient right the first time, just redraw it until you nail it. The gradient will reset itself each time.

273

STACK LAYERS TO ENHANCE A MACRO PHOTO

The finest macro lens (see #118) still has a built-in limitation: The greater its magnification, the shallower the depth of field (DOF) in the final image. Even an aperture of f/22 or f/32 sometimes can't keep all of a tiny subject within the DOF, and thus some details are lost. But in recent years software has ridden to the rescue with a startling advance called macro stacking. This simple technique involves taking many exposures of the same subject while slightly moving your focus point from frame to frame. Then you stack up these in-focus points to produce a single image that's sharp from front to back. A few systems, such as StackShot, automate the process of sequentially capturing in-focus shots, but many macro photographers prefer to do it manually. Once you've taken the photos, you can assemble them via Zerene Stacker or Photoshop. In Bridge, select the images you want to stack and go to Tools > Photoshop > Load Files into Photoshop Layers. Once in Photoshop, go to Edit > Auto-Blend Layers.

274 TRY TOUCH FOR MOBILE EDITING

Photoshop Touch lets you use layers, levels, and curves on iPhones and Androids. Image sizes are limited, but it's a useful way to "sketch" future shots or apply effects as you work. The interface differs from Photoshop itself—tools appear and disappear; icons replace menu items. To test the app, try adjusting Curves (see #290). On the home screen, tap the Add Image icon, then Add to edit. Click the Layers panel's plus sign and pick Duplicate Layer from the Options menu. Tap the Adjustment menu, choose Curves, and adjust the curve—tap to add points, and drag them up or down. Click Apply. The photo will alter accordingly.

MOBILE TIP

AFTER

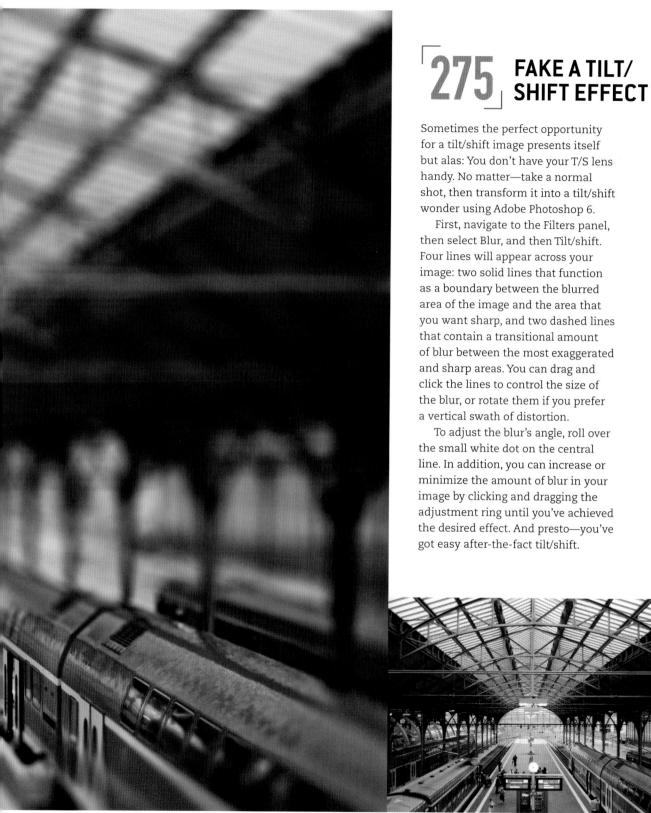

BEFORE

Walking by the lake in a Chicago park near home, I was drawn to the contrast between the cloudy gray sky reflected in the water and the bright green shrubs around it. When I checked the shot on my computer, I noticed the trees in the reflection. To create a subtle horizon, I flipped the image upside down.

-ALEXANDER PETKOV

276 ROTATE SHOTS

Easy-to-master rotation tools—found in Photoshop, mobile-phone apps, and other programs—flip photographs horizontally or vertically. You can also use them to rotate images clockwise or counterclockwise, according to your desired degree of tilt.

Yes, rotation lets you correct unpleasantly angled shots, but it's also a powerful creative tool. Use it to turn pedestrian photos into surprising, amusing, or bizarre works of art. You can simply invert an image, such as the one above. And you can even reverse gravity, turning raindrops splashing into a lake into a surreal scene of raindrops arrowing upward.

278 CLEAN UP A BACKGROUND

A distracting background can ruin even the most beautiful shot. When shooting, you can sweep away distant clutter by setting a large aperture to defocus it, or brilliantly light your foreground subject and set an exposure that shadows out background mess. But if you didn't have that foresight, use Photoshop to take the edge off the image.

Struck by the dynamic contrast of richly saturated lights bouncing off a metallic subway bench, the photographer who took the shot below composed it to emphasize the bright reflections. When he noticed afterward that the right side of his picture took in a line of ugly storefronts, he simply cropped off the right half of the image and replaced it with a mirror image of the left. Presto: No more distracting stores, and the final, symmetrical composition has a vibrant vortex that plays up the receding lines of the lights and bench slats.

QUICK TIP

277 SUPER UNDO IT

To undo a Photoshop error, hit Ctrl (Command on Macs) + Z. To revert further back, go into History and click the last correct step. The default saves 20 steps in History; for more, go to Preferences > Performance and save up to 1,000 states.

279 CROP TO IMPROVE YOUR SHOTS

Cropping is a simple yet powerful technique. By removing undesirable parts of a shot, you can emphasize or downplay specific elements, bolster or rearrange composition, or zero in on subjects you shot from a distance. Just remember that if you do a radical crop, you'll probably need to sharpen and reduce noise for a crisp and legible image.

Photoshop's Crop tool—hit C or select the icon to get it—is versatile and intuitive, especially when you use it on RAW files so you have the optimal amount of data to manipulate. Its menus offer you preset aspect ratios (such as a basic square) as well as Unconstrained, for freehand cropping. Once you select a crop and hit Enter, deleted areas will gray out; if they distract you, go to the Gear icon menu to darken them.

To reposition an image within a crop, click and hold on the picture as you move it. Grab the "handles" at the crop's corners and sides to reposition the crop frame atop your image. You can also straighten out misaligned photos via the Straighten button—draw a horizontal or vertical line, hit Enter, and Photoshop reorients your image accordingly. An important refinement in Photoshop's latest version is the Delete Cropped Pixels checkbox. Check it to permanently delete extraneous areas; uncheck it if you want to retain them (hitting the Crop tool again gives you the entire original photo).

AFTER

Whoops. You've followed the rule book, cropping out extra space and distracting details around the edges of your photograph. But now your composition feels crowded and airless. A dose of negative space can give your shot breathing room, balancing

composition and emphasizing its subject.

Working in Photoshop, pull up your original, uncropped file. Extend the picture canvas and then use Content Aware Fill to add extra space around your subject. Then tweak the subject itself a bit, boosting contrast using Curves or Hue > Saturation Adjustment Layer to shift colors and add dimensionality.

PUT A TWIST IN YOUR SHOT

Take a nothing-special photo and warp it into a vortex with software that allows you to distort an image around a center point. For arresting results, pick an image with a dynamic perspective: Tunnels, bright flowers, landscapes, and architecture are all great subjects to distort and transform into psychedelic art.

To start, choose an image with strong, graphic lines and contrasting colors. These qualities will lend structure to the image, keeping it crisp and sharp despite the applied distortion. Next, go to Filter > Distort > Twirl. Don't swirl your photo beyond recognition—torque it just enough to get the visual impact you want without obscuring your scene or subject into a featureless blur. (Note: The Twirl tool works only in 8-bit mode—if you choose a converted RAW file in 16-bit mode, reduce it to 8-bit before trying this technique.)

SCRATCH UP SOME POLAROID ART

Take retro-cool Polaroids a step further by lightly scratching them with a blunt-pointed object, such as the nonbristled end of a paintbrush. When you put pressure on a Polaroid's surface, you're moving the chemical emulsion inside, altering the image's appearance. Make it look like a cartoon by amping up outlines, as in the Polaroids shown here, or add shapes, draw patterns, or scratch away elements.

- Draw, scrape, or scratch the Polaroid a few minutes after i begins to develop.
- Experiment! Be open to blocking out large areas of your image with pattern and delving into abstraction.
- You can also peel apart th Polaroid's layers (the black backing and the white top) f direct access to the emulsion

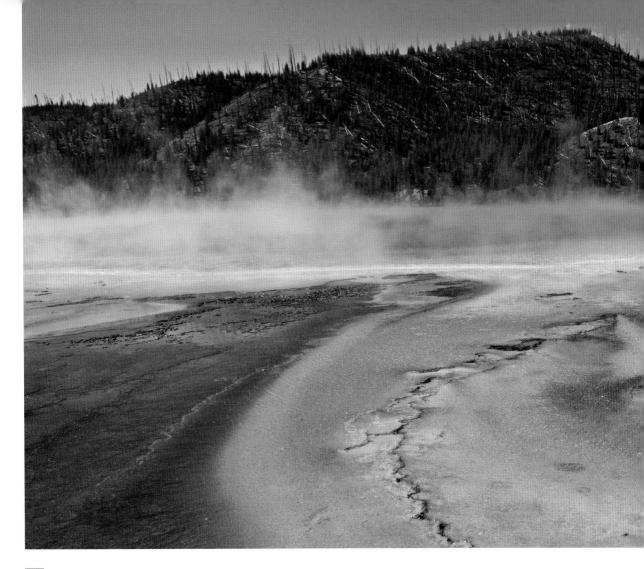

283 COOK WITH RAW FILES

As their name says, RAW files are powerful raw material. Unlike a JPEG, which is "cooked" (meaning that sensor data is heavily processed in-camera), a RAW file contains a ton of unadulterated data that you must manipulate before editing the image. But RAW files are worth the work—they give you total control over all the parameters of image processing. Here are the essentials for working with RAW files.

STEP ONE The new RAW conversion method in Adobe Lightroom 4 and Adobe Camera Raw is called Process Version 2012. If you converted an image with an earlier version, you'll see an exclamation point icon in the Develop module. Click it to update to the current

version, but beware: It will likely change the look of your image. Before updating, make a Virtual Copy of the original.

step two Before you begin conversion or adjustments in the Basic panel, scroll down to Lens Corrections. Check the Enable Profile Corrections box. If your lens has a profile made by Adobe or you've added one of your own, use it. Otherwise use Manual corrections. (It's wise to do this before doing any basic adjustments because Lens Corrections—especially its vignette removal function—can really alter your image's appearance.)

STEP THREE Return to the Basic panel. Adjust the Exposure slider, which (unlike the other sliders) is measured in increments of stops. In earlier versions, Exposure set the white point. Now it works on midtones and won't clip highlights. As you adjust any

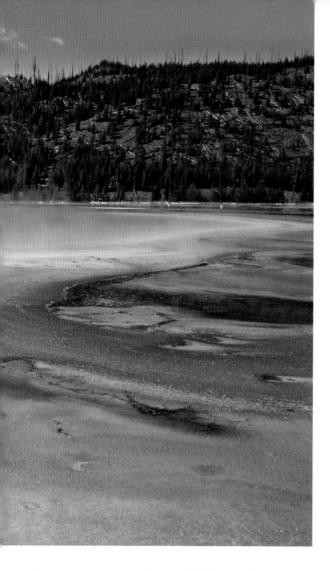

slider, the tones you affect are highlighted in the histogram. Now dial in proper contrast via the Contrast slider.

STEP FOUR Shift the Shadows slider right to bring back detail in any overly shadowed areas, or the Highlights slider left to restore detail in overly bright ones. Adjust Whites and Blacks to control clipping.

STEP FIVE In the Presence section, move the Clarity slider to add contrast and definition to midtones (taking it all the way up to 100 will net you an HDR-like look, but it won't be crunchy). Up Clarity to add punch, and Vibrance to intensify colors.

STEP SIX If your changes produced noise, go to the Details tab and add as much noise reduction as needed. Use the Adjustment Brush for localized noise removal. Finally, in the Lens Corrections tab, check the box to remove chromatic aberrations.

284 LEARN WHEN TO GO RAW

Sometimes JPEGs are your best option: when your memory card is almost full or you don't plan to print photos. But JPEGs have limits. They're compressed as they're taken, so settings are written in stone. Set the wrong white balance, for example, and fixing tone later will be a bear. Here are other times when RAW is best:

- ☐ YOU WANT TO DIG DETAIL OUT OF SHADOW. A RAW image captures about 2 more stops of dynamic range than a JPEG, so shadow detail that might be pure black in a JPEG retains detail in RAW.
- ☐ YOU WANT TO SHOOT FIRST AND BALANCE LATER. You don't have to set the camera's white balance when shooting RAW. You can adjust it to your taste when you convert the RAW file. Click on a preset (such as Daylight or Tungsten), and custom-tune it to your heart's content.
- ☐ YOU NEED TO OPEN A FILE MULTIPLE TIMES. RAW converters create images without altering the original RAW files, so you can open a RAW file repeatedly to try new things. It's like a film negative: Endless interpretations of one original are possible.
- ☐ YOU DON'T WANT TO FUSS WITH PHOTOSHOP. RAW converters control exposure, contrast, color balance, and saturation. Some sharpen and reduce noise. And that might be all the image control you want.

QUICK TIP

285 CHOOSE A RAW-SPECIFIC PROGRAM

Most cameras let you shoot RAW + JPEG simultaneously—a great idea when you're shooting photos that you want to immediately share online. But the option speedily devours memory-card and drive space, because RAW files are big boys. Most RAW devotees instead deploy programs dedicated solely to RAW, such as Apple Aperture or Adobe Lightroom, to quickly process RAW files into JPEGs.

I was shooting this ruined
Anasazi cliff dwelling in Utah
when I realized the full range of
tones wouldn't fit into a single
exposure. I decided to sacrifice
shadow detail rather than lose the
highlights, since those had the
most interesting details of the
masonry. So I kept my histogram
bunched to the right without
clipping it off. The image appeared
very bright, but it gave me the
most detail possible. Then I
tweaked the highlights and
shadows in Photoshop.

-GUY TAL

286

DODGE AND BURN DIGITALLY

To adjust shadows and highlights in digital processing, you can use Photoshop's equivalents of tried-and-true darkroom staples. The Dodge tool lets you brighten shadowy areas, and the Burn tool darkens brighter spots. For this shot, photographer Guy Tal picked the Dodge tool to shed some light on upper portions of the image, then used Burn to darken lower areas. Photoshop's Dodge and Burn can permanently alter pixels when applied to a background image layer, so Tal made the changes on a copy of his background layer, using a Soft Light blending mode for subtle effects.

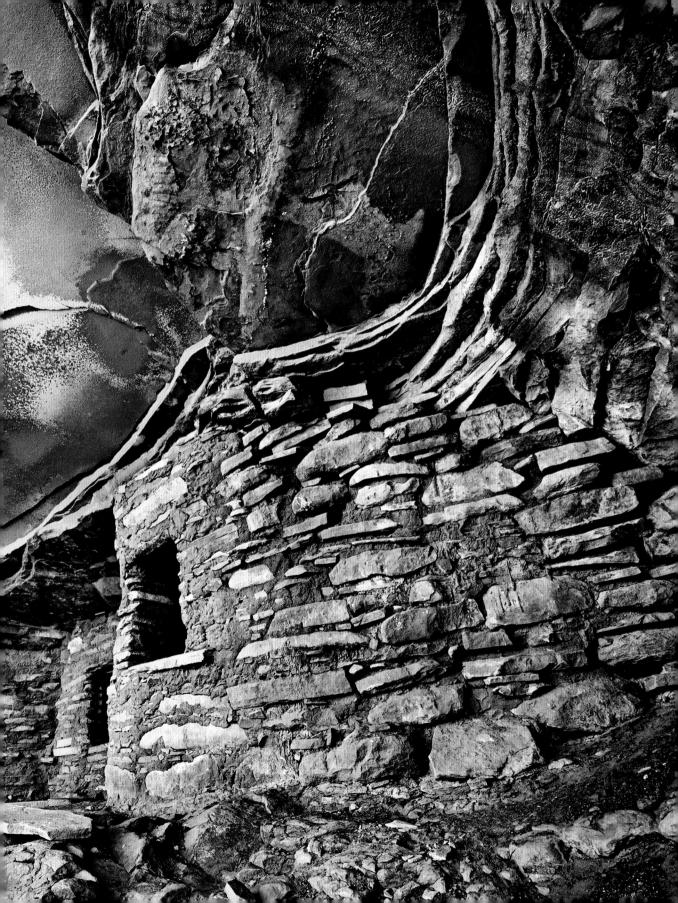

287 CONVERT AN IMAGE TO B&W

The secret to a beautiful monochrome: Start off with a great color image and let its wealth of tonal information help you make choices about which hues should go bright and which dark. Then follow these tips.

☐ ADJUST TONAL RANGE. Make sure your color image contains true black and true white before you delete its colors. To do so, create a Levels Adjustment Layer in Photoshop. Drag the white

- triangle inward until it abuts the beginning of the histogram. Do the same with the black triangle. If necessary, drag the center triangle left or right to brighten or darken midtones.
- ☐ **USE THE B&W TOOL.** In Photoshop, click the Black & White button in the Adjustments Panel, and then hit the Auto button. Grab the hand tool and place it on your image. Drag right on a tone to lighten it, left to darken it.
- ☐ TRY FILTERS AND PRESETS. In Photoshop, use the Black & White tool's pulldown menu to experiment with different looks. If you go for the High Contrast Blue Filter, you'll get a gritty, dirty effect. Try a red filter for soft skin tones, but if this effect is too much, move the Reds slider left to mellow it out.
- ☐ ADD GRAIN. Adobe Camera Raw (ACR) has a more sophisticated method for adding filmlike grain than Photoshop does. So save your image as a flattened TIFF and close the file. Double-click the Mini Bridge panel at the bottom of your screen and navigate to your TIFF. Right-click its thumbnail and select Open with > Camera Raw. Choose the Effects tab, and zoom to 50 percent. Once you increase the grain by moving the Amount slider to the right, the automatic Size and Roughness will kick in. The defaults add subtle texture, but you can increase all three sliders to make your photo really grainy.
- ☐ SPLIT TONE. ACR'S Split Toning tool adds a bit of tint to highlights and shadows to distinguish them. A classic split-tone shows warm highlights and cool shadows. To create one, click on the Split Toning tab and select a warm, yellow-orange hue for the Highlights and a cool blue for Shadows. Then slowly increase the Saturation for each.

288 MAKE YOURS MONOCHROME WITH EFEX

The digital darkroom provides many ways to turn color into monochrome. Although no single method works for every image, Nik's Silver Efex software, a Photoshop plug-in, does the trick most of the time. Among its 20 preset styles are High Structure, High Contrast Red Filter, and Dark Sepia, all of which are particularly good for landscapes. You can customize these presets with brightness, contrast, and structure slider controls, or use color filters to alter an image's tones as you would when shooting on B&W film through lens filters. Go with a green filter to lighten foliage or a red filter to darken a blue sky. Efex also lets you apply effects that mimic the look of B&W film. If you come up with a look you love, save those settings as a new preset.

289 FADE (A BACKGROUND) TO BLACK

Darkening your background draws your subject forward so it shines out as the central focus of your composition. You can easily create this effect through Brightness/Contrast in Adobe Photoshop, as the photographer of this brilliant egret did. You'll get the best results if you preserve your subject's highlights and allow the background to fall away while you're out shooting. Then clinch the effect with software.

STEP ONE Begin by hitting W on your keyboard and selecting the subject using the Quick Selection tool. Then start painting on the subject until it's nearly all selected. This first go-round can be rough.

STEP TWO Zoom in to the subject's edges and hone your selection. In Quick Selection, hold down the Alt (Option on a Mac) key to get the Subtract from Selection tool. Now paint in areas where you want to remove the selection. To make the brush smaller, tap the left bracket key ([) on your keyboard. To make it bigger, tap the right bracket (]). Just do the best you can. For the shot here, the toughest parts to fine-tune were the bird's feet and wispy feathers.

STEP THREE You now have a usable selection, so go to Select > Inverse, switching the selection from enclosing

the subject to enclosing the background. Then create a Brightness/Contrast Adjustment Layer by clicking on Brightness/Contrast in your Adjustments Panel. This makes a mask in the shape of your selection so your adjustments will apply only to the background. Then bring Brightness down and Contrast up until the background goes black.

STEP FOUR You'll immediately see where your selection looks good and where it doesn't. Any color from the original background will appear glaringly fake against the black background. To fix it, right-click on the Background Layer and choose Duplicate Layer. Then hit O for the Sponge tool. In the Options bar, choose Mode: Desaturate, and Flow: 100 percent. Zoom in and, with a large brush, paint away the distracting color.

STEP FIVE Getting rid of errant color helps, but it doesn't erase hard edges around soft details such as feathers. Click on your mask again and hit B for the Brush tool. In the Options bar, set Opacity to 50 percent. Set the foreground color to black (hit D, then X on your keyboard to do so), then paint on small areas to bring them back in. If you go too far, hit X to switch to painting with white, and repaint to cover mistakes.

290 CRUISE WITH CURVES

The Curves tool is among the most powerful in Photoshop, and it's the most versatile, too. Use it to add contrast just where you want it, to brighten or darken an image, and even to correct color. Curves simply graphs the tones of your image. As in a histogram, the darkest tones are represented on the left, and the brightest on the right. When you're viewing an RGB image, you'll see that the curve line begins at bottom

left and travels along a straight diagonal to top right. You add points on that line and move it up or down to change your image.

The good news: The Curves tool is much harder to explain than it is to use. So, to make it a little easier to understand, here are a few of the most common curves you can implement, plus details on what they do. Try them on your shots to test-drive this creative tool.

ADD CONTRAST. Behind the curve, you'll see a histogram. If it doesn't touch the edges, add contrast by moving the small black and white triangles inward to the histogram's edge. This makes the angle of the curve line steeper. Note: Use this method only when your histogram doesn't touch the edges. If you do it on an image with a good histogram, you'll end up clipping highlights and shadows.

FIX COLOR. Curves lets you manipulate your image's colors. Add or subtract red, green, or blue from a photo by using the pulldown menu to select the color that you would like to change, then manipulate that color's curve. For a warmer version of an image, pull down the blue curve to make the image more yellow. To make the image more magenta, pull down the green. To make it more cyan, pull down the red.

BRIGHTEN. If your image is too dark, call up Curves to brighten it. Here's an exaggerated example: Grab the midpoint of your curve and lift it up. The whole image brightens. The great thing about using Curves for this? Your black and white points don't change, so you won't clip highlights or shadows.

DARKEN. To darken an image, just do the opposite of what you did to brighten it. Grab the curve by the center point and bring it downward.

291 GET PERFECT CONTRAST

When you edit with Curves, first get the contrast right. Control dark tones by adjusting the graph's left side, and bright ones by adjusting the right side. Pull down the curve on the left, and dark tones darken further. Lift it on the right, and light tones brighten. Often, the curve ends up looking S-shaped.

STEP ONE Create a Curves Adjustment Layer by clicking the Curves button in the Adjustments panel. Now add contrast with the histogram as a guide. Pull the black arrow right until it aligns with the start of the bumps on the histogram's left side. This ensures that the photo's darkest tones are truly black. Drag the white arrow left until it aligns with the start of the bumps on the right so the lightest tones are close to true white.

STEP TWO Since the pollen is the focal point, use it to determine how you'll refine contrast. Zoom in, grab the pointed finger in the Curves dialogue box's top left corner, click on a bright point, and drag up. The image brightens based on the chosen tone, and the point on the curve where the adjusted tone lies is now marked.

STEP THREE Click and drag down on a shadowy area until these tones are as dark as you want them.

STEP FOUR Zoom out, then click on the points you added to the curve. Pull them up or down to refine your image. If the highlights and shadows are pleasing but the midtones could be brighter, work with the curve's center. Click directly on the curve to add a point, and drag it up until the midtones are as bright as you wish.

292 UP A SILHOUETTE'S CONTRAST

Silhouettes and shadows make great graphic elements, but there is such a thing as too much darkness—sometimes a photo's features need a little rescuing from the dark side. To cast a light on the gritty textures and stark figure hiding in a nearly monochromatic shot such as the street scene you see here, navigate to the HSL/Grayscale tab in Adobe Camera Raw and check the box to convert to Grayscale; the slider options below will change automatically. Pull the appropriate slider to the right to brighten your image, then adjust the Shadows slider to reveal more detail and the Clarity function to up the midtone contrast.

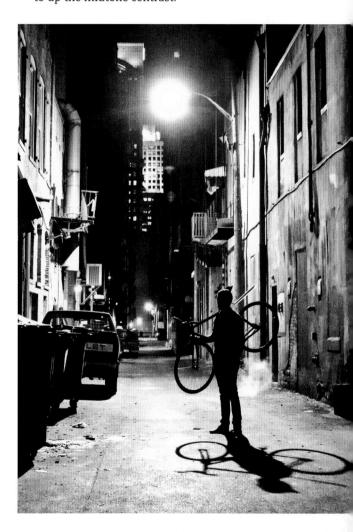

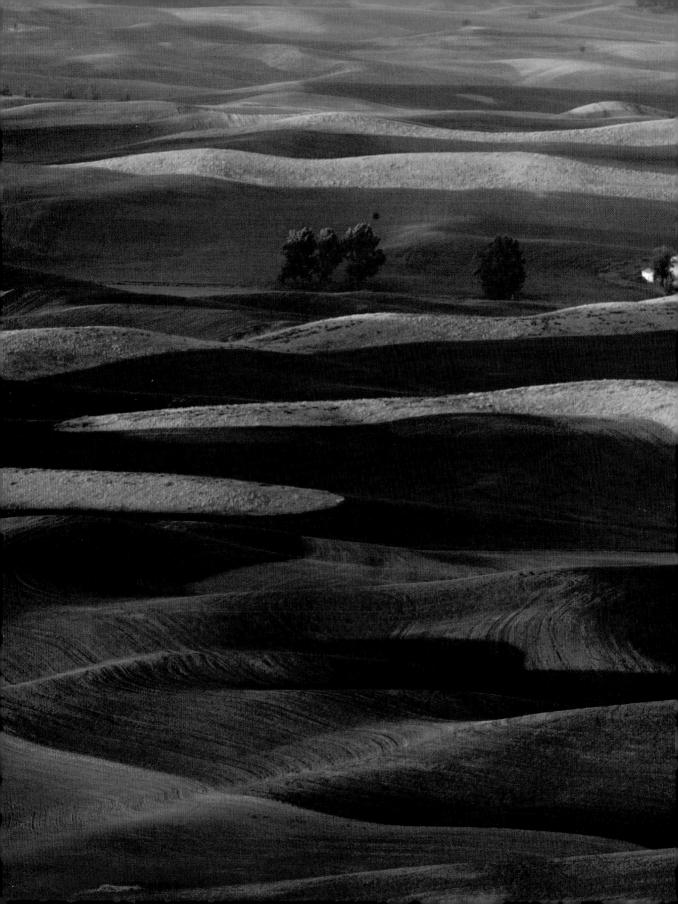

293 FIX IT WITH LEVELS

Photoshop's Levels is a powerful histogram-based corrector that zaps ugly color casts and adds convincingly natural contrast. Here's how to use it:

STEP ONE First find the image's black and white points—its darkest and lightest spots—with a Threshold Adjustment Layer (hit the Threshold button on the Adjustments panel).

STEP TWO The image turns B&W. In the histogram at right, pull the tiny gray arrow right until just a bit of white remains in the photo. That's the white point. Click and hold the Eyedropper tool in the toolbar, and choose the Color Sampler tool from the pop-up menu. Zoom in on the white spot. Click it with the Color Sampler. A target numbered 1 appears on it. To find the black point, drag the white arrow in the Threshold Adjustment Layer left until a bit of black remains. Zoom in and click with Color Sampler. Target 2 appears.

STEP THREE Delete the Threshold Adjustment Layer and make a Levels Adjustment Layer. Pick the white dropper. Hit Caps Lock to turn the cursor into a target, and align it with target 1. Click—the whites (and the whole image) brighten. Click the black dropper and then target 2. Levels resets the tones for better contrast and cleans up the blacks to neutralize color.

294 FIX IT WITH CURVES

Want to fix contrast or hue with Curves? Use a Threshold Adjustment Layer to mark the black and white points, then simply grab the black and white droppers in Curves' dialogue box to edit.

295 SOFTEN WITH BLUR

Photoshop's spanking-new Blur Gallery sports a trio of sophisticated image-smudging tools that turn your shots into impressionistic works of art. Field Blur blurs an entire photo. Tilt-Shift applies a targeted blurring effect like that of a tilt/shift lens (see #113). And Iris Blur mimics a Lensbaby, sweeping sharpness over a selected area while blurring the rest. You can finesse the size, shape, and edges of sharp areas, as well as the degree of the sharpness. Test-drive Iris Blur on a classic floral image, such as these cherry blossoms.

STEP ONE Duplicate your background layer (it's always wise to preserve an untouched version of an original shot on its own layer). Then go to Filter > Blur and choose Iris Blur from the submenu.

STEP TWO You'll see a circle of sharpness sitting on the image. Grab it by its center and pull it where you want the image to be sharpest. To adjust the blur level, shift the slider in the toolbar or grab and move the circular slider in the center of the Floating Blur tool. As you adjust, a display shows you level of blur.

BIG PROJECT

step three To adjust a sharp zone's size and shape, click and drag anywhere on the tool's outer circle to enlarge or shrink it. You'll see two small dots on the circle—drag one to make an ellipsis of sharp focus or rotate its orientation. Pull out on the little square on the circle to make an equilateral sharp region. Inside the circle are four more dots. These mark the transition between sharpness and blur. Pull them inward for a gradual transition, outward for a sharper edge.

STEP FOUR Now add another sharp area. Click on a spot you want to be in focus, adjust its size and shape, and do the same across the image as many times as needed. To remove focus from an area, click on a point and hit Delete. All these circles and points might confuse you; hit Ctrl (Command on a Mac) + H to see the image without them.

STEP FIVE Your image could look odd if many areas have the same degree of sharpness. Click on a point to select an in-focus area, then use the Focus slider in the Options bar to dial down sharpness. Do the same in other areas until your image looks smooth and balanced, then click OK. Want to save the mask for further modification? Check the Save Mask to Channels box at the top of the screen.

296 REPLACE ODD COLOR WITH ONE COLOR

You can't be fussy with grab shots. Imagine, for example, that you've captured a photo in the pouring rain, through a car windshield, on a point-and-shoot camera. While the resulting murkiness adds to the shot's atmosphere, the color looks strange. This flaw is easily remedied by using Photoshop's Black & White tool in the form of an Adjustment Layer. Then add back some color with a selenium-like tone, using a Color Fill Adjustment Layer set to Soft Light Blend mode. Dial back the layer's opacity to 25 percent to keep it from turning into purple haze.

298 USE GRAYSCALE TO FIX COLOR

If the hues in your color image appear muddy, take it into monochrome. Start with a flat conversion of your RAW file to make sure you have as much detail as possible. Then, using the Photoshop plug-in Nik Silver Efex Pro 2, turn your image B&W with the preset called Full Dynamic Harsh. Next, modify the preset by using different control points for the sky and land areas, which will keep the latter darker and less contrasty. Finally, try adding a very light selenium tone for a hint of color across the image.

99 RESTORE SOME ORIGINAL COLOR

As an alternative to converting a color image entirely to B&W, consider desaturating its overall color until it displays a subtle wash of tone. Using a full-color photo, create a Black & White Adjustment Layer, and move the sliders until you like the conversion. Then reduce the opacity of the Black & White Adjustment Layer to restore just a trace of the image's original color.

297 TONE WITH MASKS

All the color-tweaking methods described here work even better when you combine them and use masks. Click on a layer or an Adjustment Layer to select it, then click the mask icon at the bottom of the Layers panel to add a layer mask. With the mask selected, paint on your image—use a soft-edged black brush to selectively hide any previously applied tone effect, or use a white brush to restore it. Vary your brush's opacity as needed.

300 ADD COLOR BY HAND

Working manually, you can augment any area of your image with any hue you choose. First make a new, blank layer, and set its blend mode to Color. Grab a soft-edged brush and double-click on the foreground color in the toolbar to choose the tone you want. Paint it in wherever you want it. If the color is too intense, reduce the opacity of the brush (not the layer) to control the hue's effect. If you find you've built up too much color, use the Eraser tool at any opacity to reduce or remove it.

301

ADD SELECTIVE GRAYSCALE WITH HUE/SATURATION

Black-and-white images are beautiful, but some are even lovelier with a bit of tone. In the past, film photographers added color via their choice of printing paper (such as silver gelatin prints) or printing process (such as platinum or cyanotype for warm- or cool-toned prints), or they selectively added color by hand. These days, you can tone your B&W digital images in virtually unlimited ways. In Photoshop, adding an overall wash of color is simple: Make a Hue/Saturation Adjustment Layer and set its blend mode to Color. Check the Colorize box, and use the Hue slider to choose the color you'll add. To adjust its intensity, move the Saturation slider. (Disregard the Lightness slider.) Potentially the most intense of Photoshop's toning methods, this technique affects an image uniformly.

302 SPLIT TONES WITH CURVES

Use this technique when you want to apply two different tones—one for highlights and one for shadows. Make a Curves Adjustment Layer and set its blend mode to Color. Then use the pulldown menu to choose the Blue Channel rather than RGB. Make a subtle S-curve, lifting the shadows and pulling down the highlights. This will bring a blue tone into the photo's shadows and put blue's opposite, yellow, into its highlights.

303

CONTROL TONE WITH LIGHTROOM

Adobe Photoshop Lightroom 4, with its easy-to-navigate interface, allows selective adjustments via its Adjustment Brush tool, which you can use to brush white balance onto your image. Thus you can easily correct mixed lighting, or apply zones of varied white balance for creative effects. This Magritte-like shot by Andrew Wood nicely illustrates the power of both selective adjustments and Lightroom's Camera Raw processing engine. Take on a similar project to work multiple zones of an image and create a final RAW conversion that really glows. The best part? No layers are required.

simple complex

STEP ONE Before you go local with adjustments, go global via a basic conversion. Adjust white balance and exposure, and decide whether to use a built-in lens conversion. Wood took three shots of this hallway, and the one with the best highlight detail was, unfortunately, also the darkest. If you have a similar dilemma, restore as much shadow as possible, then use the Color and Luminance noise-reduction tools so the image is usable.

BIG PROJECT

STEP TWO Click on the Adjustment Brush icon and, via the Effect pulldown menu, choose the adjustment to apply. Here, more detail was needed in the window's view. In such a case, choose Exposure and then set up your brush (check Auto Mask so Lightroom will help you paint within your edges). Mouse over your image and use the right and left bracket keys to expand or shrink the brush to match the area you'll paint.

STEP THREE Now paint in your effect. Moving the sliders before you paint is tricky, so go with the default and, after you're finished painting, adjust the Exposure slider to further decrease exposure in areas where detail is needed.

STEP FOUR Further edits might be required—here the curtains and paintings were overbright and color shifts on the ceiling required selective white balance adjustment. To add a new adjustment point, click the New button. As before, choose an effect from the pulldown menu, paint it in, and adjust the slider. To re-edit an area, click on its gray dot. Note: Clicking on your adjustment point gives a preview of its location.

STEP FIVE Once you've done all your local tweaks, the final product might need a global goose. If the image looks flat, edge up the Clarity and Vibrance sliders so it will pop.

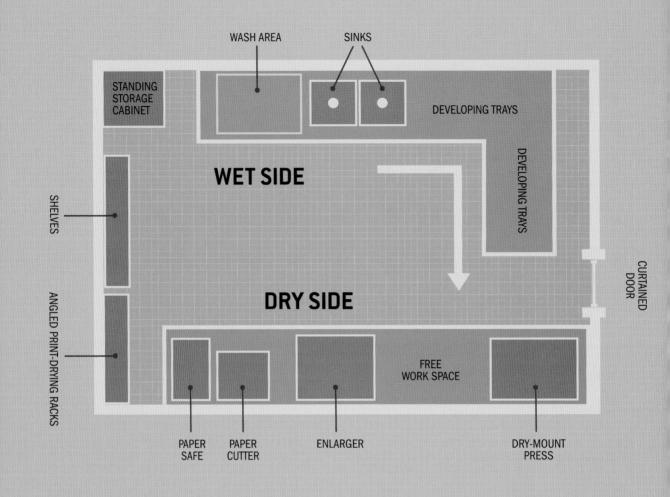

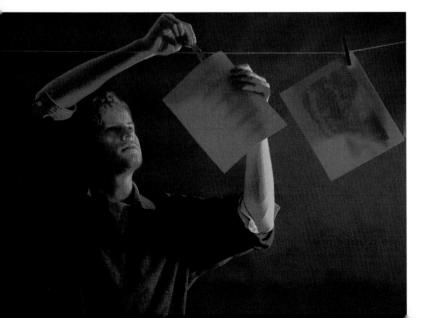

304

LIGHT-PROOF YOUR DARKROOM

Before you process your first print, make sure your new darkroom is truly lightproof. Close the door, draw the shades, and sit there for ten minutes. If any light is leaking in, your eyes will detect it by then.

305_{\perp} set up a home darkroom

If you're a passionate film shooter, you'll soon long to do your own processing. Why leave all the home alchemy to digital photographers—or consign your film to commercial processors? If you have a small room to devote exclusively to processing gear, constructing your own darkroom is a great option. (Don't work in your kitchen or bathroom. Darkroom chemicals are smelly and messy.)

For B&W processing—color work is best left to pros because it requires costly equipment—you need a small spare room or even an empty closet. Any space will do if it has an electrical outlet and a sink (ideally a long, shallow one) with running water. Lightproof it by taping or Velcroing opaque shades to window and door frames.

All darkrooms have a wet and a dry side. On the wet side is the sink, with four developing trays nearby. Your prints move through these trays from left to right, from developer to stop bath to fixer to hypoclearing solution in the last tray (see #308).

On the dry side, your enlarger—buy one with a good lens and a timer—should sit on a sturdy counter. This

is also the area where you'll handle negatives and print composition. You should invest in a sturdy easel that can hold photo paper flat under the enlarger as you make exposures, plus a stainless-steel tank and reels set for processing film rolls. Ideally, your darkroom should also have a safe for photo paper and shelves for chemical bottles and other storage. Other essentials include:

- ☐ A print-drying rack or clothesline with pins
- ☐ An amber or red safelight
- ☐ A digital darkroom thermometer to test chemicals' temperature
- ☐ Latex gloves and an apron to protect clothing
- ☐ A small, soft paintbrush to whisk dust off negatives
- ☐ Dodging and burning tools (wire, cardboard, scissors, and tape)

Setting up all this equipment should keep you busy for a while. But be warned: You'll covet other retro darkroom toys after you've fallen in love with making your own prints.

306 BUY THE RIGHT ENLARGER LENS

An enlarger is a projector that allows you to make prints from a film negative. The enlarger lens's focal length is determined by your film's format. Here's a guide to standard focal lengths:

- □ 50mm length: 35mm film
- □ 75-90mm length: Mediumformat (120) roll film
- ☐ 150mm length: Large-format film

307 CLEAN A NEGATIVE

It's not necessary to clean negatives unless they're smudged, but if you do have to remove some gunk or smears, use a specialized film cleaner. The best ones evaporate rapidly so as not to leave residue. Use a microfiber cloth for cleaning—specialized anti-static cloths are available from camera gear vendors.

308 MAKE YOUR FIRST DARKROOM PRINT

You've set up your basic home darkroom (see #305), and now an envelope of freshly developed B&W negatives is begging to be printed. What to do? Close the door, flick on the safelight, and get to work.

STEP ONE Line up the chemicals and mix them per manufacturer directions. Pour developer, stop bath, fixer, and hypo-clearing solution into four separate trays, left to right, on the counter by the sink. Developer activates photo paper's chemical emulsion, shading in parts exposed to light. Stop bath halts the developer's work, and fixer takes off unexposed emulsion so the photo won't darken in regular light. Hypo-clear washes off the fixer and other chemicals.

STEP TWO Choose a negative and load it into the enlarger's negative carrier (carrier sizes vary, depending on film size) emulsion side down. When you turn on the enlarger's light and shine it through the negative onto the enlarger base, the image should appear right side up. Bring the image into focus and turn the light off.

STEP THREE Make a test strip to decide how long to expose your photo. Cut a 1-inch- (2.5-cm-) wide strip of photo paper, set the enlarger lens's f-stop to a moderate aperture such as f/8, and set its timer for 30 seconds. Now block out the light with a cardboard square in small increments: one for 5 seconds, one for 10, one for 15, and one for 30. Develop the strip and decide which time works best for your image.

STEP FOUR Place a full sheet of photo paper, emulsion side up, on the enlarger base. Turn on the light for the selected amount of time.

STEP FIVE Place the paper in the developer and rock the tray back and forth a little. (Follow each chemical's manufacturer instructions on how long to keep your paper in each tray.)

STEP SIX Move the paper to the sink with rubber-tipped tongs. Rinse it, and drop it in the stop bath. Rock the tray again.

STEP SEVEN Rinse the paper again and put it in the fixer. Rock the tray. Then do a final hypo-clear rinse.

STEP EIGHT Hang the image on your drying rack. Congratulations: You've now created your very first B&W print!

309 STORE FILM SECURELY

Unexposed film rolls are somewhat like uncooked eggs-keep them cool to keep them fresh. Roomtemperature storage can eventually cause film emulsion to degrade, and generally color film has a shorter shelf life than B&W. Stash the rolls in zippered bags in the fridge if you plan to use them within a few months. For longer storage, put them in the freezer (warning: Never freeze Fuji or Polaroid instant film). When you're ready to shoot, just set out the rolls until they return to room temperature and condensation dries up. If they're past the expiration date, consider keeping them anyway; there may be times when you'll want the look of aged film (see #190). Cold storage is also a great way to stockpile beloved films that manufacturers might soon stop making, or that crate of discontinued film you couldn't resist buying on eBay.

310 DODGE AND BURN

If part of a print is too light, you need to "burn" that section, or expose it for a longer time to darken it. Conversely, if part is too dark, you "dodge" it, or expose it for less time to lighten it. This basic definition is easy to grasp, but dodging and burning are acquired skills requiring lots of trial and error. The tool you employ is an opaque cardboard form (or your own hand, if you like), which you move around as the print is exposed. To burn, let a dark area sit for a longer time under the enlarger's light while you block light from the rest of the image. To dodge, block light from reaching the overly dark area, or expose it for only a brief time. Move your cardboard or hand slowly during the exposure so that the light gradient looks natural and you don't make silhouettes on the final print. (For details on digitally dodging and burning, see #286.)

QUICK TIP

PROTECT YOUR PHOTO PAPER

In home darkrooms, the best place to store unused photographic paper is in the black bag you bought it in. Don't carry the paper outside the darkroom unless it's in the bag. Remember that even safelights can, over time, expose paper, so don't leave unprotected sheets lying around the darkroom. To store paper for long periods, put unopened packages in the fridge. As with film, wait until it returns to room temperature before you handle it, then use it promptly.

simple complex

312 OPT FOR EASIER HDR

High Dynamic Range imaging—merging multiple exposures into one picture with more tones than a digital camera can ordinarily capture—has never been more popular. It preserves detail in highlights and shadows when a scene has extreme lights and darks. Good HDR images start with good base photos, and you need at least three to capture the full range of tones in many scenes. The trick to getting great HDR images? Go easy during the conversion process in Photoshop, then take your base image into Adobe Camera Raw (ACR) and use its subtler—and simpler—tools to make your picture shine. Here's how to do it.

STEP ONE To get started, double-click on the Mini Bridge Panel at the bottom of your screen to open it. Navigate to the images you want to merge together and select them all. Right-click (Ctrl + click on a Mac) on a thumbnail and choose Photoshop > Merge to HDR Pro. You'll see Photoshop automatically align the images and then open them in the new HDR dialogue.

STEP TWO Choose Mode: 16 Bit and leave it at Local Adaptation. The first preview you see won't look so great—start to make it better by adjusting it to get the widest dynamic range you can. Go to the Curve tab and brighten the midtones and shadows. Make sure the highlights don't get blown out. To bring out even more shadow detail, move the Shadow slider to the right; for more highlight detail, move the Highlights slider to the left.

BIG PROJECT

STEP THREE Next, address edges and details. Move the Detail slider to the right to bring out the edges. This works in concert with Edge Glow—if Detail is set too low, the Radius and Strength sliders won't have much effect. For soft, glowing edges, increase Radius. For lots of edge contrast, increase Strength. For a realistic look, go easy on both.

STEP FOUR Click OK to open your file in Photoshop. Once there, save the file as a TIFF and close it. Open Mini Bridge again and navigate to your TIFF. Now you can use the power of ACR to add some drama to the image. Right-click on the TIFF's thumbnail, and choose Open With > Camera Raw.

STEP FIVE Tweak your photo by using the sliders as if you were working on a RAW file. Fix the white balance, use the Exposure sliders to add contrast without sacrificing shadow and highlight detail, and take advantage of the Clarity slider to add even more midtone contrast. Go into the Lens Correction tab to get rid of any chromatic aberration or lens distortion. Then click Open Image to head back into Photoshop.

STEP SIX This image could still use more contrast in the midtones, so create a Curves Adjustment Layer to add it. Last, duplicate your background layer, and, if needed, use Smart Sharpen to make it crisper.

313 GO PRO FOR TOP-NOTCH PRINTS

Printing at home is convenient and fast. But professional labs are best if your printer can't wrangle a certain size or you can't get an image to look right in your own software. Photo labs range from easy-to-use online services to high-end shops where you work directly with master printers. To ensure you'll get the prints of your dreams, follow these pointers:

FIND THE RIGHT LAB. Don't like fussing over proofs and color settings? Choose a do-it-all service offering preset print sizes (and fun extras such as photo mugs). Save serious jobs for a local shop where you sit down with a seasoned pro to work files under optimized lights on a color-correct monitor.

CALIBRATE AND PROFILE YOUR OWN DISPLAY. Your home edits translate best into pro prints when you standardize your monitor's color and contrast with a calibration device. (Top-drawer labs offer downloadable profiles for their printer/paper combos, too.) If you don't have a device—or an eagle eye for color let the lab do the color corrections. They know their printers and papers best.

FIND OUT WHAT THE LAB CAN HANDLE. Ask questions: Does the lab limit file sizes? Can it just handle JPEGs? Can it accept Adobe or ProPhoto RGB images, or must you submit in the narrower sRGB color space? (sRGB means "standard red, green, and blue" and is the standard color space for printing and online sharing.)

PICK YOUR MEDIUM. Most labs offer digital c-prints. made via laser projection onto the photo paper you specify (choosing from matte, metallic, and so forth). High-end shops make longer-lasting inkiet prints as well, besides allowing you to choose from a dizzying variety of papers and sizes.

THINK IN B&W. Some labs convert color files to B&W for you. Others ask you to send grayscales, C-print shops sometimes offer B&W prints on optimal resin-coated paper; inkjet labs also offer fiber-based papers for that traditional darkroom look. Ask before you upload.

CONSIDER ASPECT RATIO. If your shot doesn't fit the lab's printer dimensions, a technician can crop for you. Or you can do it yourself at home before you send the file.

ORDER TEST STRIPS. Before you print, select some representative images and send them to the lab for a trial run. Ask the technicians to print your tests on a few different paper stocks so you can pick the one that pleases you most.

314 FAKE AN ANTIQUE PHOTO

Handmade natural-fiber paper—specialty stock using bark, linen, cotton, or other plants—can make shots you took yesterday look as if they've aged for a century. Unlike regular photo paper—made to produce crisp, snappy prints—soft, fibrous paper produces weathered-looking images.

Buy a few kinds of paper at a stationery store so you can experiment. Gluestick a sheet of ordinary printer paper to a fiber sheet's back so it won't jam the printer. Select your image and load the paper "sandwich" in the printer, ensuring that the fiber sheet is the one that will receive the ink. Hit Print, gently peel apart the sandwich, and inspect the results. Too soft? Return to the file, amp contrast or color saturation, and print again. Sections dropping out? Try a smoother-fibered paper. Now find an old-fashioned frame, and you've got a genuine digital antique.

315 CREATE CONTACT SHEETS

Miss squinting through a loupe at image thumbnails? Want to plan crops with grease pencil rather than software? Use Adobe Bridge to print contact sheets—it lets you make PDFs without leaving the program.

First select your images or folders. Then, in the Bridge menu, go to Tools > Photoshop > Contact Sheet II. Fill in the contact-sheet dimensions and color specifications you want in the Document area; specify your preferred image layout and arrangement in the Thumbnails area. Then choose Use Filename as Caption to label the thumbnails with their source-image file names. Now click OK, name your PDF, and print out your contact

ahaat uuhanavar vau ara raadu

21.6 by 14.4 inches (54 by 36 cm)

17 by 11.3 inches (43 by 28 cm)

12.4 by 8.3 inches (31 by 21 cm)

3 by 2 inches (7 by 5 cm)

317

DETERMINE MAXIMUM SIZE

Pixel count, though not a hard-and-fast indicator of resolution, provides a handy rule of thumb for an image's enlargeability. The point of having lots of pixels in an image is that you can stuff them together tightly to make a continuous-tone image. The minimum necessary for "photo-quality" enlargements is 240 pixels per inch (ppi). So if you're using a 3000-by-2000-pixel camera, simply divide those numbers by 240 and you'll get maximum enlargement size: about 12½ by 8½ inches (32 by 22 cm).

316

UNDERSTAND RESOLUTION

These days, there's a lot of confusion over resolution and pixel count. Because digital images are made up of dots, and because dots are recorded by pixels, people assume that the more pixels, the higher the resolution and the sharper the picture. But factors besides pixel count affect resolution—which itself is an umbrella term for the amount of data that an image holds. The size of a camera's processor makes a difference, and, in fact, sometimes bigger individual pixels make for better resolution. So pixel count is just an indicator of potential resolution, and resolution is more than a measure of pixels—it's the level of detail that a camera can capture. A camera with a good resolution score offers you more options for cropping and zooming.

QUICK TIP

318

SAVE FILES AS TIFFS

A debate rages among software aficionados: Is it better to save a layered file in Photoshop as a PSD (Photoshop data file) or a TIFF (tagged image file format)? PSD, usually, because you'll probably want to reopen that file in Photoshop, which can reveal and make the most of those layers. Double-clicking a PSD file tells Photoshop to open it; double-clicking a TIFF could call up a program that doesn't use layers. Plus, PSD files can pack in more metadata than TIFFs.

A BEFORE Graininess reduces the vibrant detail and colors in the bird's feathers and in the background.

▲ TOO MUCH The noise is gone, but so is the detail. Reduce noise on a duplicate layer and add a mask on the bird.

▲ JUST RIGHT When noise is reduced only in the background, the subject retains detail and pops to life.

319 FIX NOISE WITHOUT LOSING DETAIL

Too much grain can make for an ugly picture. But go too far in taking the noise out and your subjects will look plastic. The good news: Noise reduction can improve your pictures. The bad news: It's a rare occasion when a single noise-reduction setting works for your whole image.

To start, find the noise-reduction tool in your image-editing software. Adjust the sharpness of the photo with your sharpening tools, but not so much that it ceases to look natural. If it's the defocused areas in your image that need smoothing most, dial down the tool that sharpens details all the way.

Do your noise reduction on a duplicate layer, then add a mask (see #269). Simply paint out the areas where noise reduction does more harm than good, leaving detail where you need it.

PICK THE RIGHT PRINTER

Each printer model has a maximum printing width. If you want to make mostly small prints, a printer that tops out at just 4 inches (10 cm) perfect for making 4 by 6 prints—may suit your needs. Other printers (mostly for commercial use) can be up to 44 inches (112 cm) wide. A big size may be tempting, but if you print large only occasionally, it makes sense to buy a smaller printer and send those few big ones to a lab.

CHOOSE A PRINTER INK

Some printers use dye-based ink, some use pigment-based, and some use a mix of both. In general, dye is less archival: On some papers, prints tend to fade faster (especially on matte ones) or smudge, and there may be color shift. Some dye-based inks have recently undergone an upgrade in longevity and resistance to moisture, so if you like the look of dyed inks, ask around or experiment with various options.

322 DISPLAY YOUR BEST SHOTS

Reward yourself for all your hard photographic labor with a thoughtful display of your favorite images. Creative ways to show your work are limited only by your imagination.

FRAME IT UP. Choose a solid, attractive frame to mark a photo as an artwork and protect it from damage. Select high-quality mats and frames that will last a lifetime. Hang photos alone or in complementary pairs, or line a hallway with a series of shots that tell viewers a story as they walk through your home.

SWING THEM FROM A STRING. Hang clothesline or wire between two nails and attach your photos with binder clips or clothespins. Multiple strands of photos draped across a wall lend a casual, artistic air to a room.

GO INVISIBLE. In a modern space, mount photos without frames, spray-mounting them to foam board and then using Velcro or small hooks to attach them to walls.

MAKE A PHOTO BOOK. You can design and craft a photo book via numerous services, picking size, paper, and cover style, and then designing the book in the services' own software (templates range from cute to gritty). Selections, prices, and ease of use vary widely, so research several before you order.

323 COMPREHEND COPYRIGHT

Under U.S. law, the creator of an image owns its copyright. But if you're shooting for another person or company, read the fine print on your contract before you sign—you might not be able to retain rights.

Another area of concern is the Internet: When you upload photos, it's hard to control where they'll end up. Protect them by uploading only small versions to image-sharing sites—thus they'll be useless to printing pirates. Add a watermark, too, via editing software, so your name and copyright symbol are displayed on each image.

324 PROTECT WITH METADATA

It's wise to add your name and copyright info to images' metadata. Open Bridge, then choose File > Get Photos from Camera. Click Advanced Dialogue, and then, under Apply Metadata, type in your copyright text. For detailed metadata on all images you import going forward, make a template in Bridge by going to Tools > Create Metadata Template. And if you've already imported and want to add metadata after the fact, do it via the Metadata tab in Bridge. Highlight all your photos and enter your name and copyright. The details will be applied to all photos' data at once.

CHOOSE THE RIGHT COLOR PROFILE

The color profile in which you edit and print photos isn't always the same one you'll use to share them. It makes sense to shoot JPEGs in Adobe RGB—a color model that defines an image's hues by their relative amounts of red, green, and blue—and to open RAW files in ProPhoto RGB. But when you upload shots to a website or print them at a drugstore lab, first convert them to sRGB (standard red, green, and blue). In Photoshop, go to Edit > Convert to Profile. The Source Space is the current profile. From the pulldown menu under Destination Space, choose the profile to which you want to convert your photo.

326 STORE IMAGES IN THE CLOUD

It sounds like a bunch of hovering photons, but the cloud is simply composed of server banks—and it's an increasingly popular place to securely stow photos. The best way to access it is to sign up for one of the many online storage systems.

Apple's iCloud backs up photos via its Photo Stream function—when you take an iPhone picture. it's wirelessly transferred to Apple's online storage system and syncs to all your enabled devices. Photos live in the cloud for 30 days before Apple deletes

them. Other services, such as Adobe's Revel, let you pull photos from your own devices into cloud storage and access them anywhere. Carbonite's service stows everything-images, audio, video, and textautomatically. Amazon's Cloud Drive will save everything, too, but you must manually upload.

If you're a newcomer to cloudland, try a free service such as Windows Live SkyDrive, which lets you store a few gigabytes. Whichever service you choose, incorporate its use into your workflow.

CHECKLIST

327 BE A PICKY EDITOR

To put together a first-rate image library, you must be selective. Here are five tips that will help you see your work with fresh eyes so you can edit and streamline your photo collection, giving photographic gems the attention they deserve while relegating lesser images to the trash (or recycling) bin.

INVERT TONES. For B&W photos, break free from preconceived ideas of composition by viewing the image with its tones inverted, as in a negative. The Photoshop command is Image > Adjustments > Invert.

SWITCH COLORS. This works the same way. If the inverted colors are garish, convert the image to B&W and then use tonal inversion

GO TOPSY-TURVY. View your images upside-down. This upends your notions of how the subject looks, freeing your eyes to consider the composition anew.

SEE YOURSELF AS OTHERS SEE YOU. Visualize a photo published on a magazine cover, perhaps even superimposing type or a logo with an image editor. This overrides your emotional attachment to the image, so you can evaluate your photograph as if it had been taken by someone else.

BE RUTHLESS. It can hurt, but have no mercy in discarding images. The more you throw away, the more you'll shift your focus to the standouts in your collection of digital artworks.

simple complex

328 BRING AN OLD PHOTO BACK TO LIFE

Restoring antique or historic photos is a labor of love: It takes time and patience to fix faded, torn images. It also takes software: Photoshop's Content-Aware Fill, Content-Aware Patch tool, and Content-Aware Spot Healing Brush are fabulous restoration tools. Content Aware is an advanced replacement technology that analyzes an image and seamlessly substitutes new texture and tone for unwanted image information. Its tools can rid even the most challenging photos of rips, cracks, dust, mold, and other indignities of age.

original, gently blow or brush off loose dirt and dust. Remove the frame only if the photo comes out easily. If the photo has been taped together, don't peel away the tape—that could further damage the image. If the photo is in pieces, scan its sections into a single file. Then place each piece on a separate layer: Type W to get the Quick Selection tool, and select one part of the image. Type Ctrl (Command on a Mac) + J to jump the selected part to a new layer. Do the same to the other segments, naming each layer as you go. Then turn off your background layer.

STEP TWO Move and rotate the pieces into place as if you were assembling a puzzle. Select a segment's layer, then tap the V key to activate the Move tool. Tap the arrow keys to move the sections into position, or, to rotate them most accurately, choose Edit > Free Transform and move the pivot point (centered by default) to the corner to act as a fulcrum. Then grab the opposite corner's Transform handle and rotate the piece into place. Hold down Shift as you tap the arrows to move the pieces faster.

BIG PROJECT

STEP THREE This step is best done on a dedicated layer. Click on the top layer, hold down Alt (Option on a Mac), and choose Layer > Merge Visible. Select the Spot Healing Brush (J); Content-Aware should be on. Make the brush slightly larger than the first crack that you'll repair. Now, starting at the outside edge, paint over the thinnest cracks first. To repair straight tears, click once at the start of a crack, release the mouse, hold down Shift, and click at its end. To repair large rips where white paper shows, first use the Clone Stamp (S), and then use the Spot Healing Brush to refine your cloning.

STEP FOUR Use the Patch tool, set to Content-Aware, to replace missing bits. First make your top layer into a new file: Go to Layers > Duplicate Layer and change the Destination to Document: New. Use the Crop tool to crop and straighten it. Click on the Patch tool and select the upper right corner. Click and drag your selection to the left until it fills the empty corner, then release your mouse. Conceal any telltale seams with the Spot Healing Brush.

STEP FIVE Cloning and healing can create softness. To conceal it, select Filter > Convert for Smart Filters, then add a hint of noise. Go to Filter > Noise > Add Noise. Select Uniform, check the box for Monochromatic, and use an amount from 4 percent to 6 percent.

329 EDIT EYES

Enhancing your subject's eyes really brings a portrait to vivid life. Begin with a bit of simple retouching. Clone away bushy eyebrows and other distractions, get rid of red veins in the eyes, soften any rough skin texture, and lighten any shadows. When you have a cleaned-up portrait, you're ready to go to town with Photoshop. (Use a stylus and tablet for best results.)

STEP ONE Set the Lasso tool with a generous pixel feather and make a loose selection of the color of the shadow around the eye. With the selection active, create a Hue/Saturation Adjustment Layer, then move the sliders until you like the color.

STEP TWO You can add contrast to just the pupil and iris, or choose the whole eye area from lower lashes to eyebrow. Use Lasso to make a generously feathered selection. Then create a Curves Adjustment Layer. Make an S-curve, or leave the curve untouched and simply set the blending mode to Soft Light, reducing

layer opacity until you like what you see. For this image, Soft Light with 38 percent opacity worked well.

STEP THREE To brighten the eye's iris and white, select them with a feathered Lasso (choose about 10 or 15 pixels). Use a Curves Adjustment Layer to hold the darks where they are but lighten the midtones a bit, staying fairly close to natural.

STEP FOUR Return to the layer where you did your initial retouching, and use Lasso to make a selection around the eyes, including the eyebrows. Type Ctrl (Command on a Mac) + J to copy the selection to a new layer. Go to Filter > Other > High Pass, and, on a high-resolution file, set Radius to around 8.

STEP FIVE Change the layer's Blend Mode to Soft Light. Add a mask to the layer and fill it with black, then use a white, soft-edged brush to paint back in the eyes and the brows.

330 EXTEND EYELASHES

Eyelashes, especially fair ones, sometimes fade out in portraits, but you can restore them to life with a judicious application of software mascara. Open Photoshop, and then tweak the Brush control's setting to create an eyelashlike brush. Select the brush and, in the Options bar, click the Airbrush icon to activate Flow. Click the button to open the Brush panel and hit Transfer. Set the Opacity Jitter control to Pen Pressure, then click on Shape Dynamics. Set the Size Jitter control to Fade, the Size Jitter to 80 percent, and the Control to 80. (If an 80 percent Jitter appears too rough, simply reduce the size until the brush matches the lashes you're editing.) Make a new, blank layer and sample a color from one of your subject's existing eyelashes. Now draw in improved lashes.

331 UNDO A SQUINT

Open up half-closed eyes with the Liquify filter in Photoshop or Elements. Select Liquify and zoom in on one eye. Next, choose an appropriate brush size in the Tool Options palette. Make the brush no larger than the width of the eye's iris. (If the smallest brush size is too big, zoom in closer.) Select the Forward Warp tool, place the brush in the iris (above the pupil), and gently nudge upward to create a smoothly arched eyelid. Repeat on the lower eyelid.

332 REMOVE RED-EYE

Getting rid of the red-eye that results from on-camera flash is easy in Photoshop. First, zoom in on your subject's eyes. Select the Red Eye tool found in the Spot Healing Brush tool's fly-out menu. In the Options bar, you can choose the amount you want to darken the pupils—40 to 50 percent usually works well. Then hover over each red pupil and click. The Red Eye tool will sample the pixels in this area and replace anything red with a natural pupil color.

BFFORE

AFTER

333 RETOUCH SUBTLY FOR PERFECT PORTRAITS

This is a lovely portrait of a lovely woman, and it doesn't require retouching. But if you're aiming for a somewhat idealized or younger version of your subject—or yourself—try out these steps. They'll let you subtly brighten eyes, whiten teeth, and minimize wrinkles and skin flaws.

Remember: With great power comes great responsibility, so don't go too far! The trick to beauty retouching is making subjects look like slightly better versions of themselves.

STEP ONE Eyes are often the most important feature of a portrait, so make them stand out. Duplicate the background layer and name the new layer Eye Whites. Now grab the Dodge tool, set it to midtones, and leave Exposure set to 50 percent. Zoom in close, and dodge the white parts of the eyes until they're looking a bit brighter.

STEP TWO Duplicate your Eye Whites layer and name the new layer Teeth. Double-click on the color swatches in the toolbar to get Color Picker. Use the dropper to select one of the teeth's whiter tones as the foreground color. Create a new blank layer and change its Blend Mode to Screen.

STEP THREE Switch to the Brush tool, and paint your subject's teeth with a small brush until they're white and bright. If they seem too bright, lower this layer's opacity until they look realistic. When you like their appearance, go to Layer > Merge Down to blend your whitened teeth layer with the Teeth layer that you created in Step Two.

STEP FOUR Now create a new blank layer and call it Blemishes. Grab the Spot Healing Brush, check the box for Sample All Layers, and choose Content-Aware. Then, zoomed in at 100 percent, paint out any blemishes on your subject's complexion.

STEP FIVE Make another new blank layer, and name it Wrinkles. Switch to the regular Healing Brush and set it to Sample Current and Below. Sample a spot with smooth skin on your subject's face, and then paint over a wrinkle to erase it. You need a light hand here, so if your work looks too smooth, go to Edit > Fade and turn down the effect until it looks flattering but natural. One hint: Since wrinkles grow longer as we age, especially around the eyes, just shorten them to make someone look younger. Don't take them out altogether.

335 SAVE FACE WITH SOFTWARE

Give your portrait subjects a youthful glow with a bit of all-over skin smoothing in Photoshop. First duplicate your background layer by going to Layer > Duplicate Layer. Name the new layer Blur. Go to Filter > Blur > Gaussian Blur. Set the radius to 50 and click OK. Now add a black layer mask to the Blur layer. Holding down Alt (Option on a Mac), click the Layer Mask button. Next hit B for the Brush tool. In the Options bar, pick a medium-sized, soft-edged brush, and slide the brush's opacity to 30 percent. Be sure that white is set as your foreground color, and paint the skin until it is smooth and glowing. Overdid it? Just reduce the layer's opacity.

336 PREVIEW YOUR RETOUCHING

In Photoshop, you often zoom in to adjust a portrait. From such a close view, it's hard to gauge how edits affect the whole image. Here's a trick that neatly solves the problem: Go to Window > Arrange > New Window For, and choose the file you're working on. Line up the images on your screen (or, better yet, on two monitors). Zoom in on one, out on the other. All edits you make to the zoomed-in image show on the zoomed-out one, so you see the results of your edits as you work.

334 FIX FACIAL FLAWS WITH YOUR PHONE

Smartphones can, with the right apps, flatter portrait subjects and transform even a flawed complexion into a glowing, natural-looking one. Numerous free or cheap apps—including PicTreat and MoreBeaute—for iPhone and other devices automatically reduce the visibility of freckles, moles, zits, and wrinkles and zap red-eye, and they do it all without slapping on a thick pancake of color. After shooting, you can modify the smoothing and brightness levels until you—and your subject—are pleased with the results.

MOBILE TIP

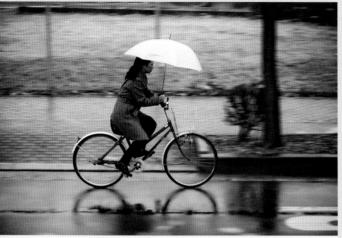

simple

337 EMPHASIZE MOTION BY FAKING BLUR

Sometimes you find yourself in a situation where, as much as you want a panning effect, you're unable to manage it—for example, when you're shooting a moving subject out of a train window, as with the image here. Fortunately, motion blur, like many effects, can be created with software.

This tutorial takes advantage of CS6's tools, such as Content-Aware Fill and Smart Objects, but you can do this in older versions of Photoshop and Elements, too—you need only Layers and the Motion Blur filter.

STEP ONE First, as always, duplicate your background layer before you start (this crucial step ensures that you'll have your original to go back to if you mess up). To fake the blur, you'll need to select the subject, move her to her own separate layer, then blur the background. If you blur the background without first cloning out the cyclist, you'll see a blurry cyclist behind a sharp one. So before you add the motion effect, she's got to go.

complex

STEP TWO Select the figure and her bicycle. Type W for the Quick Selection tool and paint to make the selection. Hold down Alt (Option on a Mac) to paint and remove a selection from where it shouldn't be. Then zoom in and, with a small brush, paint to correct any over- or underselecting that this tool has done.

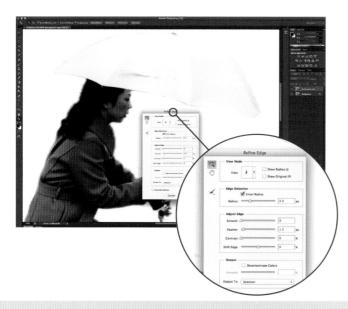

STEP THREE In the Options bar, click Refine Edge to perfect your selection. Keep the feathering low, and add a little smoothness to even out jagged edges. Check the box to use Smart Radius for edge detection. To mask along a straight edge, click at the beginning of the line, hold down the Shift key, and click at the end of the line.

If your selection is still imperfect, exit Refine Edge and then hit Q on your keyboard for Quick Mask mode to adjust it manually. For instance, here the basket was so close to the background color that it was undetectable by the autoselection tools. The solution was to paint the entire basket with the Brush tool. When you're done, hit Q to exit Quick Mask and see your selection again.

STEP FOUR Type Ctrl (Command on a Mac) + J to jump the selected subject to its own layer. Your marching ants will disappear. Reactivate your selection by holding down Ctrl while clicking on the Layer 1 thumbnail. Now click on the Background Copy layer. Expand the selection by going to Select > Modify > Expand, and expand by at least 15 pixels. Then go to Edit > Fill and choose Use: Content-Aware. Hide Layer 1 to see the results. If they're acceptable, continue, as you'll later apply a blur anyway.

STEP FIVE With the Background Copy selected, go to Layer > Smart Objects > Convert to Smart Object. Then go to Filter > Blur > Motion Blur. Set Angle to zero, and play with the distance until it looks realistic. Click OK, then turn on Layer 1. If you need to adjust the blur, double-click on the Motion Blur Smart Filter to redo it.

Photoshop versions CS3 and older don't have Smart Filters, so if you're using an older version, simply apply the filter to your layer.

338 DECIPHER DISTORTED IMAGES

Most lenses create slightly distorted images, and their linear distortion is usually worst at the frame's edge. Very wide-angle lenses are notorious offenders, but inexpensive telezooms can yield distortion, too. Some lenses also add vignetting. In specific subjects—such as those with plenty of straight horizontals and verticals—perspective distortion introduced by a tilted camera is a problem. So, if your images seem to squish or expand in the middle, or the buildings in your skyline shots seem to topple toward one another, either your lens or your angle of view may be at fault. Here's how to straighten out these two common types of distortion using Photoshop.

LENS DISTORTION is the culprit to blame when you see lines bowing inward or outward around a photograph's center. To fix the warp, use the Lens Correction filter to apply the opposite radial distortion weighted between

the center and edges. Images that include long, straight lines often need the most lens-distortion correction.

SHOOT A TARGET to create lens-correction profiles for particular combinations of your cameras and lenses. and then save and use these profiles to automatically apply corrections to any later images that you shoot with the same combination of gear. If you don't wish to craft your own profiles, you can download ones that other shooters have created and then apply them to vour shots.

PERSPECTIVE DISTORTION is easily spotted—lines that are parallel in reality converge in your image, either vertically or horizontally. You'll find this problem frequently in architectural shots. To fix the issue, go to Edit > Transform > Perspective and then pull the lines into proper orientation.

339 WIELD THE WARP TOOL

A tidily aligned photo is all very well, but sometimes you want a touch of the bizarre. Photoshop's Warp is the tool for the job. Make a selection of part of an image via your preferred method, and go to Edit > Transform > Warp. Simply grab the selection's handles to skew it in any direction.

The separate Puppet Warp tool lays a mesh over an image and fastens it with small "pins" that you use to control or resist distortion. Both subtle tweaks and surreal twists can be made with this nicely granular tool. It's similar to the Liquify tool, and it's equally skilled at generating intriguing distortions. (Note: Puppet Warp won't work on the background layer.)

340 WARP A WILD PANORAMA

At its highest levels, image editing is a fine art. Photographer Raïssa Venables cannily combines panorama techniques (see #342), compositing (see #347), and Photoshop layering and masking to craft distorted, baroque interiors for her series "All That Glitters." If you're eager for a challenge, sample a few of her techniques.

STEP ONE Shoot in the highest resolution available to you, pivoting a tripod-mounted camera 360 degrees from a single position to capture an entire interior. (Venables likes rooms that are, she says, "excessively opulent," but a simple room is a better first project.) Bracket for all you're worth—for focus so that all elements stay sharp, and for exposure so you'll have lots of highlight and shadow detail for editing.

STEP TWO Make work prints of the photos and manually assemble them with tape and scissors, as Venables does, into a rough sketch. Venables warped this image outward to emphasize the dizzying spin of her mega-panorama, but you might prefer an easier arrangement. After this planning stage, make new, high-res scans—Venables employed 17 separate images in this shot—and open Photoshop to begin the high-art phase of your work.

STEP THREE Open the first image and expand the canvas around it to the dimensions you plan for the final print. Venables printed this one at 79 by 62 inches (2 by 1.5m), so the image is as imposing as the room itself. Then draw together all the images in a panorama, hiding seams via layer masking, the Transform tool, and the Warp tool.

STEP FOUR Now let your imagination run free. Craft multiple layers and masks to "paint," collage, and distort your image. Venables twined the green and gold trim all over the distorted ceiling, relocated parts of the room, and mirrored, rotated, and erased at will, proving that image-editing software is as powerful as any paintbrush.

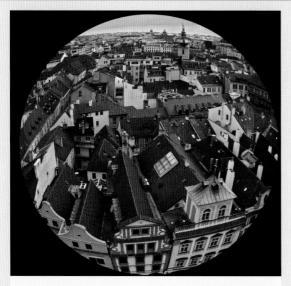

simple complex

STEP ONE Begin by cropping your photo into a square, ensuring the distortion you'll add later will look more realistic. Get the Crop tool by typing C. In the Options bar, click on the drop-down menu and choose 1x1 (Square) to automatically constrain the proportions. Make sure Delete Cropped Pixels is checked so that the distortion will be applied only to the square you have selected, and not to the pixels outside the frame. Drag the edges of your square to crop your image with a circular final product in mind, and hit Enter.

341 GIVE A PHOTO THE FISHEYE LOOK

People often use Adobe Photoshop just to fix pictures: correcting white balance, adding contrast, or removing elements that don't belong. But sometimes it's fun to use Photoshop to get a bit wacky, taking an image to an entirely different place.

To get started, try out this quick and easy trick to make an ordinary photo look like it was shot with a circular fisheye lens, complete with its telltale shape and black background. You'll need the Warp tool, first introduced in Photoshop version CS2. The technique works best on images that have lots of horizontal and vertical lines so the distortion really stands out.

STEP TWO Since the Warp transformation can't be applied to the background layer, work on a duplicate. Go to Layer > Duplicate Layer. Name it Fisheye, and click OK.

If you're looking for a shortcut, a quick way to duplicate your background layer is to drag it down to the New Layer button in the Layers panel.

BIG PROJECT

STEP THREE Now it's time to add some distortion to your photo. Go to Edit > Transform > Warp. Then, in the dropdown menu in the Options bar, choose Warp: Fisheye. The default usually provides enough distortion, but if you want more, increase the Bend percentage. (With a real fisheye lens, the closer you are to your subject, the more distorted it becomes.) When you like the way it looks, hit Enter on your keyboard to keep your transformation.

Want another way to increase the Bend? Try grabbing the small square in the center of the grid's top line, then pull it upward.

STEP FOUR With the distortion all set, add the black circle. Get the Elliptical Marquee tool and set a very slight bit of feathering: Two pixels should do it. Then put your cursor in the top left-hand corner of your photo, just inside the border. Hold down the Shift key and drag the cursor diagonally to make a circle that fits inside the image. If your selection isn't in exactly the right place, use your arrow keys to nudge it so that it encompasses all the important elements of your picture.

STEP FIVE Now reverse your selection by typing Ctrl (Command on a Mac) + Shift + I on your keyboard. Doing this will ensure your selection encloses everything outside the circle you just drew. From the Adjustment Layer menu at the bottom of your Layers panel, choose Solid Color. Select black in the color picker, and then hit OK to see how your faux fisheye photo looks.

342 WIDEN YOUR WORLD WITH PANORAMAS

Ever looked at a landscape, then peered through your viewfinder to discover that even your widest lens couldn't capture the entire scene? That's when a panorama comes in handy: You take a series of photos and piece them together later, capturing the widest possible scene with the greatest amount of detail.

You can stitch the panorama together yourself by dragging and aligning all the images in a single canvas

sized to the approximate pixel dimensions of the final version: roughly the dimension of a single frame times the number of component frames you're including in your stitched-together composition. Then use layer masks to blend the overlapping areas into a seamless whole. If you'd rather not do it on your own, let your software take over. For instance, Photoshop's Photomerge tool does an excellent job.

343 GO GLOBAL

Want to turn a panoramic photo into the whole wide world? Use this trick to transform a 360-degree panorama into a globe. Start with Photomerge and stitch your images together to make one long horizontal image. Then crop your image so that it has no border and rotate it upside down. Go to Filter > Distort > Polar Coordinates. This somewhat obscure filter is your ticket to globalization. But depending on how fast your computer is and how large an image you're rounding out, it may take time to process. Make sure Rectangular to Polar is selected, then click OK.

Now you have something that looks like a globe, albeit one that was stepped on by a giant. That's easy to fix. Choose Edit > Free Transform. That gives you handles on all sides of your image so you can change its shape. Grab the handle on the left and drag it right until the oval becomes a circle. Some white will remain, so crop it out to finish your global image.

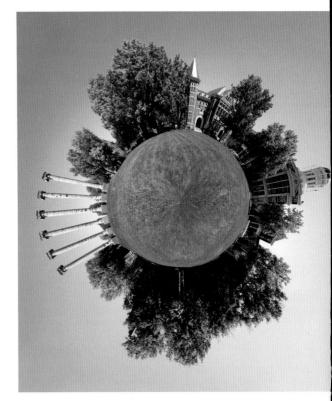

344 MAKE A VERTORAMA

You've heard of panoramas, but how about a vertorama? Yes, it's a real term: It's a panorama-like image made up of vertical slices of a scene stitched together in software. Klaus Herrmann, a German computer scientist, did just that for this interior of the St. Martin Basilica in Weingarten. It's five verticals joined together. Why vertoramas? They let you shoot an expansive interior or landscape to include far more detail than you would get in one wide-angle capture, and you end up with something like a traditional pictorial aspect ratio (i.e., 3:2), not the long sliver typical of stitched horizontals.

345 DITCH DISTORTION

Adaptive Wide Angle, a new filter in Photoshop, can correct the distortion inherent in panoramas, straightening buildings and horizons and reducing wide-angle distortion. It's compatible with Smart Objects—use it as a Smart Filter, which you can edit at any time.

I began learning image editing as I learned digital photography. I sketch an idea, then use photography and software to make it happen. To combine photos, you have to capture your elements in the same lighting and from the same angles, with the same shadows. To get multiple perspectives on a scene, I shoot from different elevations. Combining is less difficult when the photos are planned carefully in advance. I love the ability to imagine a scene and make it look real—and digital photography and editing let you do that.

ERIK JOHANSSON

346

CREATE AN OPTICAL ILLUSION

Hundreds of shots—and inspiration from mind-bending artists such as M. C. Escher—enable Erik Johansson to craft trompe l'oeil masterworks. They're composites (see #347)—very precisely planned ones.

To combine the vertical and horizontal lines of traffic in this image, he shot from multiple hills along a road, standing far enough away to capture perfectly straight lines. He assembled the photos into a rough composite in Photoshop and added background and fill from a stock library of elements such as skies and trees. The last stage—compositing—required days as he adjusted color temperatures across layers and fine-tuned contrast.

This image from Romain Laurent's "Tilt" series is so seamless and simple, it's hard to believe it's composed of many elements. But it's actually a composite of numerous separate images. To create a vertigoinducing shot of your own, try out his method:

STEP ONE First take an empty background shot (here, the cobblestone street) for your image's base layer.

STEP TWO The second layer is your trick shot of your model. Bring along a friend to support her as she leans to the side, and capture multiple images from the same perspective, making sure they all line up.

STEP THREE Postshoot, convert your RAW files (see #284) and ensure their colors match as closely as possible. Then open Photoshop to begin compositing.

STEP FOUR Choose the best overall shot of your model, then use Photoshop's high-precision Pen tool to excise your helper and separate the model as smoothly as

possible from her original background. Now layer her figure atop the base-layer background of the empty street, placing her where she was in the initial shot.

STEP FIVE Check for telltale flaws. If you can spot the assistant's shadow, remove it using a combination of the Pen tool and masks. Look, too, for areas missing from the street because your assistant's body covered them, and patch in fill from other shots.

STEP SIX Do all details look their best, or are there better versions in alternate shots? Laurent cut out and layered in superior images of the model's right shoulder, tote bag, dress bow, and left hand.

STEP SEVEN Minimize cloning and healing by using your clean base layer, and employ masks to show or hide areas as needed. Your final file, which will include many masked Curves Adjustments Layers, should skew perspective just enough to intrigue the viewer.

348 ANIMATE A GIF ON A SMARTPHONE

Several cheap apps let you conjure animated GIFs (graphics interchange format files) out of smartphone shots in mere seconds. Use them to spruce up your social avatars, amuse Facebook friends, or shock Granny. GifBoom, a popular choice, works on Androids and iPhones, as do GifSoup and GifPal. Their functions permit you to shoot brief sequences to convert to GIFs or work with existing photos, adding special effects and previewing GIFs before you upload them.

349 SWITCH OUT COLORS FOR GRAPHIC POP

Philip Habib shot these utility towers and lines against a gray sky. Looking at the image files later, he was disappointed by their weak contrast, so he swapped out the colors. If you find yourself in a similar fix, try borrowing his trick. Mask off the background using Photoshop's Color Range tool, then fine-tune lines with a hard-edged brush. Now replace the background with the shade you desire—Habib was inspired by painter Piet Mondrian's bold palette—to enhance contrast.

simple

complex

STEP ONE Since the sky will be doubled in your final picture, clean it up first. This photo shows a bright spot on the top left portion of the sky—use the Healing Brush to remove that kind of visual distraction. Then ensure you like the image's exposure and color tones. When your photo is at a good starting place, grab the rectangular Marquee tool by hitting M on your keyboard. Use it to select the whole top section of your image the section that you want "reflected" on the water's surface

STEP TWO Type Ctrl (Command on a Mac) + J to copy the selected area and jump it to a new layer of its own. Then go to Edit > Transform > Flip Vertical to turn it upside down. Type V to get the Move tool, and, holding

350 FAKE A REFLECTION

Not every scene photographs the way you see it in your mind's eye. Say you find a beautiful lake and position yourself for a composition with a strong foreground, midground, and background. The scene is lovely, but it's windy and the water is choppy, not tranquil. You take the shot, and the final result lacks both serenity and symmetry. There's no need to live with it—you can fake a mirrorlike reflection in Adobe Photoshop even if Mother Nature didn't have the grace to provide one.

down the Shift key so it doesn't wiggle left or right, drag the top half down until it meets the horizon line. If it doesn't quite fit, type Ctrl (Command) + T to transform it, and stretch it until it meets the bottom.

BIG PROJECT

STEP THREE Now make the selection. Turn off the layer with the fake reflection, select the layer below it, and use your preferred method to select anything that isn't water. Various methods work best for specific photos—here the Blue channel is a good starting place for a mask. Duplicate it, then use Levels to add enough contrast to blow out the water. Click OK, then hit Ctrl (Command) + A to select the whole layer and Ctrl (Command) + C to copy. Click on the thumbnail of the Blue copy. Turn off your extra channel so you don't see it, but save it in case you want to go back.

STEP FOUR Head back to your layers, then add a mask to the layer that contains your reflection. Press Alt (Option) + click on it to show the mask, then hit Ctrl (Command) + V to paste the contrast version of your Blue channel into it. Deselect it, then use the Brush (B) to finish whiting out the water and blacking out the foreground grasses. The foreground here is detailed, so take time to perfect it with the Pen and Quick Selection tools.

STEP FIVE Now for the fun part: making the water look realistic. Click on the layer thumbnail for the upside-down sky. Then go to Filter > Blur > Motion Blur. Choose a nearly horizontal angle (4 degrees or so) and a distance you like. Click OK. Now run that filter again, this time choosing a more vertical angle (such as 60 degrees). Finally, darken the water. Make a Curves Adjustment Layer, and lock it to the water layer by holding down Alt (Option) and clicking on the line between the two layers. Bring down midtones until your water looks real. Presto: You've got the flawless reflection you envisioned when you first composed your shot.

351 QUICKLY SHARPEN A LANDSCAPE

Most pictures, especially landscapes, turn out just a bit blurrier than they should be. Whether the blurriness is the fault of your lens, RAW processing, resizing, or other digital-workflow tasks, you'll want to subtly sharpen your images before you print or share them.

Photoshop and Elements both offer several fast options for sharpening. Adjust Sharpness in Elements. and its cousin Smart Sharpen in Photoshop, are popular options. But there's another method—High Pass sharpening. Quick and simple, it won't amp noise, create oversharpened or "crunchy" edges, or sharpen areas where you want to preserve blur. Instead, it provides just the right amount of contrast and snap.

STEP ONE Wait to sharpen until you've resized and finished the rest of your editing work. Then, in Elements, copy your background layer by right-clicking it with the mouse and choosing Duplicate Layer. Now hit Ctrl (Command on a Mac) + Shift + U to completely desaturate your duplicated backgound layer. By zapping color, you'll avoid oversharpening or increased color noise.

STEP TWO Now it's time to add the High Pass filter. Go to Filter > Other > High Pass. Move the Radius slowly upward until you can just barely see your image's edges in the gray preview. (Note: The smaller your original image, the smaller the Radius you will need.) Anything beyond five or so pixels won't truly sharpen. so don't push it too far—that would give the photograph a fake-HDR appearance. When you're done, click OK.

STEP THREE To check out the effect of your High Pass filter, change your background copy layer's Blend Mode. Use the pulldown menu found at the top left of your Layers Panel to switch your mode from Normal to Overlay.

STEP FOUR Now you should have a presentably crisp image. If it looks too sharp, simply lower the layer's opacity. But if it still isn't sharp enough, experiment with another Blend Mode. Linear Light will probably take the photo over the edge into crunchiness, so give Hard Light a try to see if that mode will take the effect up just a bit.

STEP FIVE When you're finished with your sharpening work, flatten your final image by going to Layer > Flatten Image. Then simply Save As. Remember to use a new file name.

QUICK TIP

352 CUT OFF FRINGE

Ever shoot a landscape only to notice that backlit branches or mountains show purple edges where they meet the sky? Or that one side of a backlit object is cyan and the other red? The purple stuff is called fringing, and the split color is known as chromatic aberration. Both are so common in digital pictures that they're often accepted. But fixing them makes photos look cleaner and more professional. In Photoshop CS6's Lens Correction filter, Adobe Camera Raw in CS6, or Lightroom 4, simply check the Chromatic Aberration correction box to clean up your landscapes.

353

LEVEL YOUR HORIZON

A slanted horizon can mess up an otherwise wonderful landscape. Even when you're shooting with the support of a tripod, however, it's hard to tell by eye if you've properly captured the horizon.

If your horizon turns out wonky, use the straightening capability that's in Photoshop's Ruler tool. Find it by clicking and holding the Eyedropper icon in the toolbar. Use the ruler to draw a line along the horizon, and then click the Straighten Layer button in the Options bar at the top of the screen. The world should return to an even keel.

354 PUMP UP THE CLOUDS

To add drama to a cloudy sky in Photoshop, duplicate your Background layer, then use the pulldown menu to choose the Multiply Blend mode. The effect will most likely be too strong, so dial down the layer's opacity until you get a more realistic sky. Add a mask to the layer, grab the Brush tool, and paint with black on your mask to hide all the areas that you don't want your Multiply Blend to affect.

355, ADD SPOT CONTRAST

Sometimes you'll shoot a landscape with excellent contrast in certain sections but a flat look in others. Zap dull spots one at a time using a Curves Adjustment layer and a mask. First, select the Curves button in the Adjustments panel. Click on the pointer finger in the Curves dialog (on the left in the Properties panel), place it on an area you wish to lighten, and drag upward. Do the same on an area with a tone you want to darken, but drag downward. Fill the mask with black to hide all adjustments. Set the Brush to white, with 30 percent opacity, to slowly paint them back in.

INDEX

abstract photo techniques 123_127 accessories 014 034 Acosta, Javier, 073 Action shots freeze action techniques 070. 217, 237, 247 use of extended exposure 181, use of fast shutter speed 237 use of fisheve lens 034, 036, 208 use of flash 28, 181-182 use of strobes 031-033 use of tripods 180, 183 Adobe Bridge 272-273, 287. 312, 315, 324 Adobe Camera RAW (ACR) 261, 272, 283, 287, 312 Adobe Lightroom 062, 098, 285, 303 Adobe Photoshop Adaptive Wide Angle 345 Adjustment Layers 297, 299, 301 Airbrush 330 Black and White 287, 296, 299 Blur Gallery 295 blur techniques 275, 295, 335, Brightness/Contrast 289 Burn 286 color management 293, 296-302, 325, 349 composites 340, 346-347 computer considerations 263 Content Aware tools 261, 328, 337 cropping 278-280, 341 Curves Adjustment Layer 302, 329, 347, 350, 355 Curves tool 195, 280, 290-291, 294. 302 customization 262

distortion correction 338, 345

Eraser tool 300 eye editing tips 329–332 fisheve technique 341 HSL/Gravscale tab 292 Hue/Saturation Adjustment Lavers 301 image tools overview 261 Lavers 266-273, 293, 300-301. 337 Levels 195, 293-294 masks 268-269, 297 monitor considerations 262-263 Motion Blur 337 Multiply Blend mode 354 neutral density (ND) filter simulation 272 panorama techniques 340, 342-Photoshop data file (PSD) 318 plug-ins 283, 288-298 portrait retouching tips 329-336 RAW file conversions 283-284 Red Eve tool 332 reflection faking technique 350 rotation tools 276 Ruler tool 342 scrubby slider 265 selection tools 268 sharpening 351 Smart Filters 328, 337, 345 Tilt/shift 275, 295 tone inversion 327 Twirl tool 281 uncropping 280 undo feature 277 Warp tools 339-340 Adobe Photoshop Touch 274 AF (autofocus) 005 angle shots, overhead, 046 Anna, Rhea, 222 Ansarov, Aaron, 128 anti-topple effect 113 antique photo technique 314

Dodge 286

aperture 188
Apple Aperture 285
aquatic photography 074–076
artsy shots 246
audio trigger 039–040
autobracketing 009, 162
autofocus (AF) 005

E

backdrop 013-014, 017, 029-031, 039, 042, 100 backlighting 012, 100, 172, 233 battery drain 150 beanbag support 121 Bing's Bird's Eye View 086 bird shots 247-250 black and white shots 176-179. 220, 287, 327 blue-blocker sunglasses 178 blue hour, shooting in, 187 blur computer editing techniques 275, 281, 295, 335, 337 elimination 052, 082, 170-171, 212. 251 five-second-rule 241 motion blur 031-034, 036, 157, 180 185, 189, 337 using camera movement 189 using f-stop and shutter speed selection 137, 142, 159, 168, 209 using film 154 using filters 189 using flash 157 using lenses 112, 115, 155, 242, 257, 262 using zoom setting 189 bokeh 137, 155 Bracaglia, Dan, 125 breaking the rules 106 burn 286, 310 burst shooting 235

focus 120, 192 display tips 322 C dodge 286, 310 fog shots 198-202 camera gear dog shots 067-068 food shots 044-047, 049 car kits 021 drink shots 065-066 foreground framing 129 lighting 014 freeze action shots 070, 217, 237, dust control 144 protection 077 Dutta, Subhajit, 085 247 small essentials 023 functions 009 dynamic range 161 storage 020-022 camera manual 003, 146 G camera types 001 Edwards, Stefan, 122 garden shots 042-043, 070 candid shots 218-220, 228-229 enlarger 306 gear protection 077 candlelight shots 170 exposure time 181, 184, 186, 241 gear storage 020-023 Caplan, Skip, 049 eye shots 096-098, 329-332 ghost control 215 carnival shots 159 ghosting 181 catchlight 018, 098, 250 GifBoom 348 cave shots 079 GifPal 348 f-stop 142 city shots 217 GifSoup 348 fake depth 138 clamshell 015 "God ray" shots 214 family shots 228-231 Cohen, Liad, 154 Google Earth 073, 086, 255 film 091, 093-095, 153-154, 307-309 cold storage 309 graininess 319 filters 186, 189, 194-195, 212, color control, 133-135 Green, Bud, 094 246 compass use 078 fireworks shots 166-169 composites 340, 346-347 H fisheye lens 034, 036, 112, 208, 211 composition 103-107 five-second rule 241 Habib, Philip, 349 computer editing software see flare 155, 215 Hague, James, 245 specific Adobe and Apple Herrmann, Klaus, 344 flashes software names accessory flash 014, 024 high dynamic-range (HDR) 213, contact sheets 315 in action shots 181, 182 contrapposto 224 high-speed action shots 034-036 exposure 157 copyright 323-324 fill 163 histograms 149, 151, 177, 196, 286 crepuscular ray shots 214 forced 163 Holga camera 154 crop factor 061 macro ring 014, 098 home studio 017 over-camera 037 Honig, Sandy, 156 D remote trigger 182 darkroom print development shoe mount 025 304-308, 310 synchronization 181 ice cubes, fake, 066 deepwater dive shots 076, 256 techniques for motion shots ice shots 197 depth of field (DOF) 109, 136-137, 181-182 iCloud 326 140 TTL (through-the-lens) metering illumination see lighting; reflectors desert shots 071 024, 028 image-stabilization feature 216 Diana cameras 001, 154 wireless 035, 038 infrared (IR) film techniques diffusion 011 flashlight use 054-055, 089 090-092 digicam 236 flashmeter 033, 152, 246 ISO settings 007 digital single-lens reflex see DSLR

flower shots 331, 245

T	fluorescent 19, 174	neutral density (ND) filter 186
ially fish shots 074	gear 014	new camera, trying it out 002
jellyfish shots 074 Johansson, Erik, 346	hard light 030	Nik's Silver Efex Pro 288, 298
	kits 019-021	no-parallax point 057
JPEG 004, 165, 235, 264, 283–284, 325	light fall-off 029	nodal point 057
K	light tent 042	noise reduction 319
	natural 047	Norton, Cary, 173
keystoning 139	ratio 152	
Kolonia, Peter, 216	single source 018	0
	see also reflectors	
L	Ling, Jeffrey, 238	old photo restoration 328
landscape shots 081–084	lizard shots 122	Onishi, Teru 065–066
Laurent, Romain, 347	lo-fi photography 153–154	outdoor shots, gardening mats for
LEDs 055		043
Lefebure, Regis, 036	lomography 153–154	D
lens correction 148	long exposure shots 058	P
lenses	lost sites 086–089	Paiva, Troy, 088
cleaner for 131	7.6	pan/tilt tripod head 052
film-camera 193	M	panning technique 180
fisheye 034, 036, 075, 112, 208–209,	manual exposure 005, 213	panoramas 056–057, 340, 342–343
211	manual focus 192	patterns
Lensbaby selective-focus 112,	Marcellini, Paul, 074	in nature 107, 109
242	Markewitz, Scott, 032-033	urban 125–127
macro 112, 118–120, 124–125,	memory card tips 264	performance shots 234–237
128, 244	metering 160	permission requests 088
macro simulation 117	Miller, Chuck, 190	perspective 130
	"mirror slap" 185	Petersen, Jason, 031
medium-length 249	mobile editing 274	photo editing tips 327
no-parallax point 057	moisture-proofing 201, 206	photo paper storage 311
nodal point 057	monarch shots 072	photo storage 006, 326
overview of types 112	monochrome shots 176–179	Photoshop see Adobe Photoshop
telephoto 112, 125, 245	moon shots 059	Photoshop data file (PSD) 318
tilt/shift (T/S), 112–116,	Moore, Lisa, 053-055	Photoshop Touch see Adobe
139, 243, 275	motion blur 031–034, 036, 180–185,	Photoshop Touch
ultrawide 075, 112, 123–124	188	pinhole camera 050–051
wide angle 112, 126, 254	museum shots 216	pixel count 316–317
zoom 258, 260	madean diota 210	Polaroid retro art 282
leveling guide 141	N	
light painting shots 053–055		pool shots 254
light-proofing 304	natural light 047	portraits
lighting 010–019	natural light 047	contrapposto 224
accessories 041	nature shots	lighting angles 018, 225, 227
ambient 175	patterns 107, 109	nude 099–102
angles 012	scouting sites for 073	skin-smoothing techniques 015,
blue hour 187	using a guide 080	223, 231
compass as tool 78	negative cleaning technique 307	use of color 226
flashlight app 027, 045	neon shots 158	posing 230, 232
J		

printer ink 321 professional photo labs 313 PSD vs. TIFF 318 R rain shots 203-206 RAW advantages of 004, 135, 283-285 for black and white 179, 199 blurriness 351 color control 009, 133, 135, 174, 256, 325, 347 cropping 279 and dynamic range 161 to JPEG conversion 165, 283, 285 processing 063, 285 storage 081, 264 red-eye 097, 332 reflectors 016, 018, 048-049, 221-222, 231 wet-weather 221 registration 008 release forms 101-102 reptile shots 122 resolution 316-317 restoration 328 Rober, Mark, 259 rock-star shots 233-237 rule-breaking effects 106

printer choices 320

S

safety 087, 252–253
Scheimpflug effect 114–115
scrubby slider 265
second-curtain sync 181
shadow shots 171–172
shark shots 075
shots on old film 190
shots with film camera 191
shutter speed
rules of thumb 142
"sunny 16 rule" 196

Rule of Thirds 103, 106, 110-111

skin-smoothing techniques 015, sky shots 058-060, 081-084 Smart Objects 337, 345 smartphone flashlight app 027, 045, 089 GIF animation apps 348 grid app 143 microscope 108 photo editing apps 274, 334, 348 shots 219 tripod mount 064 snorkeling shots 255 snow shots 195-196 soft-focus filters 189 split focus 192 star shots 058, 060 still life shots 049, 063 stranger shots 217-220 strobe paired with audio trigger 039-040 used in action shots 031-033 used in animal shot 122 used in aquatic shots 076 used in dog shots 068 used in still life 049 "sunny 16 rule" 196 surf shots 207-211

T

tagged image file format (TIFF)
318
Tal, Guy, 286
Taylor, Ryan, 039
Teo, Andy, 123
tethered photography 062–063
TIFF vs. PSD 318
tilt/shift see Adobe Photoshop;
lenses
time-lapse sequence 70
Togashi, Kigoshi, 246
trailing sync 181
travel shots 085
tripods 052, 064, 180, 183
Tucker, Greg, 241

TT

underwater housings 076, 206, 210 urban shots 104–105

V

Venables, Raïssa, 340 vertoramas 344 vodka, as lens cleaner, 131 voice memo feature 147

W

waterfowl shots 069
waterproof cameras 076, 254, 256
watertight housings 076, 206, 210
wedding album shots 238–240
Weinberg, Carol, 017
"wet down" 205
white balance 134, 164
Whitten, Daniel, 109
wildflower shots 042
wildlife shots 252–253
wireless flash 038
Wise, Philip, 160
Wood, Andrew, 303

Y

Yu, Byron, 183

Z

zoo shots 257–260 zoom creep 145

IMAGE CREDITS

All illustrations courtesy of Francisco Perez. All images courtesy of Shutterstock Images unless otherwise noted.

Half title page (left to right): Philip Ryan (upper left), Zach Schnepf (middle right), Nicky Bay (lower right), Will Gourley (middle left)

Full title: Bret Edge

Contents (left to right): Atanu Paul, Allyeska Photography, Kenneth Barker, Subhajit Dutta, Regis Lefebure, Jim Wark, Byron Yu, Daniel Soderstrom, Stephan Edwards, Jesse

Swallow, Carol Weinberg, Ian Plant Introduction: Charles Lindsey

GEAR & SETUP

001: Pablo Hache (bottom), Andrea Lastri (top right) 002 (top to bottom): Ian Plant, Eric Chen, Dorothy Lee 012: Kim Oberski 014 (left to right): Alberto Feltrin, Shawn Miller, Leonardo Miguel Cantos Soto, David O. Andersen 017: Carol Weinberg 024: Michael Soo 025: Danny Ngan 028: Connor Walberg 030: Matthew Hanlon 031: Jason Petersen 033: Scott Markewitz 034: Donald Miralle 036: Regis Lefebure 038: Andrew Wong 039: Ryan Taylor 040: Dan Taylor 041: Stefano De Luca (bottom left), Simon Jackson (bottom right), Graham Gamble (top right) 042: David FitzSimmons 044: Erin Kunkel (from Williams-Sonoma Salad of the Day) 045: Ali Zeigler 046: Alex Farnum (from Williams-Sonoma This Is a Cookbook) 047: Kate Sears (from Williams-Sonoma Two in the Kitchen) 048: Matt Haines 049: Skip Caplan 050 (left to right): Barbosa Dos Santos, Laurens Willis, Darren Constantino, Thomas Fitt, Stephanie Carter 052: Pascal Bögli (left) 053: Lisa Moore 054 (top to bottom): Gareth Brooks, David Yu, John Petter Hagen 057: Stijn Swinnen 058: Ryan Finkbiner 060 (top to bottom): Alexis Burkevics, Larry Andreasen 063: Debbie Grossman 064: Meghan Hildebrand 065: Teru Onishi 068: Harry Giglio 069: Jason Hahn 073: Javier Acosta 074: Paul Marcellini 076: MaryAnne Nelson (bottom) 079: Dave Bunnell 081: Jim Wark 084: Jason Hawkes 085: Subhajit Dutta 086: Ben Ryan 088: Justin Gurbisz 089: Alex Wise 092: Matt Parker 093: Stephen Bartels 094: Bud Green 098: David Becker

COMPOSING & SHOOTING

103: Glenn Losack 104: Tom Haymes 105: Guillaume Gilbert 107: Mike Cable 108: Martin Wallgren 109 (top to bottom): Daniel Whitten, Adam Oliver 110: Brett Cohen 113: Trent Bell 114: Ian Plant 115: Satoru Murata 116: Michael Baxter 117: Philip Ryan 122: Stefan Edwards 123: Andy Teo 125: Dan Bracaglia 126: Ricardo Pradilla 128: Aaron Ansarov 129: Ben Hattenbatch 130: Fotolia 132: Meghan Hildebrand 135: Kenneth Barker 142: Naomi Richmond 143: Marisa Kwek 149: Ian Plant 151: Steve Wallace (left), Irina Barcari (right) 153: Nathan Combes (top), Cameron Russell, Stephane Giner, Mathieu Noel

(left to right) 155: Allison Felt 156: Sandy Honig 158: Jeff Wignall 160: Philip Wise 161: Amri Arfiantio 162: Kevin Barry 164: Darwin Wiggett 166: Nick Benson (small) 168: Allyeska Photography 171: Rick Wetterau 173: Cary Norton 176 (left to right): Andres Caldera, Mark Rosenbaum, Brett Cohen 180 (left to right): Rick Barlow. Yew Beng 183: Byron Yu 184: Laura Barisonzi 186: Michael Soo 187: Lucie Debelkova 188: Tom Ryaboi 190: Chuck Miller 194: Douglas Norris, David B. Simon, Ray Tong (left to right) 195: Ralph Grunewald 200: Giorgio Prevedi 203: James St. Laurent 208: Cameron Booth 209: Pan-Chung Chan 212: Edwin Martinez 213: Nabil Chettouh 216: Peter Kolonia 219: Carl Johan Heickendorf 220: Maurizio Costanzo 222: Rhea Anna 223: Oyo 224: Paul Hillier 225: Brandon Robbins 227: Brooke Anderson Photography 228: Charlotte Geary 229-230: Ashley Pizzuti-Pizzuti Studios 233: Mat Hayward 236: Mat Hayward 238: Jeffrey Ling 239 (all): Delbarr Moradi 240: Herman Au 241: Greg Tucker 242: Tafari Stevenson Howard 245: James Hague 246: Kiyoshi Togashi 247: Gary Reimer 251: Martin Bailey 252: Paul Burwell 257: Daniel Soderstrom 258 (top to bottom): Lisa Pessin, Gerardo Soria

PROCESSING & BEYOND

262: Peter Kolonia 263: Timothy Vanderwalker 267: David Yu 269: Saleh AlRashaid 270: Philip Ryan 273: David Maitland 274: Debbie Grossman 275: David Evan Todd 276: Alexander Petkov 278: Jesse Swallow 279: Subhajit Dutta 280: Regina Barton 282: Stefano Bassetti and Filomena Castagna 283: Debbie Grossman 286: Guy Tal 287: Luisa Mohle 288: Darwin Wiggett 289: Cheryl Molennor 291: Timothy Vanderwalker 292: Ian Momyer 293: Kevin Pieper 295: Debbie Grossman 296: Jamie Lee 303: Andrew Wood 312: Chris Tennant 314: Helen Stead 315: Maren Cuso (from Williams-Sonoma Spice) 322: Peter Kolonia (stack of books), Dan Richards (dog book) 327: Timothy Edberg 328: Katrin Eismann 329: Charles Howels 333: Carol Delumpa 334: Filip Adamczyk 337: Lluis Gerard 338: Xin Wang 340: Raïssa Venables 341: Anna Pleteneva 343: Ben Fredrick 344: Peter Kolonia 346: Erik Johansson 347: Romain Laurent 348: Jess Zak 349: Philip Habib 350:

Index opener: Nick Fedrick Last page: Priska Battig Front endpaper: Daniel Bryant Back endpaper: Geno Della Mattia

Back cover Lisa Pessin (first row, middle), Tim Barto (second row, left), Matthew Hanlon (second row, middle), Dan Bracaglia (third row, left), Kenneth Barker (third row, right), Lucie Debelkova (fourth row, far left), Steve Wallace

(fourth row, middle)

Lee Sie 354: Dan Miles

POPULAR PHOTOGRAPHY

P.O. Box 422260 Palm Coast, FL 32142-2260 www.popphoto.com

ABOUT POPULAR PHOTOGRAPHY

With more than 2 million readers, *Popular Photography* is the world's largest and most noted photography and image-making publication. The magazine brings almost 75 years of authority to the craft, and in its advice-packed issues, website, and digital editions, its team of experts focus on hands-on how-to hints and inspiration for everyone from beginners to top-notch professionals.

POPULAR PHOTOGRAPHY

Editor-in-Chief Miriam Leuchter

Art Director Jason Beckstead
Senior Editor Peter Kolonia
Senior Editor Dan Richards
Senior Editor Debbie Grossman
Technical Editor Philip Ryan
Web Editor Stan Horaczek
Assistant Web Editor Dan Bracaglia
Technology Manager Julia Silber

Assistant Editor Matthew Ismael Ruiz
Art/Production Assistant Linzee Lichtman

Editorial Coordinator Jae Segarra

ACKNOWLEDGMENTS

WELDON OWEN

Weldon Owen would like to thank Marisa Kwek for art direction and Moseley Road for initial design devlopment, and Ian Cannon, Katie Cavanee, Emelie Griffin, Linzee Lichtman, Marianna Monaco, Peggy Nauts, Jenna Rosenthal, Katie Schlossberg, and Mary Zhang for their editorial and design assistance.

POPULAR PHOTOGRAPHY

Popular Photography would like to thank Meghan Hildebrand, Lucie Parker, Laura Harger, Maria Behan, Kelly Booth, and Diane Murray for their efforts on this title.

weldonowen

415 Jackson Street San Francisco, CA 94111 www.weldonowen.com

A division of

BONNIER

WELDON OWEN, INC.

President, CEO Terry Newell
VP, Sales Amy Kaneko
VP, Publisher Roger Shaw
Senior Editor Lucie Parker
Project Editor Laura Harger
Consulting Editor Maria Behan
Creative Director Kelly Booth
Senior Designer Meghan Hildebrand
Project Designer Diane Murray
Designer Michel Gadwa
Image Coordinator Conor Buckley
Production Director Chris Hemesath
Production Manager Michelle Duggan

A WELDON OWEN PRODUCTION

© 2012 Weldon Owen Inc.
All rights reserved, including the right of reproduction in whole or in part in any form.

Library of Congress Control Number is on file with the Publisher.

ISBN Flexi: 978-1-61628-295-0 ISBN Hardcover: 978-1-61628-449-7

10 9 8 7 6 5 4 3 2 1 2016 2015 2014 2013 2012

Printed by 1010 Printing Ltd in China.